THE GALLERY OF

FASHION

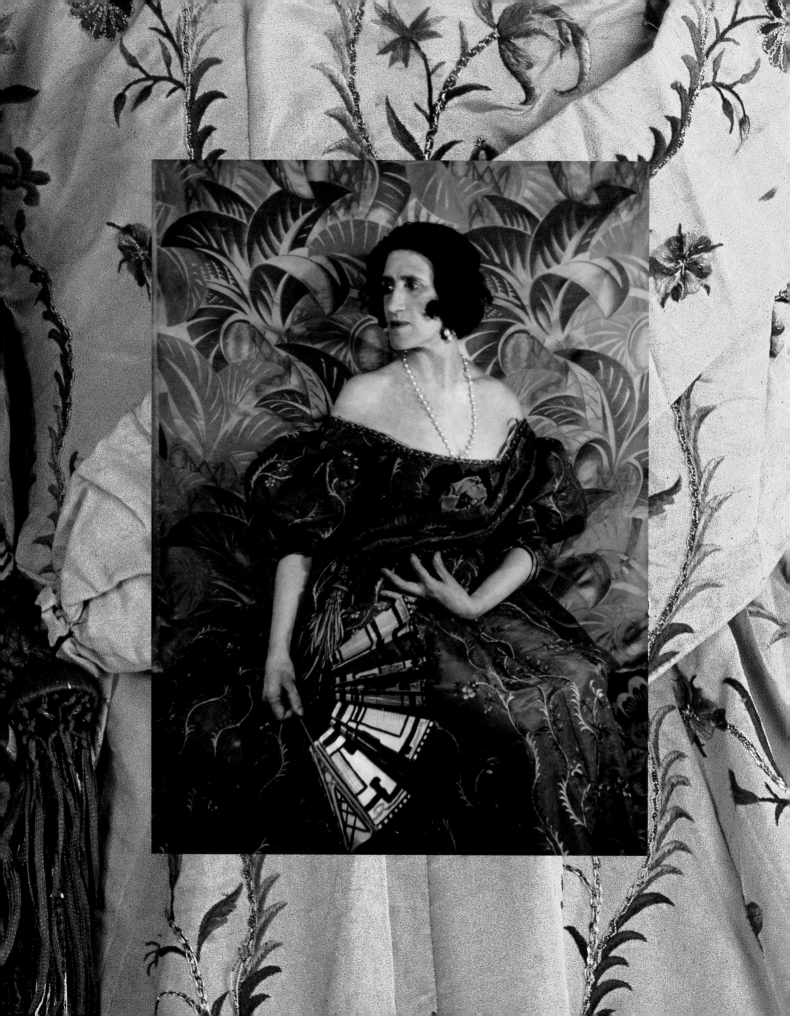

THE GALLERY OF

FASHION

AILEEN RIBEIRO

PRINCETON UNIVERSITY PRESS

First published in North America by
Princeton University Press
41 William Street
Princeton, New Jersey 08540-5237

Published in Great Britain by
National Portrait Gallery Publications
National Portrait Gallery
St Martin's Place
London WC2H 0HE

ISBN 0-691-05092-9

Library of Congress Catalog Card Number: 00-103181

Publishing Manager: Jacky Colliss Harvey
Project Manager: Celia Jones
Picture Research: Cally Blackman
Designed by Cara Gallardo, Area
Production: Ruth Müller–Wirth
Printed by EBS, Verona

Frontispiece: LADY OTTOLINE MORRELL by Cecil Beaton, 1928, NPG x402290; dress worn by
Lady Ottoline Morrell, early 1900s (detail), Museum of Costume, Bath

pp.24–5: ROBERT DUDLEY, EARL OF LEICESTER by an unknown artist, c.1575 (detail), NPG 447
pp.54–5: PRINCESS ELIZABETH by Robert Peake the Elder, c.1610 (detail), NPG 6113
pp.94–5: WARREN HASTINGS by Sir Joshua Reynolds, 1766–8 (detail), NPG 4445
pp.150–1: QUEEN VICTORIA by Thomas Jones Barker, early 1860s (detail), NPG 4969
pp.198–9: DORIS CLARE ZINKEISEN self-portrait, exh. 1929 (detail), NPG 6487

CONTENTS

ACKNOWLEDGEMENTS

This kind of book could not have been written without the many people whose help I acknowledge below, but first I should like to thank the Director of the National Portrait Gallery for making the project possible. I am grateful for their advice and comments to all the curators – Honor Clerk, Peter Funnell, Catharine MacLeod, Terence Pepper and Jacob Simon; and to the staff at the Archive, the Department of Photographs, the Picture Library and the Registry.

I should like to thank the staff at the National Portrait Gallery's regional partners – Beningbrough Hall, Bodelwyddan Castle, Gawthorpe Hall and Montacute House – for facilitating access to the Gallery's portraits on loan there.

I am grateful to the museums, art galleries, dealers and private owners who were generous with information regarding the complementary images in the book, and who in many cases provided photographs and gave permission for their works of art, costume, textiles and accessories to be reproduced here. I should particularly like to thank Christopher Lloyd, Surveyor of the Queen's Pictures; Clare Browne, Department of Textiles and Dress at the Victoria and Albert Museum; Edwina Ehrman, Oriole Cullen and Jill Spanner for their help with the costume and textiles at the Museum of London; Rosemary Harden at the Museum of Costume in Bath; and Jeremy Farrell at the Museum of Costume and Textiles in Nottingham. My thanks are due also to Hélène Alexander, Sheila de Bellaigue, Tony Benn MP, Paul Boateng MP, Alison Carter, Elizabeth Ann Coleman, Cynthia Crawford, Tracey Crawley, Valerie Cumming, Elizabeth Dawson, Celia Fisher, Mr and Mrs Adrian Goodman, Anthony Green, Germaine Greer, Lady Pamela Hicks, Joanna Marschner, Lady Antonia Pinter, Robert Ribeiro, Diana Scarisbrick, Sir Roy Strong, Kerry Taylor, David Thompson, Harvey Wilkinson and Eva Yocum.

I should like to thank Anne Hollander for her meticulous care in reading the text. I am grateful to the Courtauld Institute for financial help in connection with the research for this book. At the Institute my thanks are also due to Barbara Thompson in the Witt Library, the Photographic Survey of Private Collections and the Photographic Department.

My greatest debt is to my research assistant Cally Blackman, whose commitment, hard work and sense of humour were a constant source of inspiration. In this context I include Jacky Colliss Harvey and the Publications Department at the National Portrait Gallery, the exemplary editing of Celia Jones and the proofreading of Alison Effeny. It has been a privilege to write this book, which I regard as truly a labour of love.

Aileen Ribeiro

FOREWORD

I came to the study of portraiture through historic costume, and I came to that through a childhood passion for history and the theatre. This progression is not an unusual one; indeed, my earliest contribution to the study of portraiture, *Portraits of Queen Elizabeth I* (1963), was the result of a somewhat eccentric obsession with the Virgin Queen's wardrobe, which set in about the age of fifteen.

It was during that period, the 1950s, that the first stirrings towards the serious study of dress in this country began to get underway. I started in my teens with books by Iris Brooke and then moved on to the tomes of Herbert Norris. I met neither, although decades later Norris's family passed on to me his annotated volume after I did a broadcast tribute to his work. I also voyaged to Eridge Castle to see the display of dress collected by Doris Langley Moore and which now forms the Museum of Costume at Bath. And I loved Langley Moore's books, which featured the likes of Vivien Leigh in evocative photographs by the now forgotten Felix Fonteyn. Added to that were regular visits to the Costume Court of the Victoria and Albert Museum and, of course the National Portrait Gallery.

In the end, nothing conspired to take my researches wholeheartedly in the direction of dress which all this would have indicated, but during my era at the NPG (1959–73) I was able to move the subject on as first Chairman of the Costume Society. Its earliest committee meetings were all held at the NPG, largely because at that time internal tensions and warring factions ruled out the V&A. My role was set from the start – to get on with everyone in a field beset with mighty egos.

To begin with, there were the formidable antiquarian John Nevinson and the *grande dame* Doris Langley Moore herself, who could never agree. Nevinson had little time for any of the 'monstrous regiment of women', which to him included the saintly Anne Buck, Madeleine Ginsburg of the V&A and Janet Arnold. Stella Mary Newton, at the Courtauld, was completely beyond the pale.

This was not an auspicious start for dress studies in this country and yet, three decades on, remarkable strides can be seen to have been taken. The Society has flourished, its journal has achieved academic excellence, dress is taken seriously in exhibition catalogues and, more to the point, we have seen a steady flow of major scholarly work from the likes of Stella Mary Newton, Janet Arnold and the writer of this volume, Aileen Ribeiro.

To be truthful, the NPG should have contributed more to these developments, both in my period and subsequently. In this way the present book begins to make amends. What the portrait at its best encapsulates is not so much costume and fashion as dress and appearance. And, even more importantly, that of a single individual – an area of research still little developed. Dress is a profound expression of human character, even if only in the form of indifference to it. This elegant volume with its enlightening and authoritative text opens a window into that world, asking the reader to look beyond the face to read the clothes, and in doing so share in all the excitement of a new historical discipline.

Roy Strong

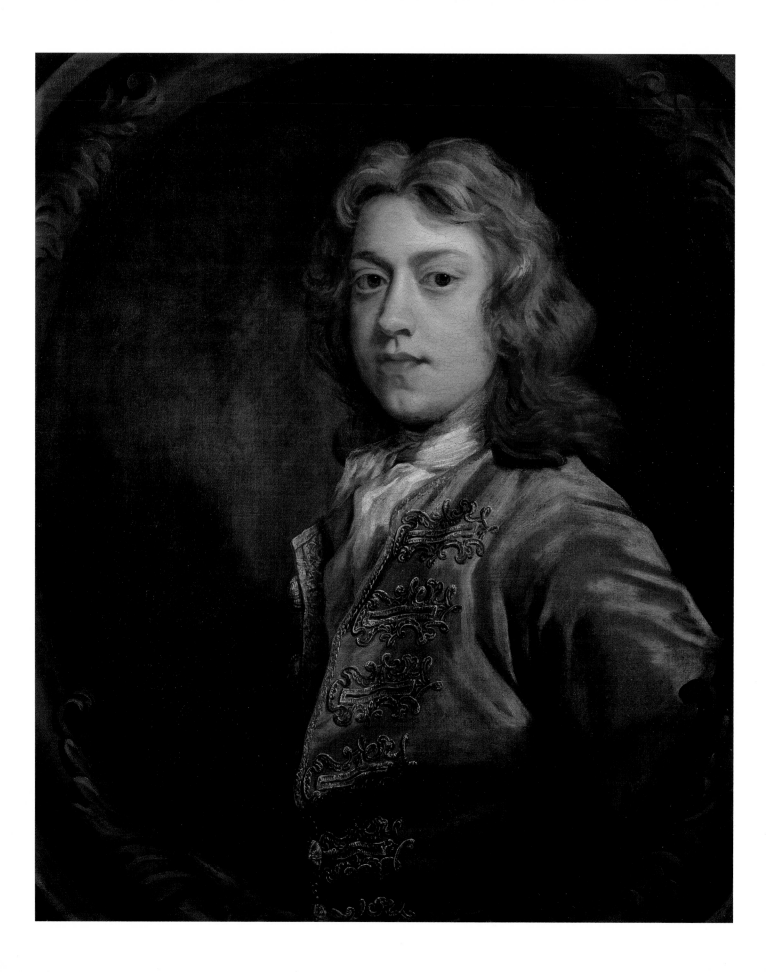

INTRODUCTION

Portraiture is one of the most accessible forms of art and the one perhaps the most widely appreciated by the general public. It appeals both as art and as the representation of people that we know of and know. At its best a good portrait provides a creative tension between the art object (painting, drawing, statue, etc.) and the image that signifies a particular person. Knowing who the portrait represents aids our enjoyment of the image. If, for example, we look at a charming and accomplished portrait by John Closterman (*fig. 1*), of an unknown youth in a blue silk coat decorated with gold braid, a sense of incompletion is part of our response: we want to know who and what the sitter was.

A gallery of portraits evokes a range of responses from the spectator. These may include immediate recognition of famous personalities of past and present, as well as an admiration of colour and form in the construction of the image. Dress and appearance in portraiture work also in these two ways – they signify and underline the identity of the person portrayed, and act as a kind of abstract art form in which style and texture, fashion and fabric, can be appreciated in their own right. The recognition of the part played by appearance and costume in a portrait leads to questions of identity, status and gender. Portraiture is perhaps as close as we can get (along with a piece of clothing or other possession of the sitter portrayed) to the reality of the past, to the living image, which triumphs over the inexorable march of time.

As Richard Brilliant points out in his perceptive study of the genre, portraiture of necessity has to be centred on the self,[i] on the humanity and individuality of each sitter, whatever the circumstances of the commission, by or for the person depicted. When, however, Brilliant argues that portraits must be about people and not things,[ii] he is only half right. An essential element in the presentation of personality must be through such external objects as clothing and accessories, which confirm and delineate identity and character.

Costume in portraiture is usually (there are exceptions) specific to the sitter and is an essential part of his or her identity. Because we too express our individuality through the clothes we wear – although they may be far less grand and expensive than those worn by

1
UNKNOWN
MAN
John Closterman,
c.1702–5.
Oil on canvas,
feigned oval,
748 x 616mm
(29½ x 24¼")
National Portrait
Gallery,
Beningbrough
Hall, Yorkshire
(NPG 1261)

élite sitters in the past – we can understand and appreciate this shared facet of human existence. When we contemplate portraits of famous figures of the past and present, their images are largely constructed – indeed created – by the clothing they wear. Costume is the most tactile of the applied arts; in certain portraits it can be apprehended almost physically, creating the impression that we can enter the frame to touch the fabrics, furs and jewellery as though they were the real thing and not merely a simulacrum. It is for this reason that many of the illustrations in this book are of surviving clothes and accessories very similar to those worn by the sitters in the National Portrait Gallery collections.

Until fairly recently our culture has yearned for physical likeness in a portrait; many people might still assert that this is the principal point of the exercise. In a general sense, issues of reality and truth must lie behind all depictions of the human form, even if such definitions are somewhat variable, for in our own individual ways we create the personality of the sitter in a portrait out of our own experiences as well as from our perception of the person depicted and the meaning of the image. The portrait becomes a kind of palimpsest built up of layers of 'readings' or viewings that our attitudes create. Looking at a portrait leads us to contemplate the idea behind this particular image; does it represent one moment (possibly significant) in the life of the individual, or is it a synthesis of a life's achievement? If the former, then a photograph with its greater sense of immediacy – even spontaneity – might do just as well as a painted portrait. But, it can be argued, we expect more of a good portrait than a mere photographic likeness; the very term 'photographic likeness' has a slight air of disdain about it, implying only a record of surface details, although a great photograph, like the brilliant and well-known image of Brunel (*fig. IX*), has more insight than many a conventional descriptive portrait of a Victorian worthy. A great portrait – whether painting or photograph – acknowledges and salutes the sitter's humanity and achievements, and records the life of the mind as well as the physical appearance. It usually incorporates the general as well as the particular; it has to be timeless as well as being – inevitably – of its own time. In the hands of some artists (I use the word here to refer to all creators of portrait images) this can present problems when a desire to explore identity imaginatively conflicts with the factual record of physical phenomena and sartorial appearance. As Brilliant comments: 'The extraordinary attempts made by portrait artists over the centuries to fix the image of persons by visualising their appearance and/or character, and at the same time to produce an accessible and acceptable object of art reveals the enormity of the task.'[iii]

Clothing in a portrait can be double-edged. The minutiae of fashion detail in some works can overwhelm the image and create an effect little better than a fashion plate. But if clothing is selected and depicted with intelligence and perception, it can reveal psychological insights as well as presenting the obvious in terms of sex, age and status. Examples that come to mind include Lawrence's portrait of Henry Brougham (*fig. 62*), where the bravura painting of the black 'colours' that represent the different fabrics of the fashionable male wardrobe emphasises the mercurial and intelligent character of the sitter. Here the skill lies in the *way* the artist paints the clothing. In Buchel's portrait of Radclyffe Hall (*fig. 82*), on the other hand, we see how the *choice* of costume can indicate personality – in this case how the stylish masculine-influenced ensemble underlines the sitter's firmness of character and steely determination as well as indicating her sexual orientation.

The link between artist and sitter was (and is) often intimate – a bit like the relationship between priest and confessor – and we do not always know what went on in the studio. Who, for example, decided costume and pose? What did the studio contain in the way of props, draperies (perhaps a range of costume), lay figures (mannequins, usually of wood, which could display clothes and accessories and create a pose) and pattern books to inspire artist and sitter? Even our knowledge of the live model in the English studio, especially in the early modern period, is relatively slight. What we can say is that most studios were in

London, the centre of power and fashion, and that the studios of society artists, in particular, were places where the élite gathered and where people wished to look — both in pose and costume — like those depicted in portraits painted by fashionable artists.

To some extent the choice of costume was determined by the nature of the commission, whether public or private. If a public commission, then the clothing might be official — knightly or aristocratic robes, uniform, clerical or academic gowns — and would be the sitter's deliberate decision. If non-occupational clothing was involved, either mainstream fashion or fanciful costume, then it could be chosen either by artist or sitter, possibly in a process of collaboration. If the sitter was very grand — for example monarchs and their consorts — their clothing was usually meticulously depicted in all its splendour, for it reflected the honour and status of the princely house; in this context Tudor kings and queens come to mind. Later, and particularly for non-royal sitters, artists could allow themselves greater licence in the depiction of fashionable dress by perhaps altering the colour and decoration of a garment or even generalising the style of dress so as to create the line rather than the detail. From the mid-seventeenth century onwards, many sitters were portrayed in draperies or fancy dress, and therefore we cannot assume that what we see in a portrait is always the literal truth.

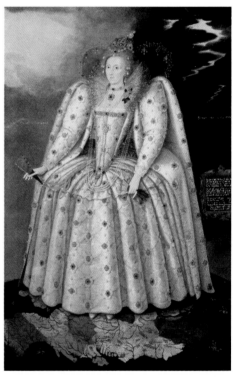

II
ELIZABETH I
(1533–1603)
'The Ditchley
Portrait'
Marcus Gheeraerts
the Younger,
c.1592.
Oil on panel,
2413 x 1524mm
(95 x 60")
National Portrait
Gallery, London
(2561)

In the sixteenth century, which is where the sequence of portraits in the National Portrait Gallery begins, the literal truth in dress is what we do see. Portraits were usually produced for an important event, such as a dynastic marriage, or as visual propaganda. Portraits of princes and potentates, exchanged between European courts, were ever-present reminders of power and prestige and became the person depicted in another sphere. In this context, although a likeness was important, especially when a royal or aristocratic marriage was under consideration, the artist's reputation rested largely on the ability to paint all the details of rich clothing and jewellery, and to convey the dignity and deportment of the sitter, which to a considerable extent was dictated by the lavish clothing and accessories.

This was particularly the case under Henry VIII, the first great Renaissance prince in England. After the relative restraint in costume evidenced by Henry VII (*fig. 1*), his son's reign saw the appearance of an opulent and lavish style of dress, exemplified by the King himself, whose larger-than-life image — padded and slashed doublet and hose and huge fur-trimmed coat — was one of exaggerated masculinity and conspicuous consumption (*fig. 2*). Images of women — even of royalty — pale beside those of Henry VIII; the King's wives are richly jewelled but their clothing is, on the whole, fairly sombre (particularly in the National Portrait Gallery) until we reach the portrait of Catherine Parr (*fig. 5*), the first full-length portrait here. The Queen is superb in her fur-trimmed brocade and velvet costume whose widening, triangular-shaped skirt is created by the new hooped underskirt called the farthingale, which was to be a dominant feature of élite female dress for over fifty years. Triangular shapes were the *leitmotif* of fashionable female dress during the second half of the sixteenth century. Top 'triangles' were created by a tight, stiffened bodice and by wide sleeves tapering to the wrist, and a lower, reversed, 'triangle' was formed by the vast farthingale skirt. In the 1590s this pyramid-shaped skirt was replaced by the square French farthingale of the kind that, for example, Queen Elizabeth wears in the Ditchley portrait (*fig. II*). The male equivalent of this body-distorting clothing was a tight-fitting padded 'peascod' doublet (stuffed to resemble a pea-pod at the front), and round, padded trunkhose (*figs 11* and *13*).

The rich, icon-like splendour of formal costume – huge ruffs and sleeves, stiffened bodices and doublets, spreading skirts and cumbersome hose – restricted movement and limited poses in portraiture; arms rest on the clothing and hands clasp fashionable accessories such as gloves and jewelled chains. The richly complex nature of élite clothing in the Elizabethan and Jacobean period, assemblages of luxury fabrics and accessories, makes it hard at times to recall that the portraits that we see are images of flesh and blood and not mere 'costume-portraits', representations of wealth and status. Only in miniatures (particularly head and shoulders), a genre largely exempt from the duty of recording all the minutiae of fashion, do the sitters literally adopt a more human face.

Less adept artists have always found it easier to depict the physical reality of clothing, with equal emphasis being given to all the constituent parts of the costume, than to select and make value judgements as to what kind of dress emphasises character; in short, to create a *painting* as well as a portrait. By the accession of Charles I (1625) competent journeymen-artists whose stock-in-trade was the meticulous rendition of fashion and fabric were no longer so much in demand. A new mood of simplicity in clothing – under the aegis of a stylish king and a young French queen – came gradually into vogue, aided and abetted in the 1630s by the genius of Anthony van Dyck, whose portraits reflected and popularised this trend. Fabrics became plainer

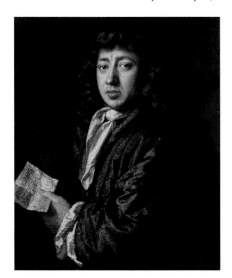

and styles of dress more closely followed the natural shape of the body; restraint and dignity were the hallmarks of Caroline court costume (*figs 22* and *23*). Van Dyck was the first artist working in England since Holbein to use costume as a complement to character, although in a very different way, turning away from the sensitivity of detail that is such a feature of Holbein's work (especially his drawings), towards a simplification of the main lines of clothing – the essence of dress – and even, in his later years, to the fanciful dress of an Arcadian idyll.

No doubt the new ease in clothes (in art and in life) that Van Dyck helped to promote, which was so evident by the middle of the century, helped to create more relaxed postures in portraiture. Increasingly, men and women were happy to be depicted *en déshabillé* (in undress), in loose gowns and draperies. The 'disengaged' style of male clothing of the middle decades of the century – a voluminous shirt barely held together by a short bolero-style doublet and baggy, loose breeches (*fig. 27*) – turned by the end of the 1660s, after various experimental combinations of coat/tunic, vest (waistcoat) and knee-breeches, into the three-piece suit. This staple of the masculine wardrobe – coat, waistcoat and breeches – remained relatively unchanged until, at the end of the eighteenth century, knee-breeches were replaced by trousers. During the second half of the seventeenth century there was a growing rivalry in fashion between the courts of France and England, led by Louis XIV and Charles II respectively. It is particularly irritating that Charles, a man of fashion as his accounts testify, should hardly ever be portrayed *à la mode*, but in official costume and even classical Roman attire.

In terms of classical dress Charles II followed the dictates of those artists who decreed that Roman costume gave dignity and decorum to the sitter thus habited, as well as an air of timelessness; many of his subjects were also painted in this way. Other Restoration portraits show men wearing loose gowns, which also evoked the notion of timelessness, and reflected the relaxed informality of the court of Charles II. Such a costume was also a comfortable alternative to the formal structured suit made of heavy fabrics elaborately trimmed, and the large full-bottomed wig of the period. Samuel Pepys tells us that for his portrait by John Hayls of 1666 (*fig. III*) he hired a brown silk 'Indian gowne', and although he found the pose uncomfortable – he had to look 'over my shoulders to make the posture for him to work by' – he declared himself 'very well satisfied' with the result.

III
SAMUEL PEPYS
(1633–1703)
John Hayls, 1666.
Oil on canvas,
766 x 629mm
(29¾ x 24¾")
National Portrait
Gallery, London
(NPG 211)

Pepys could not afford Peter Lely, who was the most fashionable artist of the period, particularly in his painting of fanciful costume and draperies. Lely established a new aesthetic in his portraits, especially those of women, where a delight in nacreous flesh and the gleam of satin and taffeta prevailed over likeness – Pepys claimed that Lely's portraits were 'good but not like'. As Andrew Wilton aptly noted, 'Lely was highly gifted at expressing glamour',[iv] a word, with its modern connotation of film-star glossiness, that is especially appropriate in this context. Lely's female sitters are often barely clothed – their draperies slide off their polished shoulders giving them an air of sexual availability (*figs 31 and 31.1*), a visual evocation of the poet Herrick's famous comment:

> A sweet disorder in the dress
> Kindles in clothes a wantonnesse.

It was Van Dyck who began the vogue for painting his sitters (usually women) in generalised romantic versions of fashionable costume, and who was also the first major and successful artist to adopt the workshop system in England, whereby studio assistants were used to paint clothing and accessories so that more than one hand worked on a portrait. This way of working became *de rigueur* for most portrait artists from the mid-seventeenth century and lasted until well into the eighteenth century. It was a system calculated to promote the simplified costume and draperies approved of by theorists, but produced portraits of little specificity in terms of dress. The *Spectator* for 1712 noted how 'Great Masters in Painting never care for drawing People in the Fashion', in the belief that contemporary clothes 'will make a very odd Figure and perhaps look monstrous in the Eyes of Posterity'. So artists such as Godfrey Kneller often depicted sitters in vague and ill-defined draperies, no longer with the sexual appeal so evident in the work of Lely. This was not for lack of skill, for when Kneller does paint high fashion, he can put on a bravura display, as with his portrait of the Countess of Mar of about 1715 (*fig. IV*) in her sumptuous silver-trimmed riding habit. Kneller's preference, and that of many of his contemporaries, was for 'timeless' simplicity in a portrait, and many of his male sitters are painted in loose gowns or classical Roman 'vests' (tighter-fitting knee-length gowns). These garments often sit oddly with the large wigs dictated by fashion, but which invalidate a sense of timelessness (*figs 34* and *34.2*). An alternative was to paint informal costume, such as the open-necked shirt and simple velvet coat that Congreve (*fig. 36*) wears in his portrait.

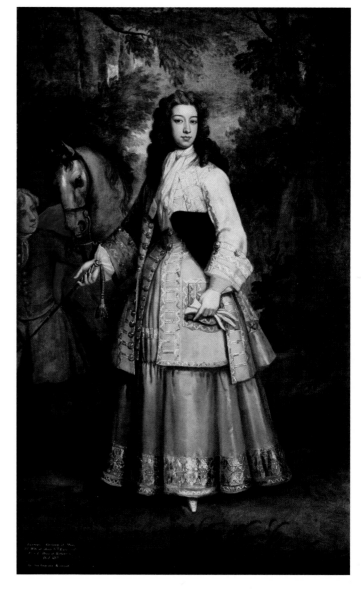

IV
FRANCES PIERREPOINT, Countess of Mar and Page (1690–1761) Sir Godfrey Kneller, *c*.1715. Oil on canvas, 2400 x 1466mm (93 x 57¾") In the collection of the Earl of Mar and Kellie

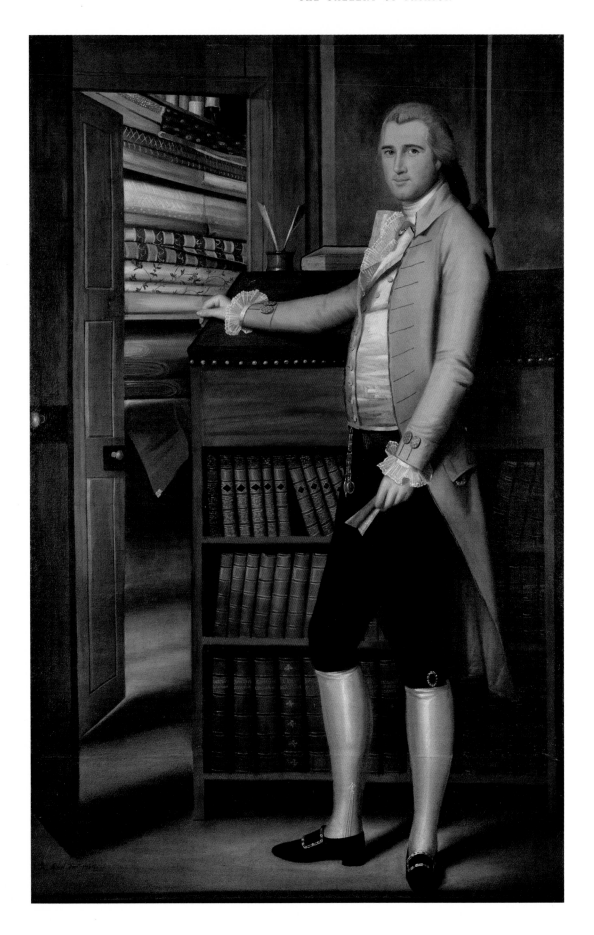

V
ELIJAH
BOARDMAN
(1760–1823)
Ralph Earl, 1789.
Oil on canvas,
2108 x 1295mm
(83 x 51")
The Metropolitan
Museum of Art,
New York,
bequest of Susan
W. Tyler, 1979

An air of grandeur and solidity imbues clothing of the early eighteenth century. The fashionable male silhouette was dictated by the towering periwig, the stiffened coat with flaring side skirts, a waistcoat almost as long as the coat and heavy square-toed shoes (*fig. 38*). Gradually masculine clothing lost its 'Baroque' heaviness, and by the middle of the century it had become more streamlined, with a less bulky coat and a shorter waistcoat; smaller, neater wigs were in vogue. Foreign travel, especially the Grand Tour, enabled men with a taste for finery to indulge it, for Italian costume was brighter in colour and more decorated (with lace and gold and silver braid) than the styles worn in England. Artists such as Allan Ramsay and Pompeo Batoni (*figs 46* and *46.2*) delighted in the details of clothing for its own sake, Batoni because he saw that this was what his patrons (English *milordi* in Rome on the Grand Tour) wished for, and Ramsay because of his empathy with the luxurious details of French costume, acquired while studying in France. English taste tended increasingly towards less formal clothing, reflected also in portraiture, for it was thought that a relative simplicity in dress could better reveal character in portraiture. Perhaps this is why we can relate better to Joshua Reynolds's fine portrait of a rather *distrait* Warren Hastings (*fig. 47*), with his lightly disordered hair and simple dark frock coat, than we can to the aloof formality of Ramsay's elegant portrait of Robert Wood (*fig. 46*) in his gold-braided coat and powdered wig.

By the late eighteenth century Englishmen were noted for modest simplicity in their everyday clothing, with a preference for woollen cloth (silk being reserved for more formal occasions) with minimal trimming and decoration. This kind of costume – widely worn by an aristocratic élite as well as the middle class – reflected an increasingly commercial society and a new emphasis placed on talent, whether cultural, scientific or mercantile; writers, inventors and bankers, for example, were increasingly portrayed in art. Trade, however, was outside the pale, and there is no English equivalent of the American artist Ralph Earl's informative portrait of Elijah Boardman (*fig. V*) in his beige frock coat, white silk waistcoat and black knee-breeches, standing in front of his counting desk at his shop in New Milford, Connecticut, in 1789; his wares (fabrics of various kinds) are clearly seen in the background, one bale unrolled to reveal a British tax stamp.

The story of women's clothing could all too easily become a litany of constantly changing styles, a naming of names encouraged by the appearance of the first regularly published fashion plates towards the end of the eighteenth century. Female costume is more complex and difficult to pin down than menswear of the period. At the beginning of the century formal costume was dominated by the mantua, an open gown with stylised back drapery revealing an elaborately trimmed underskirt ('petticoat' was the contemporary name; *figs 35, 35.1* and *39*). By the end of the first decade of the century hoops had re-appeared; initially they were a relatively modest pyramid shape, but they gradually became larger, first rounded, and then, by the 1740s, square. Extreme versions of the hoop petticoat appear only occasionally in portraiture (on the other hand they were a gift to the caricaturist) for neither artist nor sitter wished to be in thrall to fashionable excess. By the middle of the century the elegant lines of French fashion made an impact on English dress, many women adopting the *sacque* dress or *robe à la française* characterised by flowing back drapery from neck to hem. Later in the century Englishwomen returned to closer-fitting gowns in plainer fabrics, less adorned with trimming, and the *robe à l'anglaise* became one of the mainstays of the feminine wardrobe (*fig. 52*).

Although this book deals with fashion rather than fancy dress, some examples of fanciful costume have been included, as role-playing and fantasy assume great importance from the mid-seventeenth century right through the eighteenth century. Both men and women appear dressed in a variety of 'historic' and exotic costume, which often reflects their experiences and interests. In Highmore's portrait of John Montagu, 4th Earl of Sandwich (*fig. VI*), for

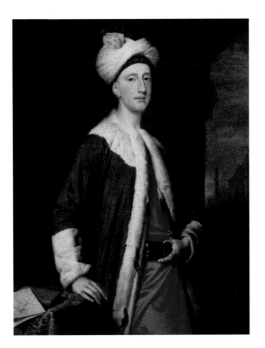

VI
JOHN
MONTAGU,
4th Earl of
Sandwich
(1718–92)
Joseph Highmore,
1740.
Oil on canvas
1219 x 914mm
(46 x 36")
National Portrait
Gallery,
Beningbrough
Hall, Yorkshire
(NPG 1977)

example, we see the sitter in the kind of Turkish costume that westerners adopted on their travels in the Levant. This is real costume, as distinct from the fanciful dress invented by the artist Angelica Kauffmann for her self-portrait (*fig. VII*), which is vaguely 'classical' with touches of the Renaissance. It is a self-conscious reference to her status as an artist and to the great art of the past. It also, perhaps, signifies her disdain for high fashion in portraiture – even her hair is 'artistically' arranged in a style more natural than the elaborate high powdered coiffure in vogue in the 1770s. It was partly because of their dislike of the excesses of fashion that many artists (most famously Reynolds) chose to depict some of their female subjects in similar loosely draped gowns, vaguely 'classical' in style and usually pertaining to notions of feminine virtue, marriage and motherhood. This sartorial vocabulary of classical allegory was intended to broaden the artistic scope of such portraits by reference to the status of the sitters, although today such images might be interpreted as a denial of individuality. The vogue for fanciful dress in portraiture as an artistic convention had largely died out by the nineteenth century, although historical costume (from classical antiquity to more modern times) remained popular for fancy-dress balls, and as subject matter for artists specialising in historical genre scenes. Such artists would often have actual costume in their studios. Frith's self-portrait of 1867 (*fig. VIII*), in which he is dressed in a lightweight beige painting jacket, shows the interior of his studio (with a bonneted and veiled model dressed in mourning black) and in the background, on a chair, an eighteenth-century-style coat trimmed with silver braid.

By the nineteenth century clothing was increasingly divided along gender lines: men's clothes assumed a sobriety of colour and plainness of fabric, while female fashions became increasingly colourful and complex. Admittedly, women's dress of the early nineteenth century was dominated by a kind of classical simplicity that found much favour with artists (*figs 56 and 58*), but at the same time as white muslins were all the rage, a romantic historicising impulse (always close to the English heart) also manifested itself, taking the form of velvet dresses *à la Renaissance* with high collars or ruffs, the type of costume we see in Lawrence's portrait of Caroline of Brunswick of 1804 (*fig. 59*).

What was perceived by many moralists as a restless desire for novelty in the progress of female dress was unfavourably compared with the relative uniformity and slower pace of change seen in men's clothes. Revolutions, both industrial and political, encouraged a

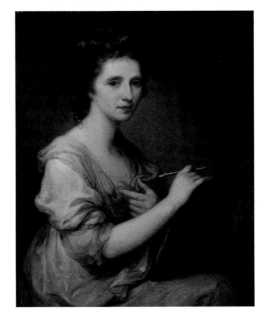

VII
ANGELICA
KAUFFMANN
(1741–1807)
Self-portrait,
*c.*1770–75.
Oil on canvas,
737 x 610mm
(29 x 24")
National Portrait
Gallery,
Beningbrough
Hall, Yorkshire
(NPG 430)

new masculine ideal in clothing – simple utilitarian suits and coats of woollen cloth – a style founded on the concept of work, self-discipline and economic reliability.

Within the limited palette of masculine costume, however, a great artist such as Lawrence could still work wonders. Lawrence was the only early nineteenth-century British artist with a genuine feel for costume and an ability to render fabrics to perfection; a far lesser artist, James Northcote, attempted to disparage him by his reference to 'a sort of man-milliner painter – a meteor of fashion'.[v] Occasionally, it is true, Lawrence invested his sitters with more glamour than they possessed; his portraits of the Prince of Wales, for example, were more flattering than the reality suggested by Gillray's caricatures (*fig. 55*), but on the whole he succeeded brilliantly in conveying the subtle sophistication of the male dress of his time: 'He revelled in the deep unmodulated blacks and the sharp white or cream of well-laundered collars and cravats. The sartorial austerities of dandyism were a source of inspiration.'[vi]

Black and white came increasingly to be thought of as the colours of modernity and feature prominently in portraiture. Joanna Woodall rightly points out that the 'authoritative palette of black, white and neutral shades [which] dominated masculine imagery … seems somewhat more exaggerated in portraiture than in surviving dress, or in genre, or contemporary history painting'.[vii] One has to observe here that men having their portrait painted would deliberately choose the almost 'timeless' quality of black-and-white formal wear over more casual attire, such as the working clothing in which Frith depicts himself and in which he was also photographed. On the whole, portraits of this period show men of the upper and middle classes, whose lives involved the wearing of formal clothes; it is rare to come across a portrait of a working-class man such as that of the poet John Clare in 1820 (*fig. 61*) in his brown coat, buff-coloured waistcoat and the printed silk neckerchief that was a cherished mark of individual finery for the working man. It is fairly unusual also in a painted portrait to see casual cloth-

VIII
WILLIAM POWELL FRITH
(1819–1909)
Self-portrait, 1867.
Oil on canvas,
610 x 464mm
(24 x 18¼")
National Portrait Gallery,
Bodelwyddan Castle,
Denbighshire
(NPG 1738)

ing worn for leisure pursuits and informal occasions; lighter outfits (both in terms of weight and colour) were permissible, but even so the colour palette was usually limited to shades of grey, blue, buff, muted checks or tweeds. Informal clothing of this kind is more likely to be recorded in the portrait photograph or in caricatures (*fig. 66*).

Masculine clothing in general was suitable to underscore character in a painted portrait, but was especially apt for photography, which from the middle of the nineteenth century provided images of a far wider range of people and variety of costume than formal portraiture could encompass. The direct predecessor of the photograph was the silhouette, a likeness cut in black paper and stuck on to card, which was popular from the last quarter of the eighteenth century. Quite sophisticated images could be created, even down to the details of dress and accessories as well as physical features (*fig. 63.1*). The fashion for silhouettes lasted until the middle of the nineteenth century, extending the franchise of

image-making and creating a link between the portrait and the photograph; when photography became established (the first photographic studio in England opened in Regent Street, London, in 1841), portraits proved to be most popular.[viii] Inevitably, painting provided models and inspiration for the portrait photographer (in its turn photography was an invaluable aid to the Victorian artist). Photography had its limitations; in one 'sitting' there was only one chance to assess the character of the person, and no time to discuss, for example, what clothes were to be worn; women, in particular, constrained by their fashionable costume and conventional poses, often look passive and lacking in personality. On the other hand, the speed of the photographic process and the modernity of the image it created could catch character and result in penetrating portraits such as that by Robert Howlett of the famous engineer Isambard Kingdom Brunel in 1857 (*fig. IX*), standing in his heavy, rumpled woollen suit – his working clothes – before the iron launching chains of the *Great Eastern*, the

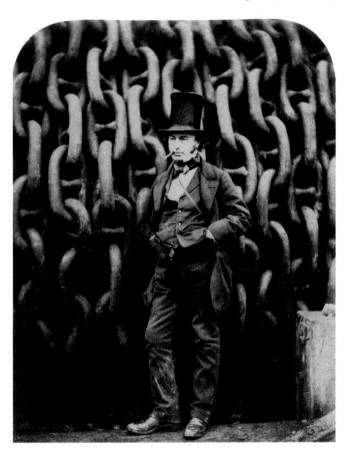

largest ship in the world at that time.[ix] The plain three-piece suit, which Brunel wears, was the mainstay of everyday masculine wear until well into the twentieth century (and still exists today, usually in the reduced form of a matching jacket and trousers); it could be made of tweed for the country, lighter wools for town.

Mostly, however, portraiture demanded more formal clothes, which for men in the second half of the nineteenth century meant a dark (usually black) suit and a frock coat with straight-edged skirts to the knee or just below. Hardly changing in style, the frock coat appears in portraits of members of the Establishment, such as politicians (*fig. 75*) and even artists (*fig. 68*) and composers (*fig. 74*). Some critics found male formal attire too funereal and uniform; Lady Colin Campbell declared that men presented 'a sombre, not to say a gloomy appearance … [with] no scope for variety from year to year, except in the shape and cut'.[x] Other commentators, such as the writer Max Beerbohm, claimed that male dress was a celebration of pared-down and austere elegance: 'Is not the costume of today,

IX
ISAMBARD
KINGDOM
BRUNEL
(1805–59)
Robert Howlett,
1857.
Albumen print,
286 x 225mm
(11¼ x 8⅞")
National Portrait
Gallery, London
(NPG P112)

with its subtlety and sombre restraint, its quiet congruities of black and white and grey, supremely apt a medium for the expression of modern emotion and modern thought?'[xi] In the portrait of Beerbohm himself (*fig. 79*) we can see something of the decorative and formalist elements of male costume so celebrated by aesthetic writers, and artists such as James McNeill Whistler.[xii]

No such elegant sobriety can be witnessed in the complex layers of women's clothing in the Victorian period. By the 1830s fashion had thrown off any lingering vestiges of simplicity to assume forms that stressed individual areas of the body rather than the harmony of the whole. We see, for example, curious segmented hairstyles, inflated sleeves (*figs 63* and *63.1*), and skirts that gradually widened – first through layers of petticoats and then with the cage crinoline of the mid-1850s. Not until the late 1860s did the crinoline, which some might think gave women the appearance of highly decorated lampshades (*fig. 69*), disappear, giving

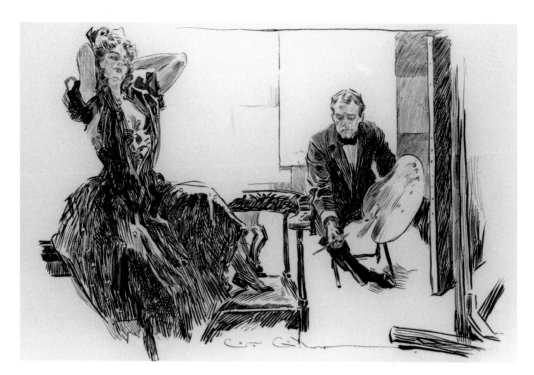

X
A Necessary
Ingredient, from
Drawings by
Charles Dana
Gibson (1898).

'He: I wonder why I can never obtain the same color effects as Reynolds and Rembrandt.
She: Perhaps it's in preparing the colors. I've heard they used to mix them with brains.'

way to a flatter-fronted dress with complex back drapery often arranged over a bustle (*figs 71* and *73*). This was a period of highly skilled dressmaking (aided by the invention of the sewing machine in the mid-nineteenth century), and when one looks at the elaborate toilettes of the 1870s and 1880s (*fig. 72*), it is not altogether surprising that many artists found it difficult to rise above the myriad details of fashionable ensembles, and ended up producing what the artist and art critic John Ruskin called 'mere coloured photographs of vulgar society'.[xiii] It was important, as the artist Francis Grant opined in 1873, that in portraiture 'truth to nature should be combined with taste and refinement',[xiv] but how could this best be achieved? Artists were told to build on the achievements of the past, the work of the Old Masters but, as the cartoon by Charles Dana Gibson, *A Necessary Ingredient* (*fig. X*), implies – the young woman sitting for her portrait acidly comments that intelligence in painting was as important as technical ability – it was not always easy to get beyond the psychological barriers created by too literal a rendition of fashionable dress, which prevented a discriminating analysis of personality. The majority of Victorian artists were obsessed by the factual in women's clothing, no doubt encouraged by the majority of their fashionable sitters. As a reaction to the prevailing materialism in society as evidenced by the conspicuous consumption of fashion, many artists and 'artistically' inclined women from the middle of the nineteenth century encouraged the wearing of simpler styles of dress, sometimes with 'historical' overtones (*figs 70* and *70.1*). In the late Victorian period such groups as the 'Souls' (mainly aristocratic patrons of the relatively *avant-garde* in English literature, art and music) wanted portraits of women to reflect more spirituality than the 'white satin duchesses' painted by such artists as John Singer Sargent. As Walter Sickert suggested in an article in *The New Age* (1910), the 'Souls' tended to patronise artists who paid less attention to the physical body and produced portraits of sitters whose 'well-bred contortions suggest a soul slightly misunderstood, dressed in cascades of chiffon on which gleams the occasional gem' (*fig. 77*).[xv]

Although it is often stated that modern dress for women appeared only at the end of the 'long' nineteenth century, in other words with the First World War, it is equally plausible to

see earlier signs of sartorial emancipation. The first serious experimentations with practical clothing came with the tailor-made suit, the blouse and skirt (*figs 78* and *78.1*) and even – in the 1890s – the first tentative steps towards the wearing of trousers, after Amelia Bloomer's premature attempt in 1851 to popularise bifurcated garments in England. It is in this light, then, that the Edwardian period appears – like the later New Look – to be the last gasp of an outmoded order, using clothing to emphasise breast and buttocks in what appears at times to be almost a parody of the female body (*fig. 80*). Images of fashionable women at the turn of the twentieth century show a silhouette where the full bosom (aided by corsetry) is pushed forward and the dress clings to the hips, flaring out in a trumpet shape at the hem.

By the end of the first decade of the twentieth century more natural and practical styles of dress, with shorter skirts, had appeared; some women even had their hair cut short, a hitherto unheard-of feature of feminine appearance. In the 1914–18 war women took over many traditional masculine jobs (public transport, agricultural employment, munitions work) and some even joined the armed forces. Whole new worlds of opportunity and previously unknown freedoms – political, social, cultural, sartorial – were opened up, and the heavy mortality rate among fighting men meant that many women found themselves the family bread-winner. New freedoms in dress in the post-war period also resulted from the emancipation of female talents, especially in the arts and in education. Women signalled this emancipation by wearing short, simple, tubular dresses, by adopting the masculine suit and tie (and trousers), and expressed their femininity by the wearing of cosmetics – hitherto make-up had been worn only very discreetly, as it had overtones of impropriety. Many society artists, in particular, found it difficult to come to terms with such revolutionary images of women, preferring to hark back to the safety of the past. Philip de László (a prolific and elegant society artist from Hungary, who had settled in London before the First World War), was quoted in the London *Evening Standard* (7 January 1927) defending his choice to paint a portrait of a woman in period costume; with modern dress, he stated: 'there is nothing to paint. When she sits down there is nothing but bare legs and bare arms. Her head is all face, with no frame of hair' (*figs 84* and *84.1*).

While many men were challenged (and often daunted) by the modern young woman, the new practicalities of feminine dress had an impact on menswear. True, men retained the suit (although summer jackets were of lighter, washable fabrics), but they incorporated more colour in their clothing; from sporting costume and working-class clothing came the knitted sweater, corduroy trousers and the coloured shirt. After the Second World War further items of casual clothing, such as denim jeans and T-shirts (derived also from working-class dress), entered the male wardrobe and this move towards the demotic is one of the main themes of contemporary menswear, allied to the ease and comfort of such sports-influenced garments as trainers and sweat-suits.

In a century when women's lives changed out of all recognition, the same desire for change was reflected in the clothes they wore. 'Plus ça change, plus c'est la même chose', the cynical critic might say, pondering the notion that there might be in the feminine soul an innate sense of delight in novelty, a feeling exploited by today's vast fashion industry, which itself is promoted by an explosion of visual media. In the first half of the twentieth century we can, through portraiture, see the main changes in fashion after the opulence of Edwardian dress: the geometric lines of the 1920s, the fluid ultra-feminine styles of the 1930s, the sharp, boxy, functional clothing dictated by the exigencies of war and the crypto-Victorian revival, the New Look of 1947 which led into the groomed gentility of the 1950s.

Within the framework of what must be grossly over-simplified summaries of decades, there were many interpretations of (and deviations from) mainstream fashion, according to age, class, economic considerations and personal inclination. It is even more difficult to assess the clothing of our own time and to make judgements as to what in future will be

XI
DAME JANET
VAUGHAN
(1899–1993)
Victoria Crowe,
1986–7.
Oil on board,
813 x 660mm
(32 x 26")
National Portrait
Gallery, London
(NPG 5928)

seen as crucial shifts of emphasis and defining moments in the story of fashion. During the second half of the twentieth century there was a bewildering variety of styles and trends – sporting and leisure clothes, new synthetic fabrics, the acceptance of the sexually provocative in dress, the input of subcultures, ethnic dress and a variety of alternative fashions. At the same time there continues to be a fascination with historic costume, a particular inspiration to contemporary designers in England. Fashion can all too easily appear like a kaleidoscope, constantly fragmenting and changing, and even a definition of what constitutes fashion itself has now become debatable; there is far less homogeneity now than in the past.

Post-war trends in society – changing definitions of identity and our place in the world, fluid and shifting personal relationships and employment, a far less formal and structured existence – are reflected both in how we dress and how we appear in portraiture. No longer does the painted portrait, perhaps, have primacy (it must be confessed that too much timid and stereotyped establishment portraiture is still produced), and painting now has to contend with such other media as photo-montage and video. This makes walking round the later twentieth-century galleries of the National Portrait Gallery an exhilarating but sometimes unnerving experience. No longer do we see the élite portrayed in all their finery, but a series of informal 'snapshots' of a much wider range of people, men and women who no longer dress up for the artist or for the camera. As Robin Gibson points out (*The Portrait Now*, 1993), the painted portrait today is often marginalised, lacking the 'mystery and power' of earlier periods, and achieving its 'traditional magic' only in 'the hands of very considerable artists'.[xvi] Even in royal portraiture, 'it is fairly usual for the artist to supply a sense of immediate access to the sitter through casual presentation'.[xvii] This we can easily see, for example, in Bryan Organ's portrait of Diana, Princess of Wales (*fig. 97*).

During the twentieth century notions of identity and likeness underwent a number of revisions[xviii] and our concerns now are just as much with psychological perception and the changing nature of truth as with the factual analysis of a person's appearance, whether in life or in art. We no longer want art to be on its best behaviour in the stillness of a painted portrait; rightly or wrongly some people think they can discern inner truth in a less formal work of art, with the sitter depicted in casual and comfortable clothing. Portraits, so the argument goes, should be images of intimacy and explorations of character, not signifiers of status, wealth and authority.

At its best, however, a contemporary painted portrait can produce both a selective biography of the sitter and a specific moment in time. One example might be Victoria Crowe's fine portrait of the distinguished doctor and scientist, later principal of Somerville College, Oxford, Dame Janet Vaughan (*fig. XI*), in which we see an image of a sitter with the touching frailty of extreme old age, but still elegantly dressed, and with facets of her life – her interests and achievements – alluded to in the painting. She wears a 'much loved' tweed jacket, thread-

XII
WALTER
RICHARD
SICKERT
(1860–1942)
Philip Wilson
Steer, before
1894.
Oil on canvas,
397 x 298mm
(23½ x 11¾")
National Portrait
Gallery, London
(NPG 3142)

bare in places,[xix] a silk scarf tucked into the neck of a sweater; round her neck on a chain is a polished pebble from a Spanish beach presented to her to mark the fiftieth anniversary of the start of the Spanish Civil War (she sent medical supplies to the Republicans). The portrait refers to Dame Janet's artistic tastes (her collection of lustre-ware china) and her family background linked to the Bloomsbury group – her mother, a great friend of Virginia Woolf, is represented by a small oval portrait behind the sitter. The painting records the wisdom and experience of a complete life, a woman of style, a more enduring quality than fashion alone.

Dame Janet was clearly not indifferent to her portrayal on the canvas, but on the whole there appears to be little debate either by artist or sitter as to the costume worn in contemporary portraits. For Paula Rego's portrait of the writer Germaine Greer (*fig. 96.2*) the sitter noted that the artist 'did not make suggestions about my clothing'[xx] and in the case of Humphrey Ocean's portrait of Tony Benn (*fig. 100*), the sitter seemed genuinely surprised to be asked about the clothes he is shown in, saying, 'I don't think we even discussed what I should wear for the portrait'.[xxi]

Portraiture is unique in its commitment to character; 'as long as there is humanity, portraiture in one form or another will continue to be a primary force in the visual arts.'[xxii] Through a gallery of portraits we can see the progress of time reflected in images of the famous and the not so famous. We can also see within different images of the same person, how their appearance, deportment, character (and clothing) change and develop as time passes. For example, Philip Wilson Steer's oil sketch of the artist Walter Sickert (*fig. XII*) of before 1894 shows a smartly dressed man of fashion in a double-breasted lounge suit, reminding us of the comment made by his fellow-artist William Rothenstein at the time that he was fastidious 'in his person, in his manners, in the choice of his clothes'. Some forty years later, in a self-portrait of the mid-1930s (*fig. XII*), we see a shambling old man whose bowed posture is emphasised by his white bowler hat and almost clown-like baggy check suit.

* * *

This book cannot claim to be a history of dress in portraiture; it is instead a discussion of dress in a selection of portraits in the National Portrait Gallery, set within a chronological narrative. The National Portrait Gallery collections, like those of many other public institutions, do not always provide a complete and comprehensive survey of art; the portraits were (and are) collected for a variety of reasons, and these do not include the provision of subject matter for the historian of dress. Furthermore, it is as well to remember that artists are not

XIII
WALTER
RICHARD
SICKERT
(1860–1942)
Self-portrait,
1930s.
Oil on canvas,
686 x 234mm
(27 x 10")
National Portrait
Gallery, London
(NPG 3134)

dressmakers or tailors, and it is not always appropriate to expect an informed knowledge of the properties of textiles and how clothes 'work' on the body. In earlier periods, inevitably, images of royalty and the élite dominate the genre, and even as the centuries progress it is not always easy to provide an equal balance between all sections of society. I have tried to strike a balance between portraits of famous people who wear clothing typical of their status, and images of less well-known men and women whose costume is of particular interest in furthering the story of how fashion has developed. It is, perhaps, tempting providence to give this book the title of *The Gallery of Fashion* (the name, incidentally, of a famous fashion magazine of the late eighteenth and early nineteenth centuries),[xxiii] for the National Portrait Gallery collections do not always incorporate the major themes in the history of dress. It is for this reason that complementary images have been included, including photographs of surviving examples of contemporary costume, as relevant both to the main NPG portraits and to the chronology of costume. The narrative of fashion has been interpreted in a fairly liberal way, and includes men and women who have not necessarily affixed this label to their appearance. Limitations of space and the fact that this book covers a period of almost five hundred years, have precluded reference to specialist clothing, such as uniform or occupational dress, which could easily form the basis for another book, as the Gallery is rich in such images.

In spite of all the *caveats* listed above, the National Portrait Gallery provides an unequalled sequence of portrait images for the study of British costume. Fashion, like portraiture itself, is particularly close to the national character, an obsession, perhaps, with self; as a Venetian visitor to England remarked in about 1500: 'The English are great lovers of themselves and of everything belonging to them; they think that ... [there is] no other world but England'.[xxiv] A more generous interpretation might be that the English love of portraiture reflects a general interest in humanity. For anyone interested in social and cultural history, in the human condition in the widest sense, and in the character of individuals in particular, images of people and their clothing demand a detailed study. The portraits selected here help to tell us who we were and are, and how we wished to look; fashion fixes a portrait in time and anchors us to a living past in a continuum with the present day.

NOTES

i Brilliant, 1991, p.14.

ii Brilliant, 1991, p.7.

iii Brilliant, 1991, p.30.

iv Wilton, 1992, p.30.

v Piper, 1992, p.179.

vi Wilton, 1992, p.52.

vii Woodall, 1997, p.5.

viii Linkman, 1993, p.20.

ix Howlett's photograph is a much more direct and impressive image than the painted portrait by John Callcott Horsley, also of 1857 (NPG 979), which shows Brunel sitting at his desk with plans in front of him.

x Lady Colin Campbell, *The Etiquette of Good Society* (London, 1893), p.87.

xi M. Beerbohm, *Dandies and Dandies* (London, 1896), p.19.

xii The historian and philosopher Thomas Carlyle, apropos his celebrated portrait by Whistler (1872: Glasgow Art Gallery), famously complained that the artist's main aim was to perfect the painting of the costume, especially the coat, rather than concentrate on the face.

xiii Piper, 1992, p.234; Ruskin was referring in particular to the glossy 'costume artist' Tissot.

xiv C, Newall, 'The Victorians, 1830–1880', in Strong, 1991, p.351.

xv K. McConkey '"Well-bred Contortions", 1880–1918', in Strong, 1991, p.369.

xvi Gibson, 1993, p.10.

xvii F. Spalding, 'The Modern Face, 1918–1960', in Strong, 1991, p.419.

xviii A number of causes for this state of affairs have been proposed: 'psychology's dissolution of the concept of the rational human being. Marxist notions of a non-distinctive social existence, sociologists' and social historians' insistence on the social rather than the personal nature of identity, philosophers' doubts about the nature or reality of the self, and the anxious decentring and fragmentation of human experience in the modern age, characterised by the disruptive force of world wars, atom bombs, mass culture and the broken hegemony of the West over world politics, and so forth', Brilliant, 1991, p.171.

xix NPG archive, information from the artist.

xx Letter from the sitter.

xxi Letter from the sitter.

xxii Gibson, 1993, p.8.

xxiii Niklaus Wilhelm von Heideloff's *Gallery of Fashion*, 1794–1803.

xxiv C. A. Sneyd (trans.), *A Relation or Rather a True Account of the Island of England* (London, 1847), p.20.

THE
SIXTEENTH
CENTURY

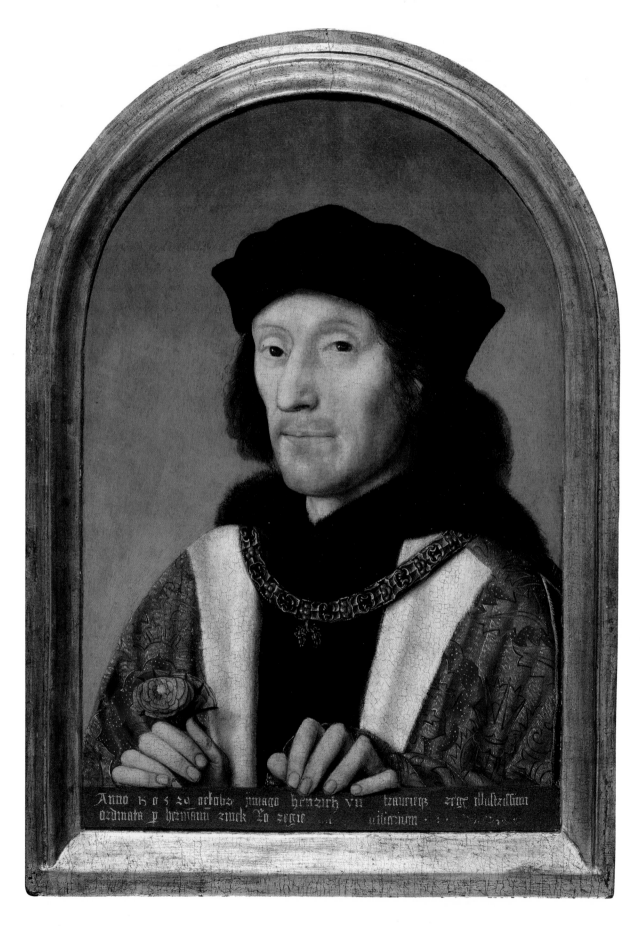

1 HENRY VII (1457–1509)

This portrait of the shrewd and calculating founder of the Tudor dynasty, which was established after the defeat of Richard III at the Battle of Bosworth in 1485, is a nicely judged image of substance and symbol. It was painted when Henry VII came on the marriage market for the second time, seeking the hand of Margaret of Savoy, daughter of the Holy Roman Emperor Maximilian I (the marriage never took place). This is possibly why the King wears round his neck the collar and badge of the Golden Fleece (premier order of chivalry of the Holy Roman Empire), to which he was elected in 1491. The rose in Henry's hand is a symbol of love, but it also refers to the unity of the previously warring houses of York and Lancaster, which was cemented by the King's first marriage, to Elizabeth of York (1465–1503).

Henry's clothes indicate modest luxury allied to comfort. Over a black doublet he wears a coat of brocaded red velvet lined with white squirrel fur. The sleeves of this coat reach almost to his knuckles; an alternative way of wearing this garment was to push the hand through the slits on the upper arm, thus forming hanging sleeves. Such a slit, hinted at in this portrait, can be seen more clearly in the fur-lined coat worn by Henry in Torrigiano's painted and gilded terracotta bust (*fig. 1.1*).

Commissioned in 1512, the face was taken from the King's death-mask, but with the signs of death smoothed out. Both these images of the King show him wearing a biretta-type hat of blocked (or moulded) felt; such hats later became part of academic and clerical dress. Torrigiano's bust shows the King with a flattering and youthful hairstyle, falling in soft waves to his shoulders, whereas the painted portrait indicates – more realistically – that he had thinner and more grizzled hair. Either to hide a wrinkled neck or to keep out the cold, the elderly King (fairly aged by the standard of his time) wears a collar or tippet of sable, then, as now, the richest and most sumptuous of furs.

1.1
HENRY VII
Pietro Torrigiano, 1512.
Painted and gilded terracotta,
915 x 690 x 360mm
(36 x 27³/₁₆ x 14³/₁₆")
Victoria and Albert Museum, London

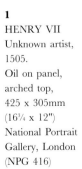

1
HENRY VII
Unknown artist, 1505.
Oil on panel, arched top,
425 x 305mm
(16¼ x 12")
National Portrait Gallery, London
(NPG 416)

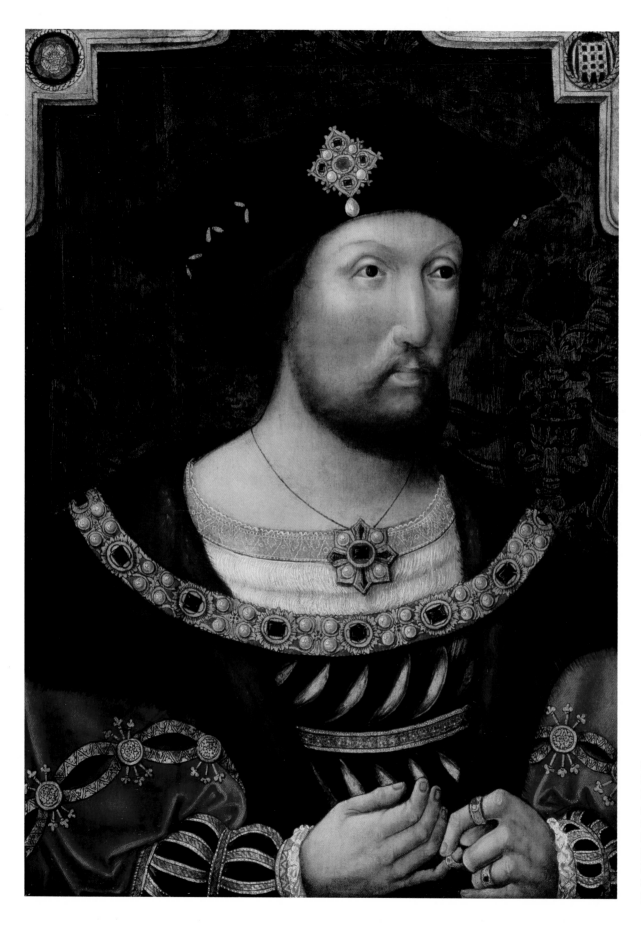

2
HENRY VIII
Unknown artist,
*c.*1520.
Oil on panel,
508 x 381mm
(20 x 15")
National Portrait
Gallery, London
(NPG 4690)

2 HENRY VIII (1491–1547)

Although not a very accomplished portrait, this work gives some idea of a Renaissance monarch's love of luxury and display. Henry was also a major patron of the visual arts and gave lavish entertainments at court. Already impressive in his physical appearance, the King's impassive and watchful face is adorned with a reddish-brown beard, which – according to the Venetian ambassador in 1519 – he grew in emulation of his great rival, Francis I of France.

Expensive fabrics with rich ornamentation make up the King's costume. He wears a doublet of black velvet, with slashes ('ventes' in contemporary accounts) revealing a lining of yellow silk. Gold braid decorates the doublet sleeves, as it does his coat of crimson satin lined with sable. Henry spent a great deal on furs, including many sable-lined gowns, and during his reign a series of sumptuary laws limited expensive furs, as well as costly fabrics such as cloth of gold and silver, to the royal family and the aristocratic élite. Gold-embroidered shirts, such as that of fine pleated linen worn by the King, were also forbidden to those under the degree of knight.

Henry wears on his head a Milan bonnet, a felt hat with a turned-up and stiffened brim, which is decorated with gold 'aglets' (decorative jewelled tags) and a hat brooch of a ruby surrounded with diamonds and pearls set in gold. Vast quantities of jewellery feature in images of the King and his court: here Henry displays a pendant at his neck, and round his shoulders a large collar of pearls and diamonds in gold.

Even more jewels can be seen in the image (*fig. 2.1*) of Henry VIII taken from a portrait-type of some twenty years later. Nearly every part of his intimidating and monumental figure is covered in lavish ornamentation, from his richly jewelled cap to the gold-figured doublet sleeves, the openings of which are held together with large rubies. The huge, loose-fitting 'Turkey gown' (the better to contain the King's corpulence) of pink satin lined with lynx fur is trimmed with gold and silver braid and fastened with ruby and diamond clasps.

2.1
HENRY VIII
Unknown artist,
after a portrait of
*c.*1542.
Oil on panel,
889 x 667mm
(35 x 26¼")
National Portrait
Gallery, Montacute
House, Somerset
(NPG 496)

3 CATHERINE OF ARAGON
(1485–1536)

Initially married to the eldest son of Henry VII, Prince Arthur (d.1502), Catherine became the first wife of Henry VIII in 1509, the year of his accession to the throne. It was the custom for royal brides to relinquish their own fashions in favour of those belonging to their newly adopted country, and here Catherine wears English dress, most notably the unbecoming 'gable' headdress with its stiff black understructure and rigid perpendicular 'billiment' (decorative jewelled edging to the hood). Gold brocade 'lappets' (pendants in the form of long rectangular strips or tubes of fabric) are pinned up over a

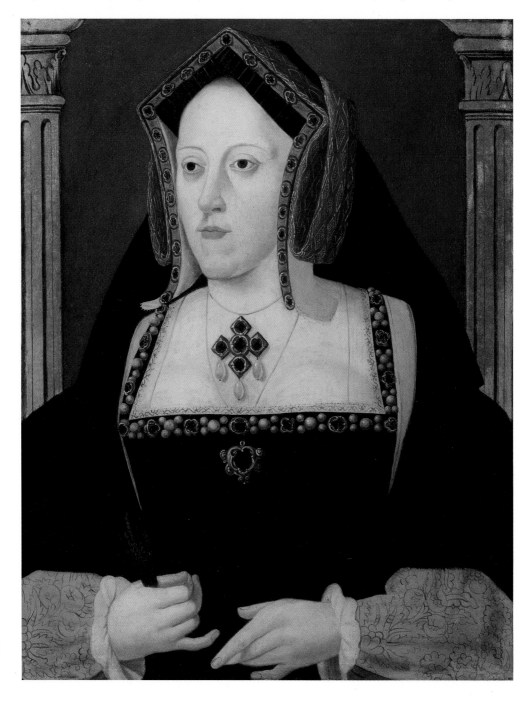

3
CATHERINE
OF ARAGON
Unknown artist,
*c.*1530.
Oil on panel,
559 x 445mm
(22 x 17½")
National Portrait
Gallery, London
(NPG 163)

3.1

*Two views of
an unknown
English lady*
Hans Holbein
the Younger,
*c.*1535.
Pen and ink,
159 x 109mm
(6¼ x 4¼")
British Museum,
London

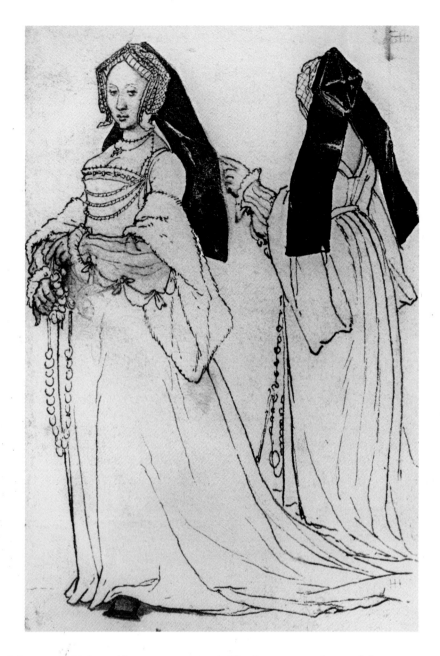

black velvet fall of drapery, which could
be either a single or double back drop.
Holbein's drawing of an unknown woman of
the mid-1530s (*fig. 3.1*) shows how the back
of the hood has a box-like structure, with
two wide pendant tubes of material. In the
mid-1530s it was fashionable to throw one
side of the hood up over the head and pin
it in place.

Catherine's black velvet dress reveals
little of the natural body shape. The breast
is flattened under the tight bodice (corsets,
or 'stays' first appear as an essential part
of female underwear in the early sixteenth

century). The large upper sleeve of the gown,
trimmed with fur, reveals a gold undersleeve.

The Queen's jewellery is somewhat old-
fashioned in its late Gothic simplicity,
especially the charming heart-shaped pen-
dant – possibly of garnet – set in gold, at
her bosom. Catherine was a fervent Catholic
and the three pearls on the pendant round
her neck may be a reference to the Trinity.
Pearls decorate the jewelled band or 'square'
that outlines the top of her dress, and above
this there is a glimpse of the fine blackwork
embroidery (linen embroidered with black
silk) that edges her linen shift.

ETATIS SVÆ·21·

4
UNKNOWN
WOMAN
After Hans
Holbein the
Younger, n.d.
Oil on panel,
737 x 495mm
(29 x 19½")
National Portrait
Gallery, Montacute
House, Somerset
(NPG 1119)

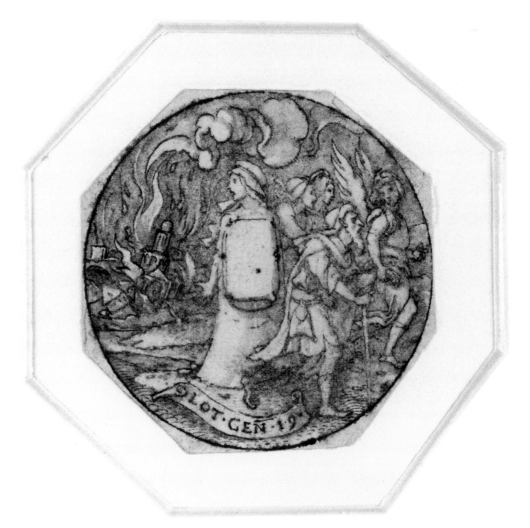

4.1
Design for
medallion of
*Lot with his
Family, guided by
an Angel, fleeing
from Sodom*
Hans Holbein
the Younger,
1532–43.
Pen and black
ink with grey
wash, cut
octagonally,
50 x 50mm
(1¹⁵⁄₁₆ x 1¹⁵⁄₁₆")
British Museum,
London

4 UNKNOWN WOMAN

Whoever the sitter is (once thought to be
Catherine Howard, she has been tentatively
identified as Elizabeth Seymour, who mar-
ried Gregory, Lord Cromwell in 1537/8),
she is dressed with taste and luxury in a
black satin gown which has a yoke or a
shoulder mantle of black velvet open at the
neck and lined with white silk. This style of
dress was a modest alternative to the low,
square-necked gowns worn on more formal
occasions. The dress has a plain bodice,
which sets off the wide sleeves laid with
thick gold braid and aglets; also focusing our
attention on the sleeves are beautiful cuffs of
fine blackwork. By this time the skirt is open
at the front and we glimpse a chequered
black and gold 'forepart' (a triangular piece
of fabric filling in the central, parted section

of the skirt); it forms a back drop to a large
pendant attached to the jewelled waist girdle.
Renaissance jewellery often had religious or
mythological motifs that could be 'read' like
portable works of art (indeed, some were
just as expensive); here, the sitter's bodice
pendant shows Lot's family being led away
from Sodom, relating, perhaps, to a similar
design by Holbein (*fig. 4.1*).

By the time this portrait was painted in
about 1540, the English hood (as worn by
Catherine of Aragon, *fig. 3*) had given way
to the French hood, set further back on the
head and shaped on the top and sides with
a curving gold band. It is worn over a stiff-
ened white undercap, or coif, trimmed with
gold gauze and braid, and which fastens
under the chin.

5 CATHERINE PARR (1512–48)

Last wife to Henry VIII (they married in 1543), Catherine was renowned for her learning and religious knowledge; after the King's death in 1547 she married Lord Thomas Seymour, and died the following year in childbirth.

This is one of the most detailed and sumptuous costume portraits of the mid-sixteenth century. The artist has taken great pains in the depiction of the French gown of stiff silver brocade, paying particular attention to the lustrous lynx fur that lines the skirt and adorns the sleeves. The huge padded under-sleeves (which appear to distort the arms) and the forepart of the skirt are of red velvet richly embroidered in intricate designs made from gold thread and pearls, some in the shape of stylised lovers' knots. The bodice of the gown is long and pointed, and the jewelled 'square' holding the neckline in place prevents the heavy sleeves from sliding off the shoulders.

Jewellery gilds the lily of the intense patterning of this costume. We see rubies and pearls in the billiment of the French hood, and at the Queen's breast is a gold crown-shaped brooch, possibly a gift from Henry to his new bride. Falling from her waist is a long chain of antique shell cameos, perhaps once owned by Catherine Howard, who may also have owned the diamond, ruby and pearl pendant attached to the necklace at the Queen's throat. Like fur linings and borders (which could be moved from one garment to another), items of jewellery were interchangeable, and this pendant can be seen – attached to a different necklace – in another portrait of Catherine Parr of about the same time (*fig. 5.1*). In this portrait the Queen wears a less formal costume, a dress of red satin damask trimmed with gold braid and jewelled aglets; among the designs on the gold embroidery is a stylised Tudor rose. The collar is a beautifully observed example of 'drawn-thread work', where the threads are drawn from the linen to create geometric patterns, then oversewn to give further richness of detail; this kind of embroidery was one of the forerunners of lace. Women have often borrowed from the male wardrobe for less formal wear, and here Catherine Parr wears a masculine bonnet (quite close in style to the ones worn by Henry VIII, *fig. 2.1*, and Edward VI, *fig. 6*), of black velvet studded with gold aglets and pearl pins, and adorned with a white ostrich plume beautifully worked with gold and sequins.

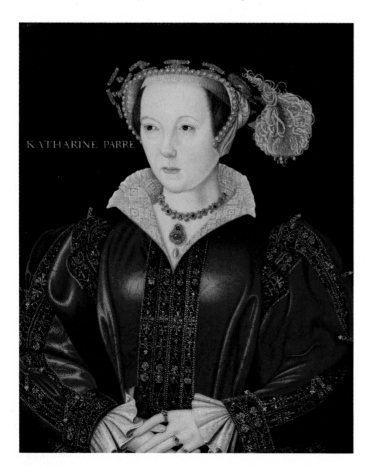

KATHARINE PARR

5.1
CATHERINE PARR
Unknown artist, *c.*1545.
Oil on panel,
635 x 508mm (25 x 20")
National Portrait Gallery,
Montacute House,
Somerset (NPG 4618)

5
CATHERINE PARR
Attributed to
Master John, *c*.1545.
Oil on panel,
1803 x 940mm
(71 x 37")
National Portrait
Gallery, London
(NPG 4451)

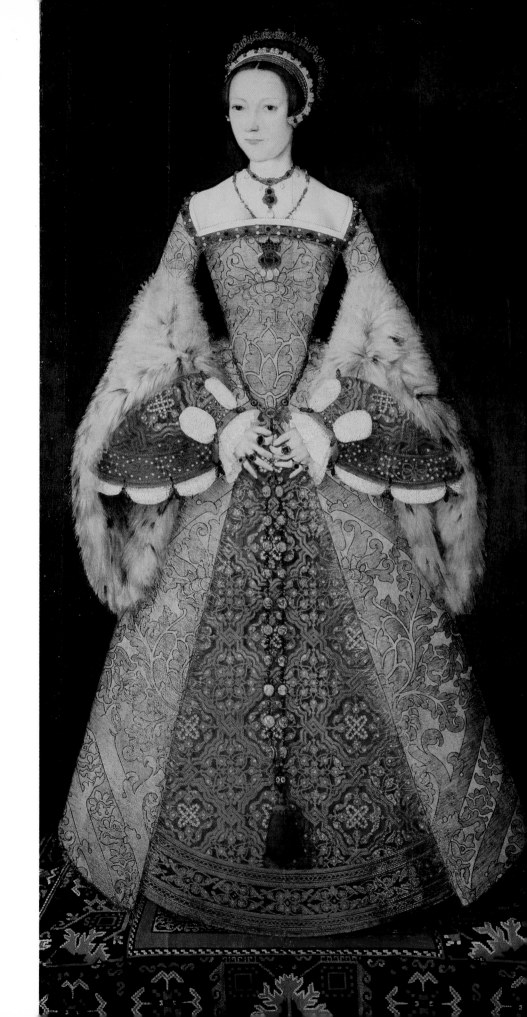

6 EDWARD VI (1537–53)

Henry VIII had set a trend for the kind of four-square, solid horizontality that one sees especially in his later portraits, and here the young Edward VI, king at about the age of nine, seems in his pose and costume to be a pale mimic of his father. The formality of the costume (the Great George, or large jewelled pendant of St George and the

dragon, of the Order of the Garter, is worn over his shoulders) seems almost to overwhelm the rather sickly looking boy, his legs braced to keep his balance under the weight of an embroidered red velvet coat lined with lynx.

Like Nature, Tudor costume abhorred a vacuum, and every surface of clothing is decorated – with slashes, with embroidery and with jewelled ornamentation. Slashing, or cutting into the fabric, usually to reveal a contrasting lining, was very popular, and here the gold-embroidered doublet is slashed, as are the barely visible breeches of cream silk trimmed with gold twist. Such breeches were known as 'trunkhose', and usually came to mid-thigh; the rest of the legs were covered in 'hose' (stockings) – here of white silk. On his feet the King wears slashed white leather shoes.

Edward's flat black velvet cap is trimmed with hat brooches and gold aglets; the latter also appear holding together the openings of the coat's hanging sleeves.

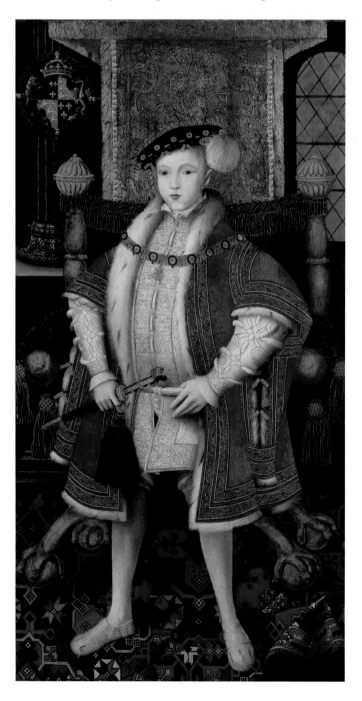

6
EDWARD VI
Unknown artist,
*c.*1547.
Oil on panel,
1556 x 813mm
(61¼ x 32")
National Portrait
Gallery, London
(NPG 5511)

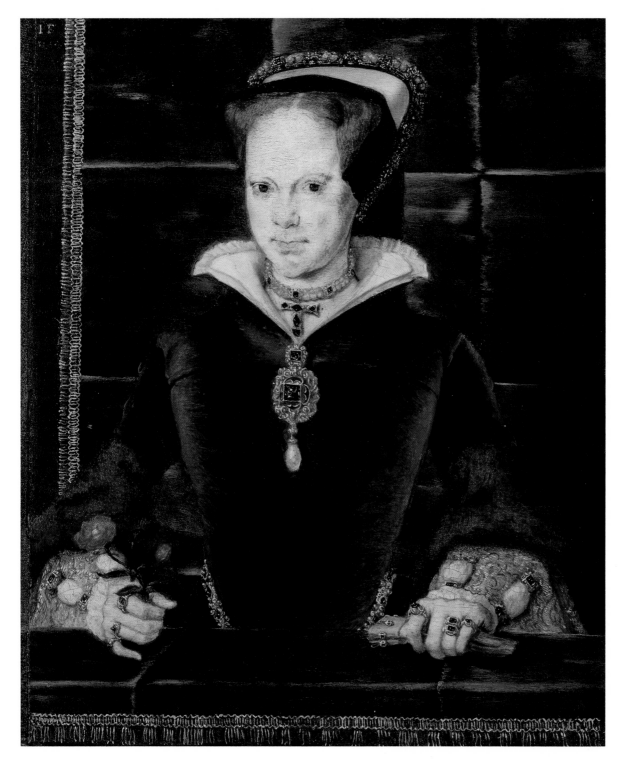

7
MARY I
Hans Eworth,
1554.
Oil on panel,
216 x 169mm
(8½ x 6⅝")
National Portrait
Gallery, London
(NPG 4861)

7 MARY I (1516–58)

Something of Mary's determination and vulnerability – inherited, respectively, from her father Henry VIII and her mother Catherine of Aragon – can be seen in this small portrait, which was painted at the time of her marriage to Philip II of Spain. She holds a rose, signalling her love for her husband. Just before their marriage, at

7.1
MARY I
After Jacopo da
Trezzo, *c.*1555.
Electrotype of
medal, diameter
(actual size)
67mm (2⅝")
National Portrait
Gallery, London
(NPG 446[1])

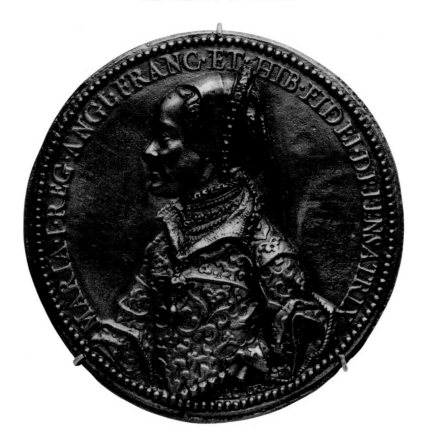

Winchester in July 1554, Philip gave Mary the large brooch with pendant pearl, called 'La Pellegrina' (now owned by Elizabeth Taylor), which features so prominently in this image.

Mary's dress is a French gown of murrey-coloured velvet, the upper sleeves of which are trimmed with sable. The under-sleeves are made of cloth of gold with fake slashes of white silk, and set with diamond and gold clasps. Murrey (mulberry) was a purplish-red colour much in fashion in the mid-sixteenth century, especially for velvet. In Mary's Wardrobe of Robes for 1554 (Public Record Office, London) there is a reference to a 'Frenche Gowne of Murrey vellat', and on the day before her marriage, at a reception to mark the approaching nuptials, the Queen wore a tight-bodied murrey velvet gown lined with brocade.

Diamonds and pearls set in gold form the girdle round her waist and the billiment of her French hood. A good view of the kind of headdress she wears can be seen in a medal of Mary after Jacopo da Trezzo of about 1555 (*fig. 7.1*). We can see how the rigid curve of the billiment holds the cap in place, and how the hood is formed of two pendant falls, one of which is pinned up at the back.

8 SIR THOMAS GRESHAM (1519–79)

As befits a diplomat and financier, Gresham is dressed in subtle but rich costume on a black and gold theme. The Protestant son of a wealthy merchant, he undertook on behalf of the Crown much financial business in Antwerp, a city whose bourse inspired his creation of the Royal Exchange in London, opened by Queen Elizabeth in 1571. The Royal Exchange was famous for the wide range of luxury goods and services on offer: fabrics could be made up by tailors and seamstresses, and 'drawers' drew embroidery patterns for customers' fine linen. The Royal Exchange was also a fashionable meeting place for Elizabethan society.

Gresham (a member of the Mercers' Company) wears a black velvet hat decorated with gold ornaments and a sleeved long jerkin of cut black velvet (the 'cuts' imitate small, diagonal slashes), which is slashed vertically to reveal a silk doublet striped in gold and silver. Over his shoulders is a black velvet cloak, a garment that by the mid-sixteenth century had largely replaced the coat.

There is just a brief glimpse of a gold chain crossing his chest over the doublet; such chains were especially popular in Germany and the Netherlands, the fashion spreading to England in the second half of the century. The sword, on which Gresham rests his left hand, indicates his status (he was knighted in 1559), and the black velvet purse embroidered in gold draws attention to his career as an astute man of business.

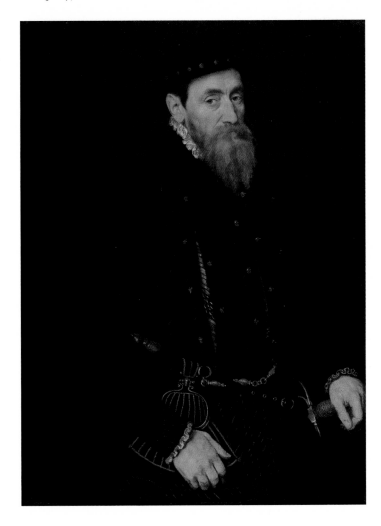

8
SIR THOMAS
GRESHAM
Unknown artist, *c.*1565.
Oil on panel,
1003 x 724mm
(39½ x 28½")
National Portrait
Gallery, London
(NPG 352)

THE GALLERY OF FASHION

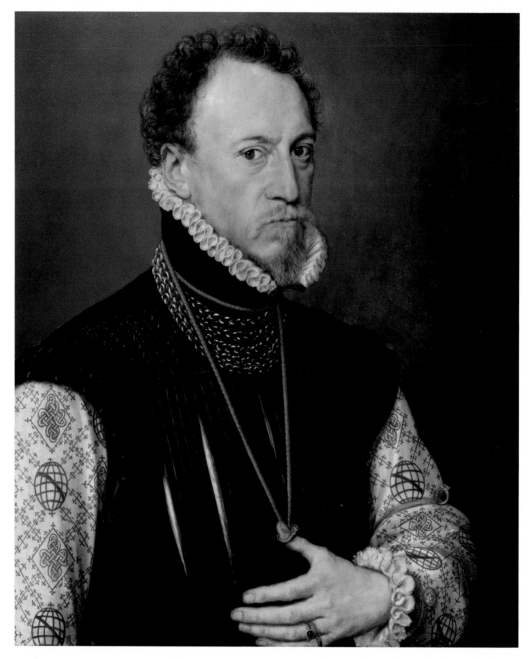

9
SIR HENRY LEE
Antonio Mor,
1568.
Oil on panel,
641 x 533mm
(25¼ x 21")
National Portrait
Gallery, London
(NPG 2095)

9 SIR HENRY LEE (1533–1611)

This portrait, painted when Lee was in Antwerp, reveals something of the sitter's interests and allegiances; such images are not always easy to 'read', and need to be deciphered and interpreted, just like some Elizabethan poetry. Lee held a unique place at the Elizabethan court. He was the Queen's Champion from 1559 to 1590. In about 1571 he initiated the Accession Day Tilts, tournaments to celebrate the accession of Elizabeth (17 November 1558). By the 1580s these had become highly spectacular entertainments in which knights in fancy dress on richly caparisoned horses and with lavishly costumed entourages took part in elaborate jousts in honour of the Queen. Lee's costume probably alludes to his relationship with Elizabeth.

In a display of carefully contrived informality, Sir Henry wears a black jerkin over a white shirt. Black and white – which often signify despair and hope in contemporary symbolism – were the colours of Elizabeth, whose honour the Queen's Champion defended. The jerkin, probably of fine leather, is slashed into vertical strips on the chest (and probably at the back), and 'pinked' (embellished with small decorative cuts) on the shoulders. The collar is high and supports the ruff, which by now has become a separate item of clothing, quite divorced from the shirt out of whose ruffled collar it originated. Lee's shirt (*fig. 9.1*) is of fine white linen embroidered in black with true lovers' knots and armillary spheres (celestial orbs that represent the harmony of the sun and the planets in orbit round the earth); such motifs symbolised the wearer's love for the Queen – and/or wife/mistress. In her portrait by Marcus Gheeraerts the Younger (known as the Ditchley Portrait) Elizabeth I wears an earring in the shape of an armillary sphere in her left ear (*fig. 9.2*); Lee, who owned Ditchley Park in Oxfordshire, commissioned the painting.

Another reference to Lee's attachment to the Queen may be signalled by the jewellery

9.2
Detail of earring in
'The Ditchley Portrait'
(*fig. II*, p.11).

he wears – diamond rings on ribbons round his sleeve, and another ring, a ruby set in gold, on a long red silk cord round his neck. Medieval tournaments were the inspiration behind the Accession Day Tilts, and traditionally knights wore their lady's token, a mark of favour (a glove, scarf, ribbon or jewel) either in their helmet or on their sleeve. The colour red indicates passion and sacrifice; when worn, as in this portrait, with Elizabeth's black and white, it probably refers to Lee's attachment to the Queen.

9.1
Detail of *fig. 9*.

10 ELIZABETH I (1533–1603)

This is an honest and truthful portrait of the middle-aged Elizabeth, emphasising the Queen's taut, high-boned face and her hooded, slightly sunken eyes. By this time in her life cosmetic aids to beauty were necessary; here they include a red wig, artificially whitened skin and reddened lips. Elizabethan face paint (paint was the contemporary word for make-up) included a variety of substances to whiten the skin, some of which (lemon, sulphur and borax) were safe, whereas others (white lead, for example) were dangerous to the health as well as to the complexion. Rouge and lip salves usually took the form of fabric and papers impregnated with reddish dyes which came from ochre, henna, cochineal and the wood of the East Indian brazil tree; there was also vermilion, an injurious rouge made from mercuric sulphide.

The Queen wears a day dress comprising a matching bodice and skirt of brocaded white silk, worn over the pyramid-shaped Spanish farthingale. The bodice is cut rather like a man's doublet, fastening down the centre front and trimmed with horizontal rows of red and gold braid that end in tassels. This somewhat martial decoration may indicate that she wears a Polish gown – the sixteenth century was a period when styles of dress from all over Europe were popular at the English court, a form of role-playing that sometimes also reflected changes in foreign policy. A slight air of the masque can be seen in the Queen's pearl diadem holding her black veil in place and the large fan of coloured ostrich plumes that she holds in her right hand.

For all its rich and jewelled luxury, this dress is modest when set beside the extremes of late Elizabethan costume exemplified in a portrait of the Queen painted in the mid-1590s by an unknown artist (*fig. 10.1*). Here Elizabeth is depicted in a vast drum-shaped French farthingale over which is a long pointed bodice with large padded sleeves. She wears an open French ruff partly supported by a wired gauze collar edged with pearls, and on her head is a golden wig piled high with jewels and a small crown. The dress is of jewelled black velvet, but the dominant feature is the skirt and stomacher (an inverted triangle of material that filled in an open bodice-front) made of white silk with painted flowers, birds, butterflies and sea monsters. The flowers are a particular reference to the Golden Age, when spring reigned eternal and where lived Astraea, virgin goddess of purity and innocence. By the late sixteenth century Elizabeth had become the icon-like Virgin Queen of legend, an image created, to a large extent, by her extraordinary, unearthly costume and appearance.

10
ELIZABETH I
Unknown artist,
*c.*1575.
Oil on panel,
1130 x 787mm
(44 x 31")
National Portrait
Gallery, London
(NPG 2082)

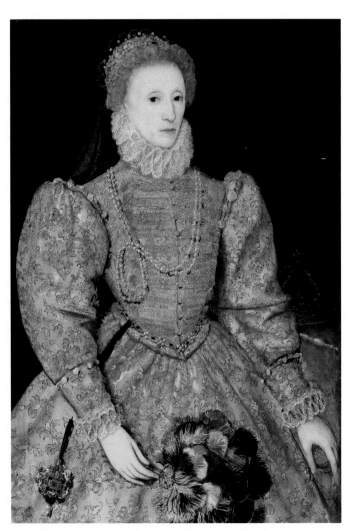

10.1
ELIZABETH I
Unknown artist,
mid-1590s.
Oil on canvas,
2235 x 1651mm
(88 x 66½")
Hardwick Hall,
The Devonshire
Collection,
Tha National
Trust,
Derbyshire

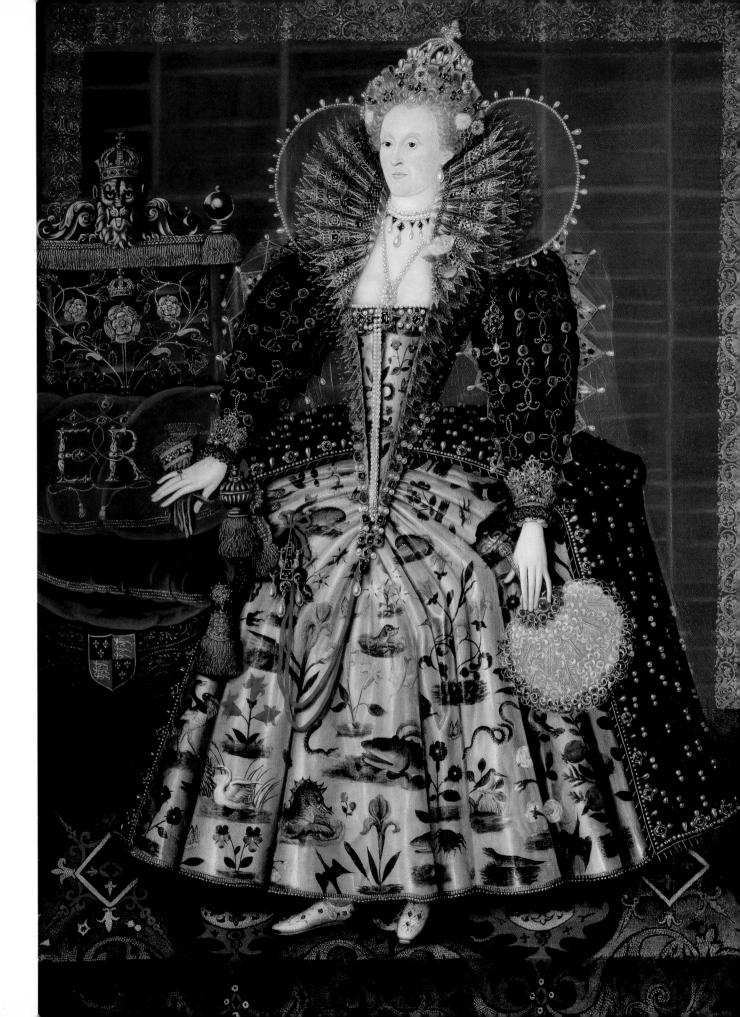

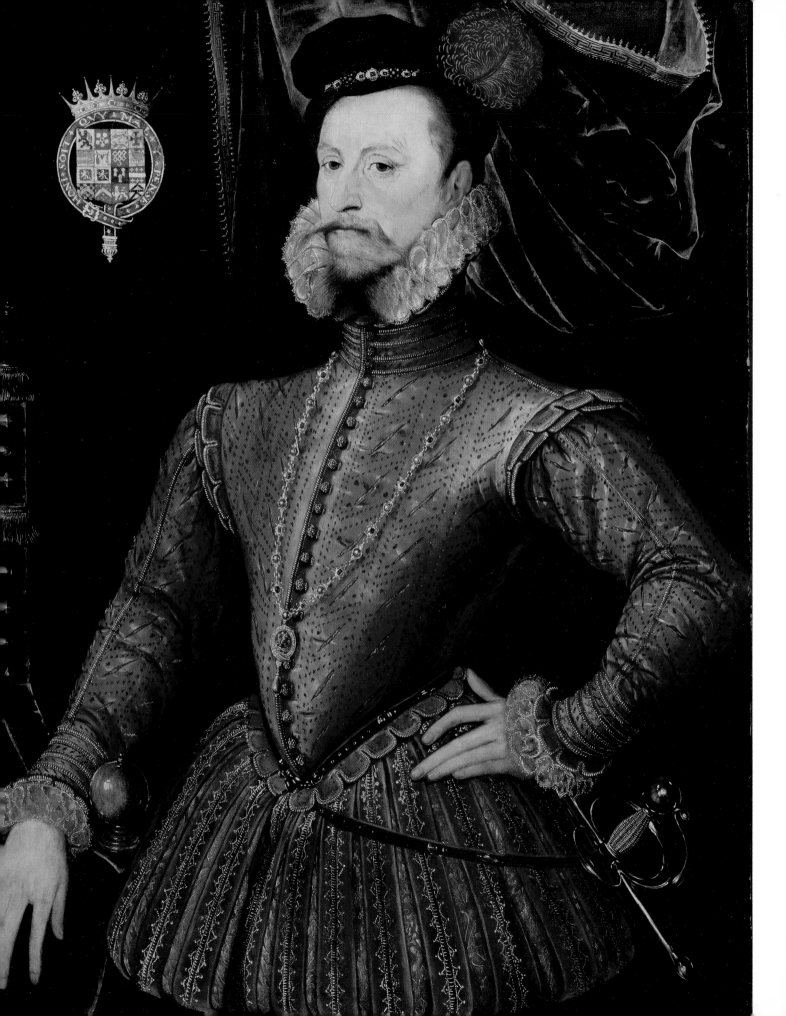

II ROBERT DUDLEY, EARL OF LEICESTER (1532?–88)

11
ROBERT
DUDLEY,
Earl of Leicester
Unknown artist,
*c.*1575.
Oil on panel,
1080 x 826mm
(42½ x 32½")
National Portrait
Gallery, London
(NPG 447)

From a family with close links to the Crown, Dudley was the typical Elizabethan courtier, rising to great heights on the strength of his personality and physical presence, rather than on merit (he was a not very successful military commander). In spite of his tortuous marital history (his first wife, Amy Robsart, was found dead in mysterious circumstances in 1560, and his two further marriages were shrouded in secrecy and controversy), he captivated Elizabeth I, who made him Master of the Horse, Knight of the Garter and – in 1564 – Earl of Leicester. He entertained the Queen with great magnificence at Kenilworth Castle, Warwickshire, in 1575.

Leicester's sense of style (and self-esteem, perhaps) can be seen in this portrait where he shows off a suit of pink satin trimmed with silver lace, comprising the newly fashionable peascod-fronted doublet and the padded trunkhose, which served to emphasise a slim waist. The doublet is pinked (a play on words of the kind the Elizabethans appreciated), and the trunkhose are slashed over a lining of pink and silver brocade. The high collar and the starched ruff give an air of hauteur to the image, reinforced by the conventional and dignified pose of hand on hip, and the Lesser George of the Order of the Garter on a jewelled chain. Dudley's cap of black velvet has a band of gold set with diamonds and pearls, and – echoing the theme of clothing as the pink of perfection – he has added a pink ostrich feather.

Slightly later in date is another portrait of Dudley (*fig. 11.1*), in which a similar elegance of costume is apparent. The doublet

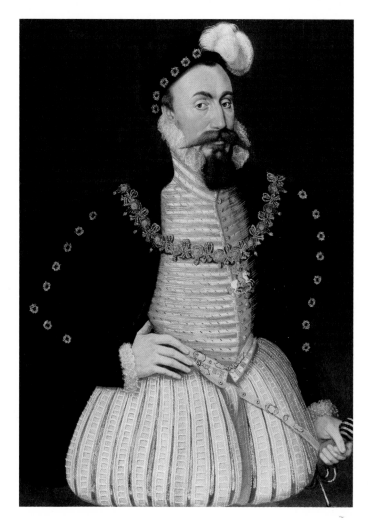

is of white satin, trimmed with bands of gold braid, and the trunkhose are made from panes (ribbon-like strips of material) of cream silk, decorated with white braid and laid over gold satin. The Great George of the Order of the Garter indicates a slightly more formal and conservative costume, and instead of the fashionable cloak, Dudley wears a short coat richly lined with sable, and with jewelled clasps all along the upper seam of the sleeve, matching his hat brooches.

11.1
ROBERT
DUDLEY,
Earl of Leicester
Unknown artist,
*c.*1575–80.
Oil on panel,
965 x 686mm
(38 x 27")
National Portrait
Gallery, Montacute
House, Somerset
(NPG 247)

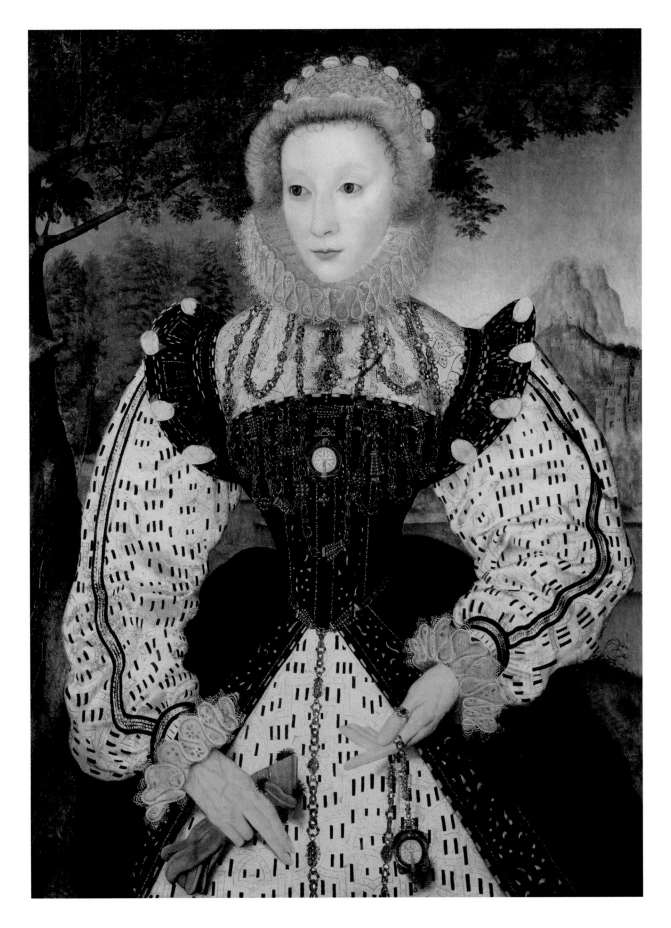

12 UNKNOWN WOMAN

12
UNKNOWN
WOMAN
Unknown artist,
*c.*1580.
Oil on canvas,
962 x 702mm
(37⅞ x 27⅝")
National Portrait
Gallery,
Montacute House,
Somerset
(NPG 96)

This is a problematical portrait, both from the point of view of the sitter (who was once thought to be Mary, Queen of Scots, or even her mother Mary of Guise, wife to James V of Scotland), and from the state of the painting, which has suffered from clumsy conservation, including some re-painting. However, the details of the costume provide useful information in a period that, as far as the National Portrait Gallery collection is concerned, has few portraits of women.

What this unknown sitter wears is a charming and sophisticated summer ensemble of black and white. The dress consists of an overdress of black silk, the fabric cut open over white silk to form a decorative pattern on the bodice and down the side fronts of the skirt. The sleeves and forepart are of white silk embroidered in black. Above the bodice is a delicately embroidered 'partlet' (a decorative infill, sometimes attached to a ruff, which covers the neck and bosom); the translucent effect of the fine, embroidered linen is a subtle contrast to the matte silk of the skirt and sleeves.

This was a period when carefully chosen accessories added to the rich complexity of clothing. Here the sitter wears a small white cap covered with gold net and decorated

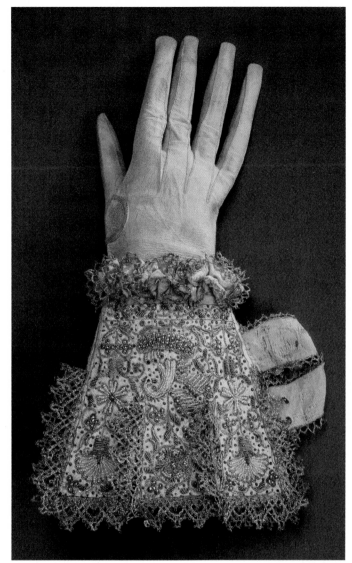

with puffs of white silk and gold ornaments. Among the gold and pearl chains looping over her shoulders is a cameo set in gold at her breast, and an intriguing pendant (possibly a watch?) hangs from her waist (*fig. 12.1*), matching a similar item pinned to her bodice. The delicacy of the dress is complemented by the gold-embroidered ruffs at neck and wrists, and by a pair of pale grey leather gloves decorated with turquoise silk tassels and gold embroidery; such gloves were often perfumed and were popular as lovers' gifts (see *fig. 12.2*).

12.2
Leather glove
with silk and
metal thread
embroidery,
lace and sequins,
early seventeenth
century.
Museum of
Costume, Bath

12.1
Detail of *fig. 12.*

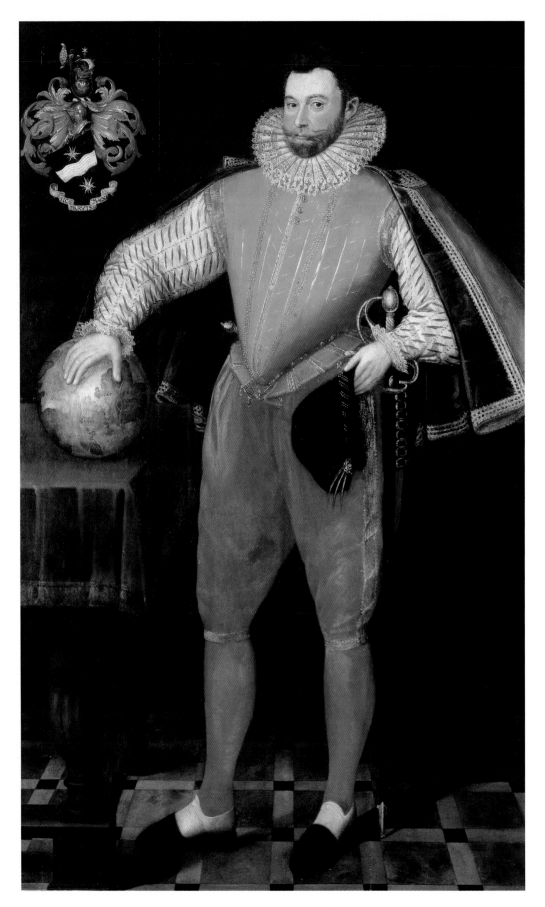

13
SIR FRANCIS DRAKE
Unknown artist, *c.*1585.
Oil on panel,
1813 x 1130mm
(71⅛ x 44½")
National Portrait Gallery,
London (NPG 4032)

13.1
Man's cloak of
crimson silk
velvet, embroi-
dered with silver
and gold metal
thread, late
sixteenth century.
Museum of
London

13 SIR FRANCIS DRAKE (1540?–96)

The quintessential Elizabethan adventurer – sailor, pirate and explorer – Drake is portrayed here with a globe which draws attention to his exploits, notably his famous voyage round the world (1577–80) after which he was knighted by the Queen on his ship, the *Golden Hind*, at Deptford.

But it is also as a man of fashion that we see him here, adopting the exaggerated peascod line so popular in the period, and which aroused criticism from a number of moralists. In *The Anatomie of Abuses* of 1583 the Puritan Philip Stubbes denounced the wearing of 'monstrous' doublets and jerkins for 'being so hard quilted, stuffed, bombasted and sewed, as [men] can neither woorke nor yet well plaie in them through the excessive heate thereof.' Furthermore, Stubbes continued, such garments made their wearers look 'inclined … to gluttonie, gourmandice, riotte and excesse'. Stubbes also attacked the vogue for wearing the kind of large ruff that we see in Drake's portrait, a costly item of dress that he said led to vanity, and – on more practical grounds – made it difficult to move the head freely. Proclamations were passed (in 1577 and 1580) against excessive size and depth of ruffs, but – like nearly all sumptuary legislation – they were ignored.

Drake's costume consists of a doublet of slashed cream silk under a red jerkin trimmed with silver-gilt braid. His knee-length breeches (known as 'Venetians') match the jerkin. Ironically, considering his lifetime career of attacking Spanish ships, he wears a fashionable short Spanish cloak of pink lined with sage-green velvet. Such cloaks, a number of which survive from this period (*fig. 13.1*), were usually worn over one shoulder, the better to show off the lining. He carries a soft black velvet hat trimmed with pearls, and has a silver hat jewel in the shape of a heron's feather, or aigrette, set with diamonds and cabochon (that is, rounded, not faceted) rubies. Feather motifs were popular in jewellery, and can be seen, for example, in designs by the Fleming Arnold Lulls (*fig. 13.2*).

Drake's extraordinarily long sword is not a misrepresentation by the artist, but a reflection of the fashionable reality; edicts were passed, unsuccessfully, to limit the length of such weapons. A more practical touch in Drake's appearance is his choice of black leather 'pattens' (overshoes), which protect his white leather shoes patterned with small diagonal cuts.

13.2
Design for jewelled aigrette by Arnold Lulls, 1550–60.
Ink and water-colour drawing on vellum, 220 x 155mm (8¹¹⁄₁₆ x 6⅛")
Victoria and Albert Museum, London

TANDEM SI

14 SIR CHRISTOPHER HATTON (1540–91)

14
SIR
CHRISTOPHER
HATTON
Unknown artist,
probably
seventeenth
century after a
portrait of 1589.
Oil on panel,
781 x 654mm
(30¾ x 25¾")
National Portrait
Gallery,
Montacute House,
Somerset
(NPG 2162)

Courtier and lawyer, Hatton is portrayed here more as the former than the latter, although he became Lord Chancellor in 1587. The late sixteenth century is a period of extremes in male dress – stuffed peascod doublets with wide padded sleeves, balloon-like trunkhose and short flaring cloaks – and Hatton follows the fashionable silhouette. His doublet is of white satin with tiny pinked cuts, and overlaid with horizontal bands of red silk trimmed with gold lace; it fastens down the front with large gold buttons. His cloak and breeches are of black satin with an unusual decoration of pearls set in gold (or possibly cloth of gold), forming equilateral triangular shapes. His collar (an increasingly fashionable alternative to the ruff towards the end of the century) and his cuffs are of black-work (black silk embroidery on white linen) with a scrolling design of fruit and flowers; such embroidery patterns were probably inspired by the popular herbals of the period.

Hatton's black velvet hat is lavishly trimmed with jewelled ornaments – black pearls and rubies set in gold – and a large cameo brooch holds the ostrich feather in place. He draws our attention to another cameo, attached to a gold chain; the image is that of Queen Elizabeth, whose favour Hatton had won in 1564 by his dancing at a masque. A contemporary cameo (*fig. 14.1*) shows a bust portrait of Hatton (less flattering than the painted portrait), with an image of a golden hind on the reverse. This was his personal crest and it is possible that Drake named his famous ship in honour of Hatton, one of the backers for his circumnavigation of the globe.

14.1
Double-sided
cameo with
portrait of Sir
Christopher
Hatton on one
side and a
golden hind on
the reverse,
*c.*1590.
Sardonyx and
gold, actual size
38 x 30mm
(1½ x 1¼")

15 SIR HENRY UNTON (1557?–96)

15
SIR HENRY
UNTON
Unknown artist,
*c.*1596.
Oil on panel,
740 x 1632mm
(29⅛ x 64¼")
National Portrait
Gallery, London
(NPG 710)

This unique narrative painting (probably commissioned by Unton's wife Dorothy) gives us a detailed record of the public and private life of an Elizabethan gentleman, soldier and diplomat, from cradle to grave. On the right, is Unton as a baby in his bearing mantle (a rich and decorative cloth worn for christenings and other ceremonial occasions), being held by his mother, who wears black and the fashionable open French ruff of the 1590s (the clothing makes no attempt at historical accuracy and is completely of the period when painted). On the left is Unton's effigy, in armour, in Faringdon Church, Oxfordshire.

The painting is dominated by a portrait of Unton in a plain black doublet over which is a 'cassock' trimmed with gold braid. The cassock was a short coat, usually with open, hanging sleeves, and it can also be seen worn by our protagonist during his travels in Italy and France. After studying at Oxford, Unton spent some time in Italy and is depicted (in the top right-hand corner of the painting) riding on horseback under the shade of a white parasol. This is certainly one of the earliest images of an Englishman carrying such an accessory. Parasols and umbrellas (the latter word derives from the former, meaning protection against the sun, rather than the rain, as in the English meaning) were for many years derided by Englishmen as effeminate, and were accepted only in the late eighteenth century.

Unton served in the Earl of Leicester's rather fruitless military expedition to the Netherlands (1585–6) and is shown in the top right of the painting wearing armour, with his servant holding his helmet. He was knighted at the Battle of Zutphen (1586), famous mainly for being the occasion of the death of the poet and courtier Sir Philip Sidney. In the 1590s Unton went on a number of diplomatic missions to France, where he died. His death-bed scene shows him in a white linen night-shirt and coif, attended by servants and a doctor in the customary long black gown (such gowns, medieval in origin, were long retained by professional men – doctors, lawyers, clerics, academics).

One of the most interesting scenes is a rare depiction of a masque (*fig. 15.1*) held at Unton's home, Wadley House in Faringdon. Masques were élite entertainments, which

took the form of mimed *tableaux vivants* accompanied by music, presentations of allegorical and mythological themes in honour of ceremonial events such as marriages, or the arrival of exalted visitors. Under the early Stuarts, and in the hands of the court architect Inigo Jones, the masque developed into a sophisticated court entertainment. In Unton's masque the theme is explained to the guests by way of a written text handed to Lady Dorothy Unton by Mercury, messenger of the gods, in a winged helmet. The female masquers, led by the goddess Diana in her crescent-moon headdress, are dressed *all'antica* (or rather, an Elizabethan notion of the antique), in silver bodices and skirts (without 'unpoetic' farthingales) embroidered with flowers. Their long blonde wigs and red face masks were traditional masque costume, and as such are listed in the accounts of the Office of Revels, which was responsible for all the theatrical entertainments performed at court. Interspersed between the masquers are children as cupids, taking their customary role as torch-bearers; they wear all-in-one black or white garments, possibly of knitted silk.

15.1
Detail of *fig. 15* showing a masque at Wadley House.

THE SEVENTEENTH CENTURY

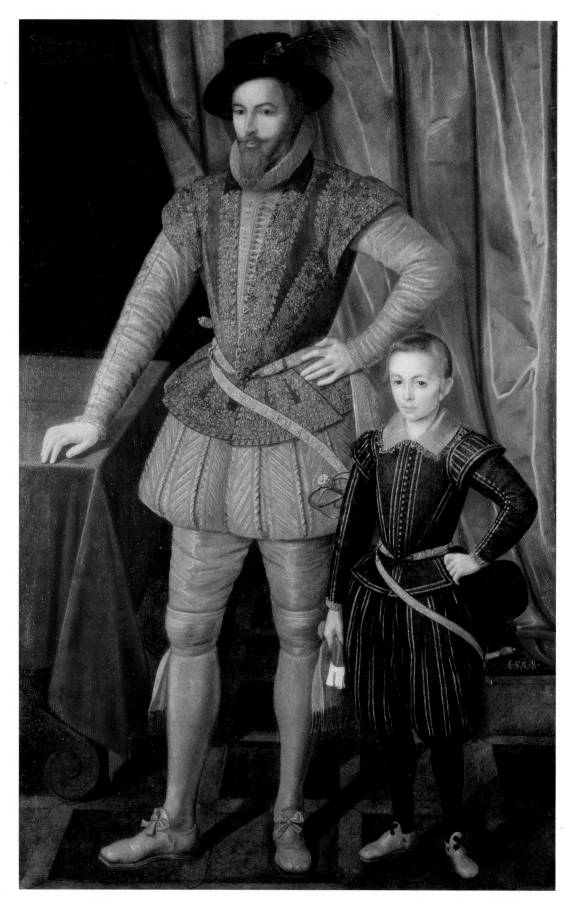

16
SIR WALTER RALEGH
and his son WALTER
Unknown artist, 1602.
Oil on panel,
1994 x 1273mm
(78½ x 50⅛")
National Portrait Gallery,
London (NPG 3914)

16 SIR WALTER RALEGH (1552?–1618) AND HIS SON WALTER (1593–1618)

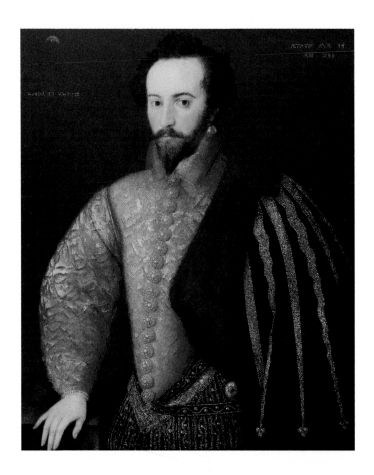

This is not a particularly skilful portrait of the relationship between father and son, but rather an image of two individuals inhabiting the same space. None the less, it is useful for the contrast between the generations in terms of costume, and the detail with which the clothing is depicted. Sir Walter Ralegh and his son were close, and both died in the same year; the son was killed during his father's disastrous Orinoco expedition to find gold, and Ralegh himself, long fallen out of royal favour, was executed by order of James I.

Ralegh's buccaneering qualities as soldier and explorer are still evident in this portrait of a man now well into middle age, but still famed for his style and sexual appeal – qualities that had won the attention of Queen Elizabeth. The seventeenth-century diarist John Aubrey in his *Brief Lives* described Ralegh as 'a tall, handsome and bold man'. It may be as a tribute to the Virgin Queen that Ralegh wears a white suit, comprising a pinked satin doublet and trunkhose with diagonal slashes to the panes of silk. Attached to these padded breeches are 'canions' (tubular extensions of fabric) of white watered silk. Over the doublet is a fine leather jerkin embroidered in silver and pearls; a pendant pearl adorns his ruby hat jewel.

Ralegh was especially fond of pearls; as well as signifying wealth and taste, they were one of the attributes of virginity, so wearing them was a pledge of devotion to the Queen. In an earlier portrait of Ralegh (*fig. 16.1*), pearls are everywhere; they cover his trunkhose, and form large buttons on his doublet of ruched and cut silk. His sable-lined cloak has an almost surrealist design of

pearls like rays of moonlight, ending in a trefoil. Queen Elizabeth was sometimes referred to as Diana (or Cynthia), goddess of the moon, and a crescent moon appears in the top-left corner of the painting.

In the double portrait, the son copies his father's pose, hand on hip. As was often the case, the style of dress worn by the boy is less formal and more up-to-date than that of his father; new trends usually first appear in informal clothing. The young Ralegh wears a suit of dark turquoise silk, decorated with tiny cuts and silver braid; the full, rather baggy Venetians fastening under the knee are more fashionable than trunkhose, which were increasingly reserved for very formal, ceremonial wear (see *fig. 17*). His 'falling band' (turned-down collar) is a relatively new fashion.

16.1
SIR WALTER RALEGH
Attributed to the monogrammist 'H', 1588.
Oil on panel, 914 x 746mm (36 x 29⅜")
National Portrait Gallery, Montacute House, Somerset (NPG 7)

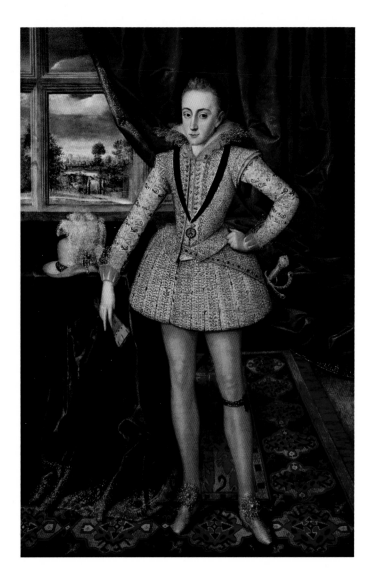

17 HENRY, PRINCE OF WALES (1594–1612)

This portrait may have been painted to commemorate the creation of Henry, eldest son of James I and Anne of Denmark, as Prince of Wales in 1610. The Prince was given the Order of the Garter (the premier order of English chivalry) soon after his father's accession to the throne in 1603, and he wears the Lesser George on a ribbon round his neck, and the garter itself below his left knee. (The Lesser George is a small oval gold or jewelled pendant of St George and the dragon, encircled by the Garter; worn on a chain or, more usually, a blue ribbon. It is worn on non-ceremonial occasions.) The cream-coloured beaver hat on the table (*fig. 17.1*) has a jewel of pearls and enamelled gold, forming the letters *HP* (Henricus Princeps), which holds in place a panache, or spray, of white ostrich plumes, these refer to the three Prince of Wales feathers, also to the feathered headdress associated with the Order of the Garter and they were also very fashionable.

Something of Henry's style and charm can be seen even within the confines of a formal portrait; he was a true Renaissance prince, athletic and cultivated and – even in his early youth – a patron of the arts. His doublet is of brocaded silk, over which he wears a jerkin of cream silk embroidered in red. Red embroidery also decorates the panes of cream silk that form the top layer of his padded trunkhose. This style of costume, which could all too easily look clumsy, especially on an older man, gives Prince Henry a balletic grace, an impression reinforced by his long, slim legs in their red silk stockings.

Grace and delicacy appear in the accessories to the Prince's costume. Like many young men of fashion, he wears a standing collar, lightly starched and edged with fine *reticella* lace, which matches that on his cuffs. *Reticella* was an embroidered lace made of fine plaited or needle-woven strands of linen, producing a light, geometric and gossamer fabric, which features prominently in Jacobean portraits. Also popular in this period, for formal wear in particular, were 'shoe-roses' of the kind that Henry wears, puffball confections of metal lace and spangles; the Prince's are made of silver with a central pearl, and they decorate shoes of pinked white leather.

17
HENRY, PRINCE OF WALES
Robert Peake the Elder, *c.*1610.
Oil on canvas, 1727 x 1137mm (69 x 44¾")
National Portrait Gallery, London (NPG 4515)

17.1
Detail of plumed hat in *fig. 17*.

18 PRINCESS ELIZABETH, LATER QUEEN OF BOHEMIA (1596–1662)

In this portrait of a solemn young girl in a rigidly brushed-up hairstyle, it is hard to recognise the beauty, charm and good humour for which Elizabeth was famed later in life when Queen of Bohemia. Elizabeth's attraction seems to have lain more in the mobility of her features and the vivacity of her manner than in conventional good looks.

She stands full length, wearing formal costume over the French farthingale, which her mother Anne of Denmark insisted on retaining for court, although by this time it

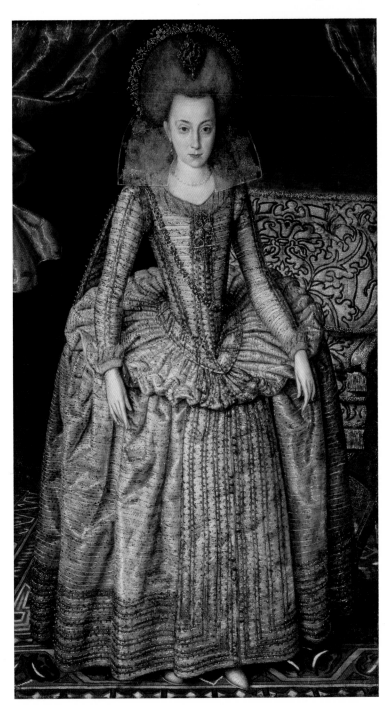

18
PRINCESS ELIZABETH,
later Queen of Bohemia
Robert Peake the Elder,
*c.*1610.
Oil on canvas,
1713 x 968 mm
(67½ x 38⅛")
National Portrait
Gallery, London
(NPG 6113)

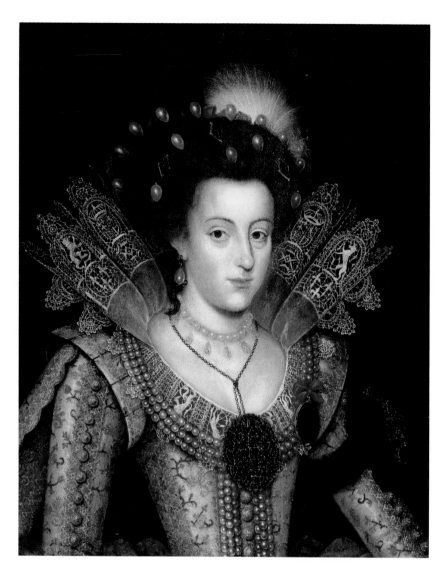

18.1
PRINCESS
ELIZABETH,
later Queen
of Bohemia
Unknown artist,
1613.
Oil on panel,
784 x 622mm
(30⅞ x 24½")
National Portrait
Gallery, London
(NPG 5529)

was no longer high fashion. The fabric of the dress is a brocaded silk trimmed with silver lace and sequins. Her childish figure is accentuated by the long pointed bodice, and the stiff, whaleboned corset underneath pushes down the farthingale at the front, forcing it to rise at the back, creating the curious tip-tilted look characteristic of formal dress at this period. As usual with court finery there is a great display of jewellery, which includes a girdle of rubies and diamonds and a chain of table-cut diamonds diagonally crossing her bodice. (Until the invention of brilliant-cut diamonds in the late seventeenth century all diamonds appear

in art as matte and black.) In her stiffly set hair is a large ornament of rubies and diamonds set in gold with a pendant pearl; pearls – suitable for a young virgin princess – form a halo-like diadem which matches in delicacy the high *reticella* lace collar veiled by fine transparent silk gauze that frames her face.

On St Valentine's Day 1613 Elizabeth, dressed in cloth of silver, was married to Frederick V, Elector Palatine. Frederick was the great hope of the Protestant cause in Europe, and later (briefly) King of Bohemia, until his defeat by the armies of the Catholic League in 1620 forced him and his family to flee to The Hague. A portrait of Elizabeth (*fig. 18.1*), probably painted at about the time of her marriage, shows a suitably sumptuous and rich costume. Her standing lace collar (*reticella* again) incorporates the royal coat of arms and the heraldic lion and unicorn. Some of this lace, a unique commission, is placed over a red silk partlet, which partly covers the low neckline of her dress. Ropes of pearls, possibly from the famed collection of Elizabeth I, adorn the bodice of the dress; pearls stud her hair like cloves in an orange, and in her right ear is a pearl, attached to which is a lock of hair (probably her own) tied with a black ribbon. Elizabeth was very close to her brother, Prince Henry (*fig. 17*), who died of typhoid in 1612. Possible references to her loss may be seen in the black silk armband and the gold-and-black enamelled locket, which probably contains his miniature, pinned to her dress.

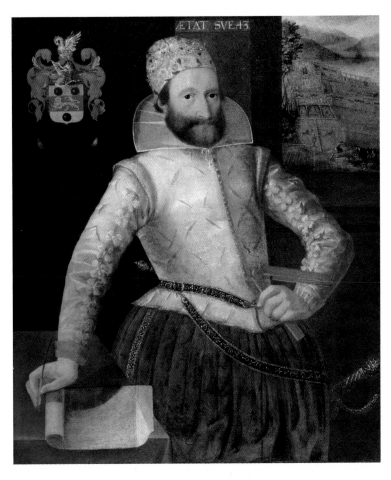

19

PHINEAS PETT
Unknown artist,
*c.*1612.
Oil on panel,
1187 x 997mm
(46¾ x 39¼")
National Portrait
Gallery (NPG 2035)
On loan to the
National Maritime
Museum, London

19 PHINEAS PETT (1570–1647)

19.1

Man's nightcap,
English, early
seventeenth
century.
White linen
embroidered
with gold thread,
coloured silks and
gold lace, height
235mm (9¼")
Museum of
Costume and
Textiles,
Nottingham

In September 1612 Pett recorded in his auto-biography that he 'was begun to be drawne by a Dutchman … ', and this is a rare image of a practical professional man of this period, the tools of his trade given prominence by the artist. Pett was master-builder of the Royal Navy, responsible for the *Prince Royal*, commissioned in 1610 (seen here in the top right-hand corner of the painting being fitted out in the royal dock-yard), and in 1637 the *Sovereign of the Seas*.

Pett is also portrayed as a man with a taste for modest finery in dress, wearing baggy breeches (Venetians) and a doublet of white silk decorated with diagonal slashes, tiny peppercorn buttons down the centre front and silk ribbon bows on the sleeves. The standing collar, rather Spanish in style, is of plain linen but it is superimposed on pink silk and matches the cuffs.

The most beautifully observed item of Pett's costume is his linen cap, embroidered with flowers and trimmed with gold lace. Such caps (some of them the work of wives and daughters) were worn indoors for comfort, but rarely appear in portraiture. There are, however, a number of fine examples in museum collections (see *fig. 19.1*).

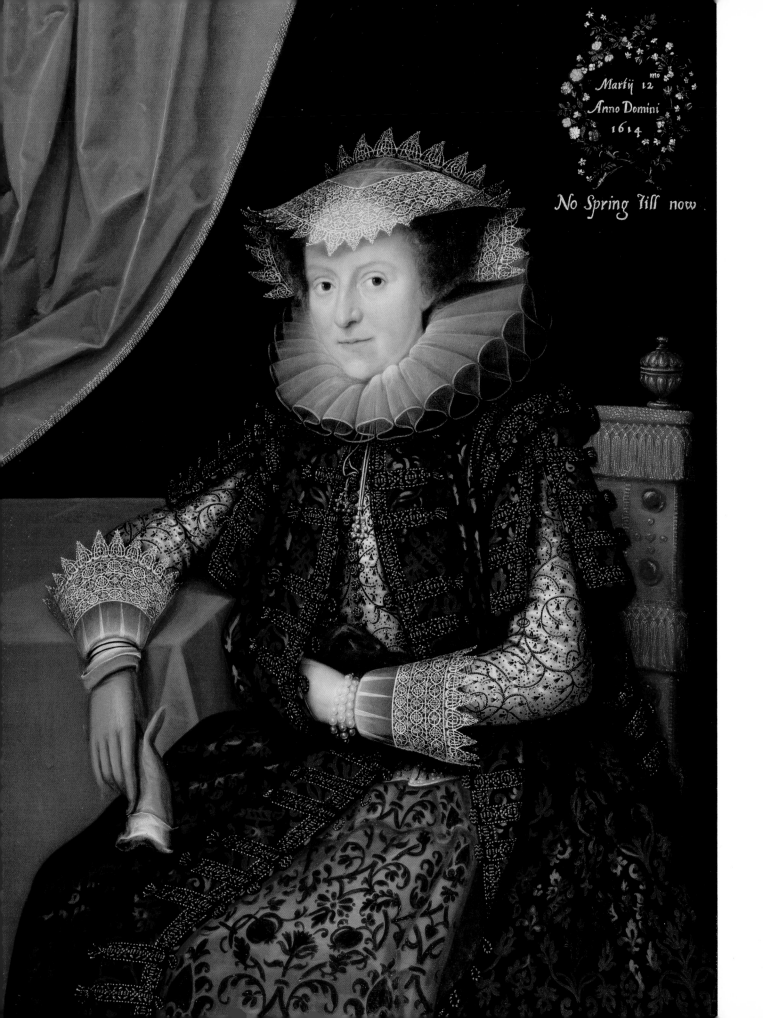

Martij 12.mo
Anno Domini
1614

No Spring Till now

20 MARY, LADY SCUDAMORE
(d. 1632)

Little is known about this sitter, except
that she was the daughter of Sir Thomas
Throckmorton, and in 1599 married, as her
second husband, Sir John Scudamore. The
inscription on the portrait refers to the
marriage of her son John, on 12 March
1614 (Old Style) to Elizabeth Porter. It is
probable that the portrait was commissioned
to celebrate this event, and for Lady
Scudamore to show off the patterned com-
plexity of her costume.

She is seated in conventional pose at a
table, one hand gloved and the other insert-
ed in a fold of her overgown. Her gloves are
of fine kid lined with white silk, the fingers
elongated to mimic the same effect in the
hand – long, tapering fingers were counted
a sign of elegance and good breeding. She
wears a spiky *reticella* lace cap (starched or
wired to hold its shape), and matching lace
edges her cuffs (an example of similar *reticella*
can be seen in *fig. 20.1*). Linking the costly
luxury of her headdress and her richly deco-
rated costume is a plain ruff of semi-trans-
parent linen, tied at the centre front with
tasselled strings.

Lady Scudamore's costume is a harmo-
nious combination of red, black and white.
Her overgown with hanging sleeves is made
of red and black damask, with a design of
stylised leaves, flowers and stems; it is deco-
rated with black and gold braid, and the fas-
tenings (loops and buttons) are arranged
alternately from neck to hem. Such elegant
yet comfortable loose gowns were usually
worn with a bodice and skirt; here the skirt
is of cut velvet, black on red, and the bodice
is of white silk embroidered in black and
gold thread and tiny gold spangles known as
'oes'. These jackets (some of which survive
in museum collections, see *figs 20.2* and
20.3) were sometimes made by the wearer
herself or professionally embroidered.

20.3 Detail
of jacket in
fig. 20.2.

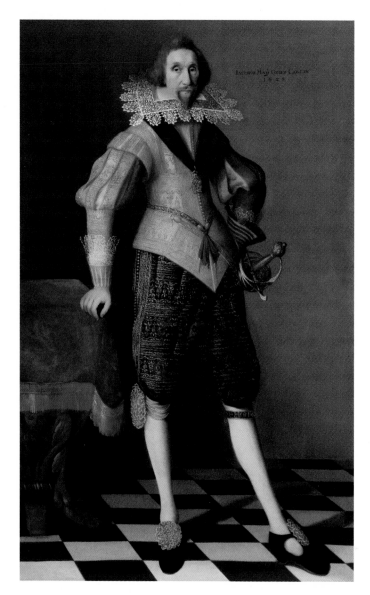

21
JAMES HAY,
1st Earl of Carlisle
Unknown artist, 1628.
Oil on canvas,
1946 x 1200mm
(76⅝ x 47¼")
National Portrait Gallery,
Montacute House,
Somerset (NPG 5210)

21 JAMES HAY, 1ST EARL OF CARLISLE (*c.1580–1636*)

James Hay, diplomat and courtier, was a favourite of James I and Charles I; he was created Earl of Carlisle in 1622. The sitter's rich costume and courtly elegance (he lived in great splendour and was renowned for his extravagant lifestyle) is the dominant impression given by this portrait, forming a contrast with his drawn face, sunken eyes and greying hair.

Hay wears black knee-breeches decorated with gold and silver embroidery, rows of braid and small gold buttons down the side. His doublet is of white silk with gold embroidery. His left sleeve, incidentally, is unpatterned, perhaps because the artist concentrated his attention on the gold-fringed glove his sitter wears (where is the other glove?), or perhaps through inadvertence (unlikely) or maybe because the Earl was in a hurry. In the year the portrait was painted Hay went – courtesy of the complex political intrigues involved in the Thirty Years War – on a diplomatic mission to Lorraine and Piedmont to help foment unrest against Cardinal Richelieu of France.

The right choice of accessories and knowing how to wear them distinguished the man of style from his less fortunate fellows. Hay's stance, one foot slightly in front of the other, draws attention to the Garter below his left knee, and to the rosettes of gold satin and braid that decorate his other knee and his shoes. Rich lace continued to be an essential requisite of formal costume, and the Earl of Carlisle wears a superb standing linen collar of cutwork (an embroidered lace created by the removal of linen threads; the spaces were 'framed' with buttonhole stitches to form decorative patterns) edged with Venetian *punto in aria* ('holes in the air'), a needle-lace with a scalloped border.

22 CHARLES I (1600–49)

It is clear from this portrait how Charles I valued the notion of kingly dignity and restrained elegance in his clothing. He is portrayed here with the appurtenances of royalty – crown, orb and sceptre – and with the insignia of the Order of the Garter, which symbolised for him the traditional chivalric ideals of duty, piety and obedience. Inflexible in politics, ascetic in his private life, he was a cultivated and intelligent patron of the arts; perhaps his highly developed aesthetic sense filtered through into the understated style and subtle colour combinations seen in his costume. In terms of fashion, the age of Charles I is one of simpler styles, where the beauty of plainer fabrics was more highly

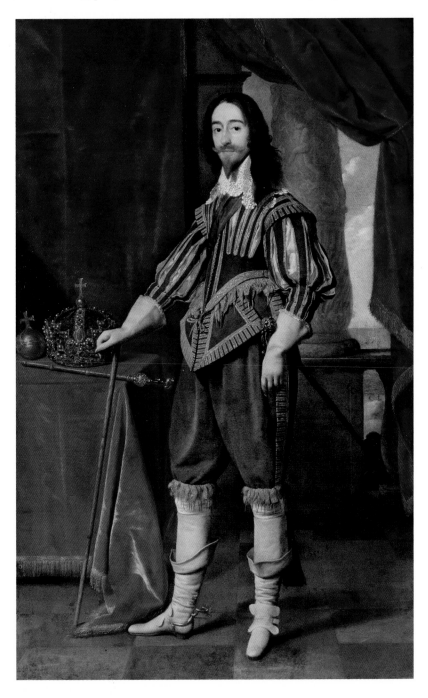

22
CHARLES I
Daniel Mytens,
1631.
Oil on canvas,
2159 x 1346mm
(85 x 53")
National Portrait
Gallery, London
(NPG 1246)

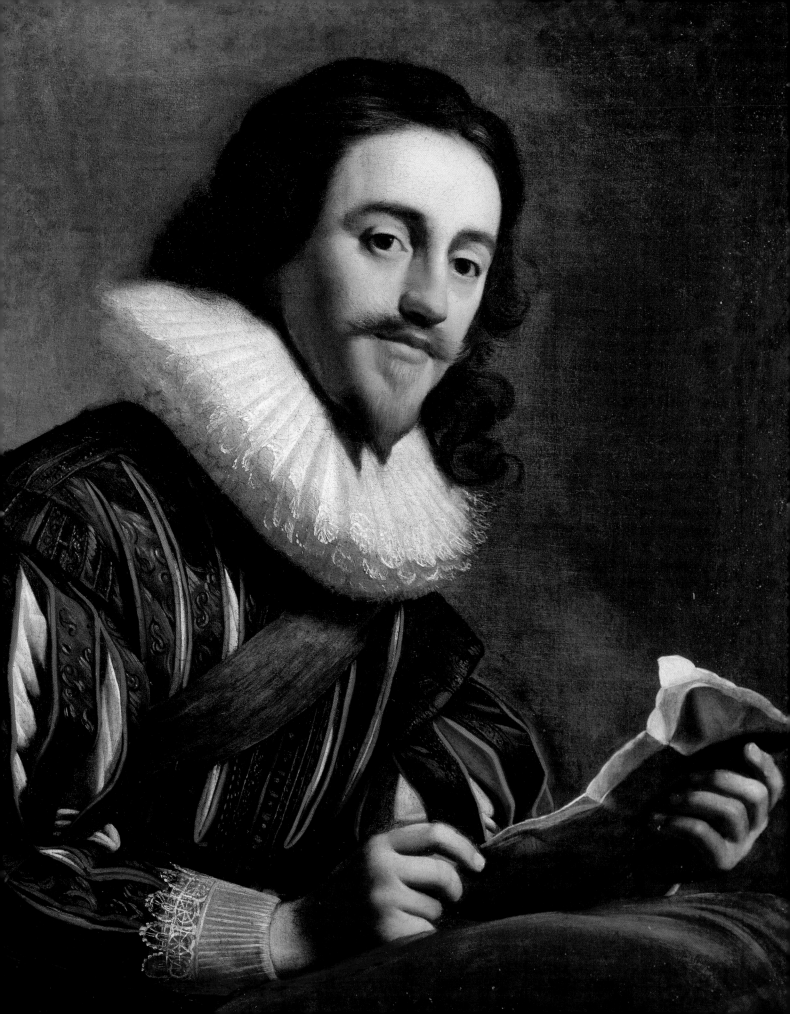

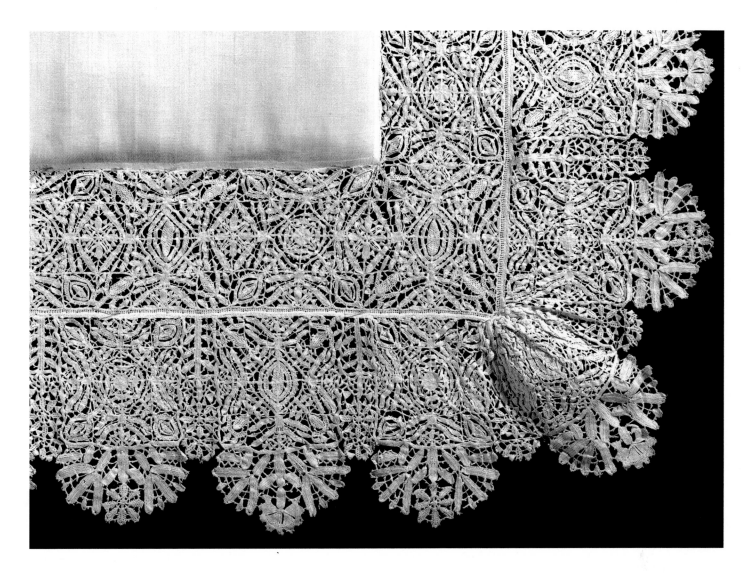

22.1
CHARLES I
Gerard
Honthorst, 1628.
Oil on canvas,
762 x 641mm
(30 x 25¼")
National Portrait
Gallery, London
(NPG 4444)

considered than those that were patterned or over-decorated. In contrast to the often crude finery of James I's appearance, Charles's wardrobe accounts reveal a fondness for suits of one colour, sometimes with contrasting linings to the doublet, as in this portrait, where we see a sophisticated combination of ash grey trimmed with silver braid and aglets, the doublet lined with pale yellow.

An equally stylish sense of colour can be seen in an earlier image of the King by Honthorst (*fig. 22.1*), where Charles is shown, less formally, in pensive mood, wearing a doublet of sage-green figured silk lined with carnation-coloured silk. The doublet is rather like one listed in the King's wardrobe for the year 1633/4: 'a suite of greene Tabie [tabby, a watered silk taffeta] lined with Carnation Tabie cutt with and upon Carnation Taffatie ... the doublet cutt in panes.'

In both these portraits Charles follows the dictates of fashion by wearing his hair long, a virtual impossibility when starched ruffs and high collars were the rule; it was the vogue also to have one's hair slightly longer on one side. The Honthorst portrait depicts a soft, falling ruff, made of layers of lace-edged linen, and Mytens shows Charles wearing a collar of needle-lace. Similar needle-lace edges a handkerchief (*fig. 22.2*) associated with Charles I. In the full-length image of the King, it is worth noting how the fine leather gauntlet gloves match his floppy boots; the most highly prized leather came from Cordoba in Spain.

22.2
Detail of linen
and lace hand-
kerchief said to
have belonged
to Charles I,
English, 1633–5.
Museum of
London

23 QUEEN HENRIETTA MARIA (1609–69)

The stylish elegance of Caroline female costume lay in the beauty of relatively unadorned fabrics, most notably the shining silk taffetas and lustrous satins painted by the court artist Anthony van Dyck and his contemporaries. In this portrait the Queen wears a dress of sage-green satin; green was the colour of true love, and features promi-

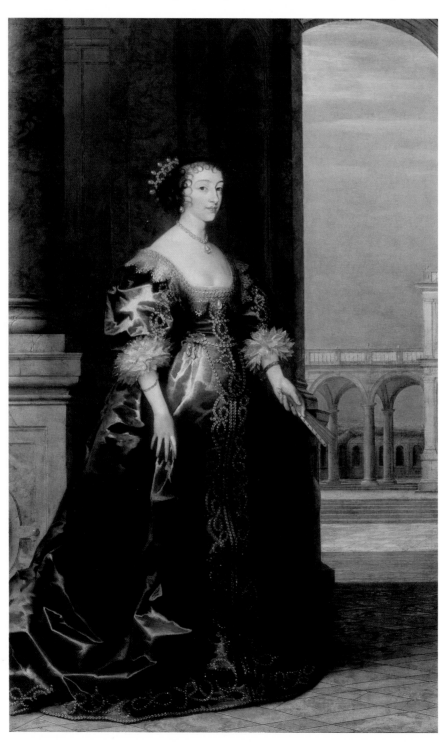

23
QUEEN
HENRIETTA
MARIA
Unknown artist
(background by
Hendrik van
Steenwyck), *c.*1635.
Oil on canvas,
2159 x 1352mm
(85 x 53¼")
National Portrait
Gallery, London
(NPG 1247)

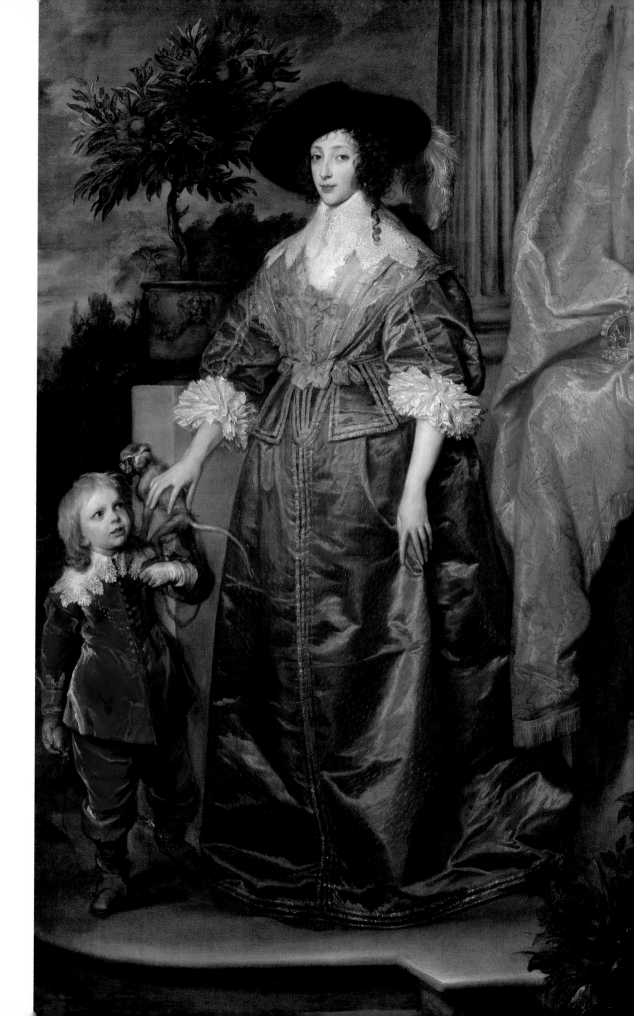

23.1
QUEEN
HENRIETTA
MARIA with
SIR JEFFREY
HUDSON
(1619–82)
Sir Anthony van
Dyck, *c.*1633.
Oil on canvas,
2193 x 1348mm
(86¼ x 53⅛")
National Gallery of
Art, Washington,
Samuel H. Kress
Collection

nently in the royal wardrobe accounts, an indication, perhaps of the mutual devotion of Charles I and Henrietta Maria. This beautiful dress, with its low neckline and full, rounded sleeves, is decorated with arabesques of pearls. Pearls also form the Queen's coronet, necklace and earrings; they stud the mount of her coral-coloured fan, which echoes the red ribbons on her bodice. On her left wrist is a black silk bracelet (fastened with another pearl), through which a gold ring is threaded. Such bracelets – holding small items of personal jewellery – were worn by both men and women (see *figs 26* and *26.1*). Women also wore them to show off the whiteness of their skin and to draw attention to a beautiful arm and hand. In one of Robert Herrick's poems, 'Upon a black twist rounding the arme of the Countess of Carlile' (Lucy Percy, Countess of Carlisle was a close friend of the Queen), we read:

I saw about her spotlesse wrist
Of blackest silk, a curious twist,
Which, circumvolving gently there
Enthrall'd her Arme, as Prisoner.

Also worth noting is that here, for the first time since classical antiquity, the forearms are bare.

The beautiful costume and elegance of Henrietta Maria's portrait makes it fit to be placed alongside any image of the Queen by Van Dyck, the artist most associated with her. Although he preferred to paint her in white, with its connotations of neo-Platonic love and purity, there are other portraits where the Queen wears dresses of the intense but subtle colours also in fashion, such as can be seen in his painting of Henrietta Maria and her dwarf Jeffrey Hudson, which dates from about 1633 (*fig. 23.1*). Here her costume of blue satin, decorated with tiny, pinked cuts and gold braid (Van Dyck was as adept with patterns as with plain fabrics) comprises a doublet-style bodice and skirt. With the addition of what her accounts for 1635 refer to as 'a fine black beaver hatt' of the kind worn by men, the Queen is dressed for outdoors, probably about to go riding. Such masculine elements in feminine attire, especially when worn by the Queen, attracted adverse comment, particularly from Puritan moralists, that reflected the increasingly critical attitude towards the court in the country at large.

24 JOHN BELASYSE, BARON BELASYSE (1614–89)

Provincial painters are often better than more sophisticated artists in their recording of costume, even though their figures can be awkwardly posed and placed in oddly perspectived interiors. There is a naive charm about Jackson's masterpiece, his portrait of Belasyse, painted in 1636, possibly to commemorate the sitter's marriage of that year – a portrait of his wife hangs in the background.

Belasyse was a Catholic and a Royalist, who fought for Charles I in the Civil War. His finery might indicate his political convictions, if we see (as W. C. Sellar and R. J. Yeatman stated in their comic masterpiece *1066 And All That*, 1930) cavaliers as 'Wrong but Wromantic', as distinct from Roundheads, characterised as 'Right but Repulsive'. The truth, as always, was more complicated, but popular conceptions of the Royalists – then and now – saw them as rather dashing, ultra-fashionable young men of the kind painted by Van Dyck and other court artists. Belasyse's red silk suit trimmed with silver lace is a good example of the relaxed and unstructured look of fashionable male costume of the 1630s, a style largely deriving from France. The breeches are long and tubular, trimmed with ribbon bows of silk gauze; the doublet is open from mid-chest, allowing a glimpse of the shirt, more of which is revealed by the open sleeve seams. A wide lace collar drapes over his shoulders, and the same lace, possibly English needlepoint, edges his cuffs and his boothose – socks with decorative borders turned down over the boots. (Needlepoint, or needle-lace, is lace made with a needle and thread on a parchment pattern.) Belasyse's boots are of light brown Spanish leather, lined with yellow silk, and with red soles and heels; his silver spurs are buckled on with butterfly-shaped leathers, which also help to protect the ankle from the stirrups.

Provincial artists did not, on the whole, select or filter costume as did more adept painters, but depicted everything they saw with equal emphasis, often in quirky detail. This can be useful to the dress historian, for a greater range of less usually depicted garments can sometimes be seen. For example the coat draped on a table in the background (*fig. 24.1*) matches Belasyse's doublet and breeches, and here we have in essence a three-piece suit, forerunner of the fashions of some thirty years later.

24.1
Detail of coat in *fig. 24*.

25 ARTHUR CAPEL, 1ST BARON CAPEL (1604–49) AND HIS FAMILY

This family portrait, clearly inspired by Van Dyck's first great royal group of 1632 but minus the courtly bravura, is a sympathetic study of the modest costume of the gentry class, in an identified setting – the formal garden of the Capels' home, Little Hadham in Hertfordshire.

Arthur Capel, raised to the peerage in 1641, was a Royalist general in the Civil War and was executed shortly after Charles I in 1649. He is shown wearing a black satin suit with collar and cuffs of English bobbin lace (see *fig. 25.1*) made by the twisting, plaiting and interweaving of threads attached to bobbins, and – somewhat unexpectedly – hose of an intense green. His black beaver hat lies on the table behind him. His eldest son Arthur clutches his own hat, similar in style (these hats, signifiers of incipient manhood, often look far too large for their young owners), against his pale

25
ARTHUR CAPEL, 1st Baron Capel and his family,
Cornelius Johnson, *c.*1639–40. Oil on canvas,
1600 x 2591mm (63 x 102")
National Portrait Gallery, London (NPG 4759)

25.1
Collar and cuffs
in linen bobbin
lace, English,
*c.*1635.
Victoria and
Albert Museum,
London

Noble woman of England

W. Hollar inu et fecit

Nobilis Mulier Anglicana

1

pink doublet. Until the age of about five when they were 'breeched', small boys wore frocks of the kind we see here; the baby Henry, seated on his mother's lap, has a coral teething ring on a ribbon round his waist – a traditional belief held that coral protected children from evil.

For women, the late 1630s and early 1640s was a period of relative simplicity in costume, and everyday dress consisted of bodice-and-skirt styles, particularly well depicted in Wenceslaus Hollar's beautifully detailed fashion etchings (*fig. 25.2*). Lady Capel wears a

blue silk bodice and matching skirt; the bodice has yellow ribbons laced over a stomacher and the neckline is covered by a lace-edged kerchief pinned with a small jewelled brooch at the neck. The two girls are identically dressed (sisters close in age often were) in yellow silk. The elder daughter, Mary, has flowers in her hair, and the younger, Elizabeth, has a basket of roses, one of which she holds out to her tiny brother. Flowers were a conventional attribute of youth and beauty, but here there may be specific reference to the family interest in horticulture.

25.2
'Noblewoman
of England'
Wenceslaus Hollar,
1643.
Etching from
Theatrum Mulierum,
95 x 63mm
(3¾ x 2½")

26 SIR THOMAS KILLIGREW (1612-83)

This is a comparatively rare portrait of what contemporaries called 'undress' – the kind of loose-fitting, comfortable clothing worn by a gentleman in his study. Killigrew had been a page in the household of Charles I (a portrait of the recently executed monarch hangs on the wall, and among the books is *Eikon Basilike*, the King's supposed spiritual autobiography).

The sitter was famed for his licentious wit, and he was a convivial companion of Charles II in exile; during the Interregnum he was the King's Resident in Venice, where this portrait was painted. After the restoration of the monarchy, Killigrew held court office as a Groom of the Bedchamber, but his prime interest was the theatre; he was a

26
SIR THOMAS
KILLIGREW
William Sheppard,
1650.
Oil on canvas,
1245 x 965mm
(49 x 38")
National Portrait
Gallery, London
(NPG 3795)

26.1
SIR THOMAS
KILLIGREW
and an unknown
man
Sir Anthony van
Dyck, 1638.
Oil on canvas,
1327 x 1435mm
(52¼ x 56½")
Royal Collection

prolific playwright (a pile of his plays can be seen in the portrait) and he built and managed the Theatre Royal in Drury Lane.

It is as a man of letters that we see him here, in a white satin 'vest' (a knee-length gown buttoning down the front) tied round the waist with a striped silk sash; the three-quarter-length sleeves have fur cuffs and the same fur lines his white satin nightcap. Round his left wrist is a black ribbon, to which is attached a *memento mori* (either a seal or a miniature); this may relate to the recent demise of Charles I or to the death, more distant in time, of his wife Cecilia in 1638. In an earlier portrait of Killigrew with

an unknown man by Van Dyck (*fig. 26.1*), we see a similar sign of mourning. A ring, possibly belonging to his dead wife, is threaded through a black ribbon on Killigrew's wrist, and a cross with her interlaced initials is pinned to his slashed black doublet. Although black was a fashionable colour (see *fig. 25*), as was plain linen for sleeve ruffles, Killigrew's outfit is also appropriate for mourning. The unknown man's doublet seam is open down the back, revealing the shirt; this is not a gesture towards the rending of clothes as a sign of grief, but an indication of the new fashion for elegant negligence in male costume.

27 THOMAS CHIFFINCH (1600–66)

Like the previous portrait, this is also an image of a man in royal service, first as a page to Charles I and then as a confidant to Charles II. At the Restoration he was appointed Keeper of the Privy Closet, the Pictures and the King's Jewels, a highly appropriate post given his interest in collecting 'precious treasures and curiosities', a popular antiquarian pastime in the period. Chiffinch is portrayed here with some of his 'treasures' – seals, miniatures, cameos, intaglios and coins – and he holds a page of a musical score in his right hand.

The almost disordered negligence of male clothing in the mid-seventeenth century is clearly visible here. The doublet is open from mid-chest and its short sleeves open down the front seam to display the billowing white linen of the shirt underneath. A black silk mantle draped asymmetrically over his right shoulder adds to the air of artistic 'undress', as does the shirt open at the neck minus collar or cravat. Although what we see here is real clothing, there is already a perceptible trend towards the portrayal of generalised costume and drapery, which features so prominently in the later seventeenth century.

More specific than the costume is Chiffinch's hair, painted falling in a frizzy bush to his shoulders. It may not be his own, for it was in the 1650s that the vogue for wigs began, a fashion lasting well over a hundred years. Long hair of any kind – whether the wearer's own or someone else's – attracted some hostility during the Interregnum, being linked to those with Royalist sympathies. A flavour of such criticism can be gained from the title of a contemporary tract, *The Loathsomnesse of Long Haire*, published in 1653 by Thomas Hall, a Puritan clergyman, in which 'these Periwigs of false-coloured haire which begin to be rife …' were singled out for attack.

27
THOMAS CHIFFINCH
Attributed to Jacob Huysmans, *c.*1655–60.
Oil on canvas, 1130 x 933mm (44½ x 36¾")
National Portrait Gallery, London (NPG 816)

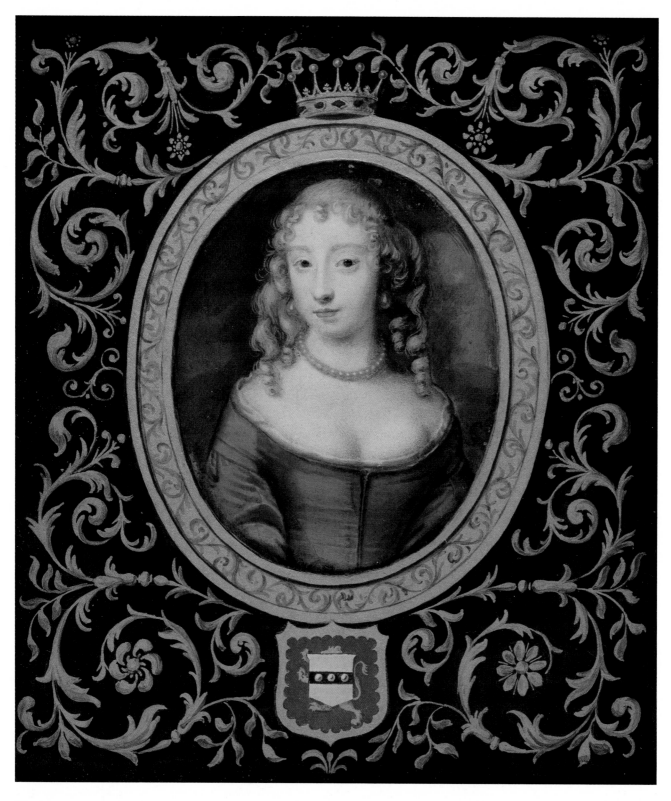

28
FRANCES JENNINGS, Duchess of Tyrconnel
Samuel Cooper, *c.*1665.
Miniature on vellum,
actual size 73 x 61mm (2⅞ x 2⅜")
National Portrait Gallery, London (NPG 5095)

28 FRANCES JENNINGS, DUCHESS OF TYRCONNEL (1647/9–1730)

'La belle Jennings', the far prettier elder sister of Sarah, Duchess of Marlborough (see *fig. 35.2*), first appeared at court, aged fifteen, as a Maid of Honour to Anne Hyde, Duchess of York. She was famed for her 'dazzlingly fair' complexion, her blonde hair and her perfect figure; to a modern eye she has something of the seductive shyness of Lady Diana Spencer (*fig. 97*).

The low-cut, tight-bodiced gown of the kind worn by the sitter had first appeared – paradoxically – in the 1650s during the Interregnum; Thomas Hall inveighed against the 'laying out of naked Breasts' as a 'temptation to Sinne' in his *Divers Reasons Against Painting, Spots, naked Backs, Breasts, Arms &c* (1654). It was a style, however, particularly associated with the beauties who flourished in the free and easy sexual climate of the court of Charles II. Such a costume was not only sexually appealing because the breasts were on display, unhidden by any lace, but

also – perhaps – because the wearer was a captive within the confines of a tightly boned bodice, the low-set sleeves restricting the movements of her arms. An extant garment of about the same period, a bodice of blue watered silk (*figs 28.1* and *28.2*) bears out the veracity of Cooper's depiction; it has a concealed front fastening and is well-boned, even in the upper sleeve – this was to keep the shape taut and to prevent the bodice falling too far off the shoulders.

The famous letter-writer Dorothy Osborne noted, apropos her portrait by Lely of 1653 (*fig. 29.1*), that 'There is a beauty in youth that everyone has once in their lives… ' Here we see Frances Jennings in the first flush of her beauty, dressed very cleverly in an unadorned dress of plain silk, her skin complemented by pearls at her ears and round her neck, and her fair hair arranged in curls over her forehead and falling in artful ringlets over her shoulders.

28.1
Front view of watered silk bodice, English, 1645–55. Museum of London

28.2
Back view of bodice in *fig. 28.1*.

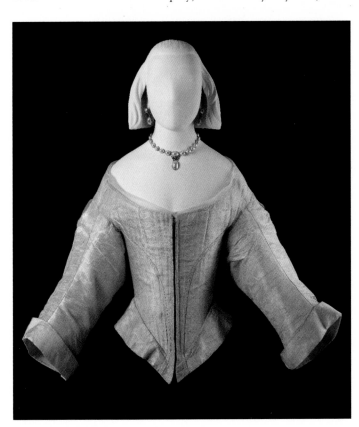

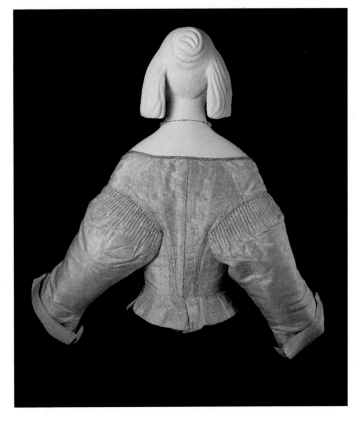

29 DOROTHY OSBORNE, LADY TEMPLE (1627-95)

Dorothy Osborne's claims to fame are the lively and entertaining letters addressed to her suitor, the diplomat and writer Sir William Temple, during their years of enforced separation (her family disapproved of him) until they were able to marry in 1655. Temple's diplomatic career eventually took them to The Hague, where he was instrumental in arranging the marriage between William of Orange and Mary Stuart in 1677.

Netscher's portrait depicts the sitter as a handsome woman, with no reference to the smallpox that pitted her face – a frequent hazard of the time. Her dress, worn over a voluminous white linen shift, is of brown

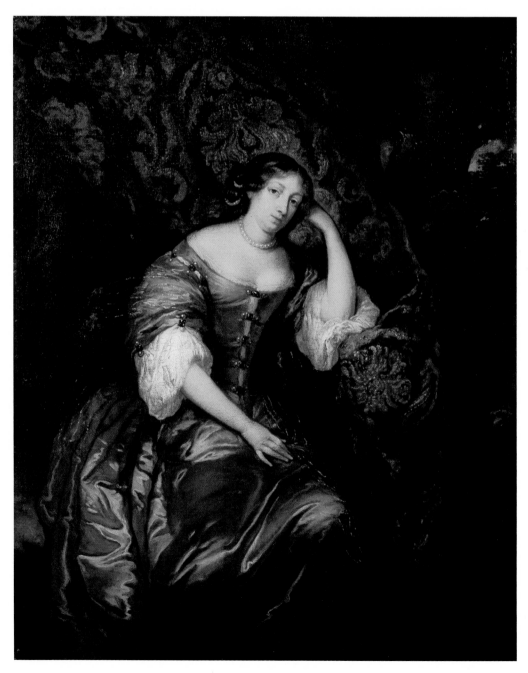

29
DOROTHY
OSBORNE,
Lady Temple
Gaspar Netscher,
1671.
Oil on canvas,
476 x 387mm
(18¾ x 15¼")
National Portrait
Gallery, London
(NPG 3813)

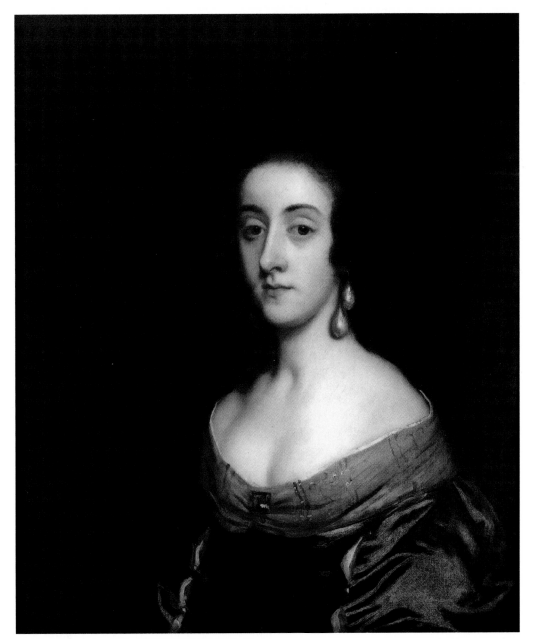

29.1
DOROTHY
OSBORNE,
Lady Temple
Sir Peter Lely,
1653.
Oil on canvas,
765 x 632mm
(30⅛ x 24⅞")
Private collection

satin, fastened with pearl and diamond clasps on bodice and sleeves; there are pearls entwined in her hair, a striped blue-and-gold scarf trails over her arms, and she sits, somewhat unconvincingly, against a backdrop of gold brocade.

Uninformative as the portrait is in terms of costume detail, it is very typical of its time; it follows the line of fashion, but it is an invented ensemble. However, the artist has at least given more specificity to the fabrics in this portrait than we see in Lely's image of the same sitter painted in 1653 (*fig. 29.1*), where she appears with a scarf arranged around the neckline as a kind of collar and improbably large (probably fake) pendant pearls in her ears. In a self-deprecatory letter to Sir William in 1653 on the subject of this portrait, Dorothy Osborne noted Lely's inability to capture a likeness, but commented that it was 'the best I shall ever have drawn of me... ' This may very well be true, but neither portrait does the sitter justice as one of the most attractive personalities of the period.

30
SIR ROBERT
VYNER and his
family,
John Michael
Wright, 1673.
Oil on canvas,
1448 x 1956mm
(57 x 77")
National Portrait
Gallery, London
(NPG 5668)

30 SIR ROBERT VYNER (d.1688)
AND HIS FAMILY

Compared to the generalised costume and
vague draperies of so much English painting
in the second half of the seventeenth century,
Wright's portraits provide welcome informa-
tion on the details of fashionable clothing.
Vyner was a banker and goldsmith, who
made the regalia for the coronation of
Charles II (he eventually went bankrupt as a
result of the Crown's failure to repay money
he had lent). When we look at this portrait,
which shows the family in the garden of
their house in Middlesex, we see an image
of relaxed and civilised prosperity. Vyner
himself dominates the canvas in his fashion-
able loose gown of Italian silk, worn over
a fine shirt trimmed with Milanese bobbin
lace and with small diamond-and-gold
brooches at neck and wrists. Even in
undress, however, the full-bottomed wig was
a necessary part of masculine appearance

among the élite. His son Charles is more formally dressed, in a short-sleeved coat of blue brocade and wide breeches (known as 'petticoat' breeches because they were very full and open-ended like a woman's skirt); his costume is fashionably trimmed with bunches of blue and yellow ribbons. As a contrast to this splendour – it is probably his first grown-up suit and he even wears a sword hanging from a handsome baldric trimmed with gold and silver fringe – his hair is casually arranged, falling naturally to his shoulders.

In 1665 Vyner married Mary Hyde, a wealthy widow, whose daughter Bridget stands by her mother in a dress of pale blue silk. Her status as a child is confirmed by her apron and the streamers falling from her shoulders; these long fabric pendants were partly an echo of old-fashioned hanging sleeves, and partly related to the leading strings worn by babies and young children to control their movements. They were retained in the costume of young girls – as a sign of dependence – until their mid-teens.

Lady Vyner's own dress is a clever mingling of the ornate – a stiffened gold brocade bodice and a skirt of striped coral silk – and the fashionably informal – a loose French overgown, called a *sacque*, of pale grey taffeta lined with blue; early in March 1669 Pepys refers in his *Diary* to his wife putting on 'her French gown called a Sac'. Lady Vyner's hair is tightly frizzed all over – perhaps aiming at an effect complementary to her husband's wig – with the exception of long ringlets (possibly false), which fall over her shoulders and draw attention to her décolletage and bare shoulders. As well as the ubiquitous pearls round her neck, she wears unusual earrings of gold and silver filigree, rather Spanish in style; perhaps they were commissioned by the husband as a gift to his wife.

31 NELL GWYN (1650–87)

Nell Gwyn – Pepys called her a 'mighty pretty creature' – was a light comedy actress, among the first wave of women on the stage in England, who made her debut in 1665 at the Theatre Royal, Drury Lane. Shortly afterwards she took on a more famous role, that of mistress to Charles II. Most aptly in the eyes of contemporary moralists, who equated loose gowns with loose morals, she is portrayed here (there is some dispute about the identity of the sitter) in a 'loose-bodied', or completely unstructured, gown, of yellow satin; her white linen shift spills over at the low neckline of the dress and surges out from under the short sleeves. This kind of generalised costume, based on the fashionable 'dishabill' (*déshabillé* – this is a period when many French words for modes and manners began to enter the English language) features prominently in Lely's portraits, leading to a somewhat depressing uniformity of image.

31
NELL GWYN
Studio of Sir
Peter Lely,
c.1675.
Oil on canvas,
1270 x 1016mm
(50 x 40")
National Portrait
Gallery, London
(NPG 3976)

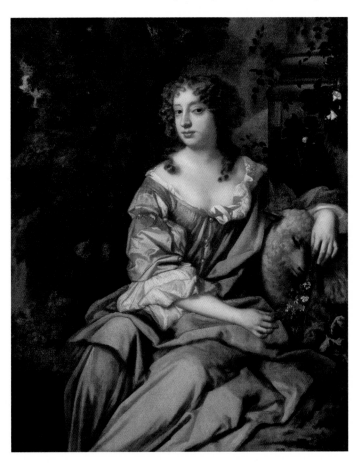

31.1
NELL GWYN
Simon Verelst,
c.1680.
Oil on canvas,
737 x 632mm
(29 x 24⅞")
National Portrait
Gallery, London
(NPG 2496)

However, the basic female undergarment, the linen shift, is usually depicted accurately, for this item of dress, closest to the body, had the greatest erotic potential of the whole female wardrobe.

In a later portrait of Nell Gwyn by Verelst (*fig. 31.1*) the shift alone is worn; the fabric is gathered in a drawstring round the neckline, looped up on one shoulder and open down the centre front, allowing one nipple to be seen. It is clearly an image in a direct line from those of Renaissance courtesans who are depicted in nothing more than a little jewellery and shifts that glide off their shoulders. This portrait in particular was to be 'read' as an image of woman as desirable object; even the hectic red of the rouged cheeks mimics sexual ardour.

It was no wonder that so much flesh on display prompted attacks from such critics as the *littérateur* Abbé Boileau (1636–1711) whose 1675 treatise on the subject was translated into English in 1678 under the title *A Just and Seasonable Reprehension of naked Breasts and Shoulders*. Breasts were the prime erogenous zone of the period, whitened and softened with various cosmetic washes, brushed with powder made from seed pearls – the nipples of court beauties were sometimes even painted pink with a mixture of cochineal and egg white.

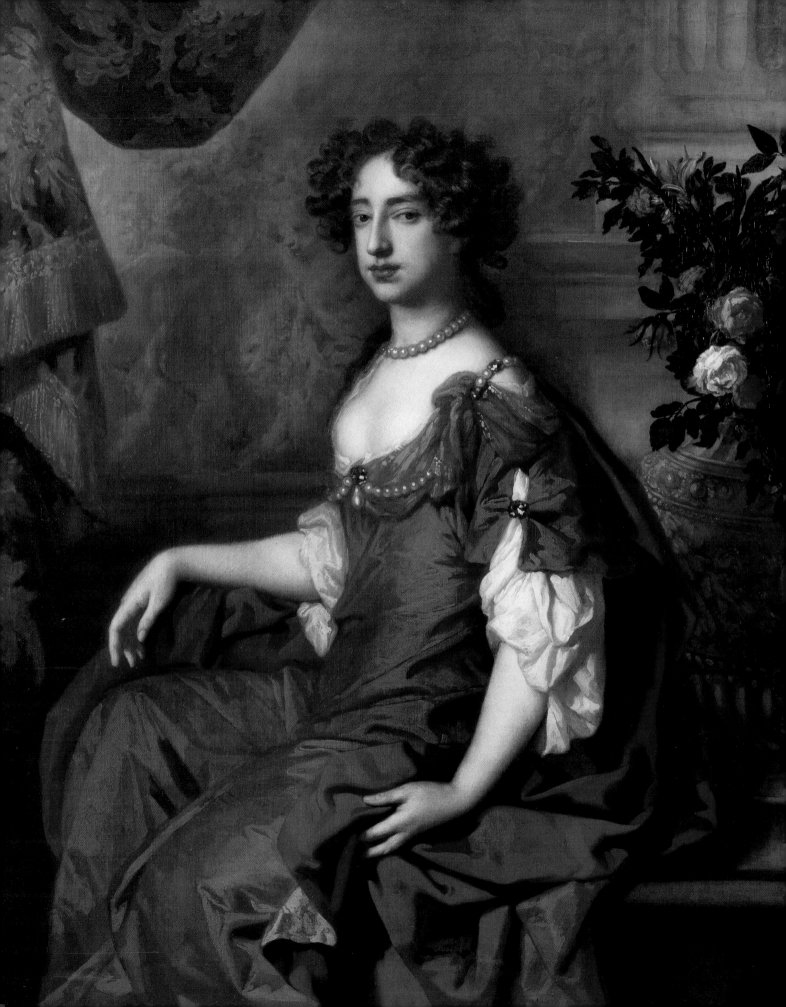

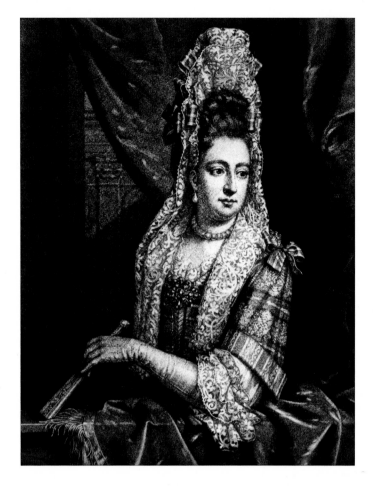

32 MARY II (1662-94)

This portrait was painted to commemorate the marriage, in November 1677, of William of Orange and Mary Stuart, the tall, statuesque daughter of James II and Anne Hyde. Like so much costume of its kind, Mary's dress is a fiction based on the loose, informal gowns (with the implied presence of stays beneath) in vogue; it is little more than a piece of orange-red drapery pinned together with a few jewels. Only her hairstyle – bunches of curls described by the French noblewoman Madame de Sévigné in one of her famous letters to her daughter as a 'coiffure hurlubrelu' – is real, although the pearls round her neck may be those given to his bride by William of Orange on their marriage. The rich, luminous simplicity of pearls was the perfect accessory to every kind of female costume, real or imaginary.

If we wish to see portraits of Mary as a woman of fashion, it is necessary to turn away from Lely, and look at the work of less well-known artists; for example an engraving by John Smith, made shortly after Mary became Queen (*fig. 32.1*). Here she appears in a mantua, the formal gown of the period, made of striped and figured silk, with short sleeves (here at least the portrait by Lely unconsciously follows the fashion), which are trimmed with ribbon bows on the shoulders. A large diamond brooch is pinned to the

stomacher of her dress; Mary owned a number of diamond brooches, equal favourites with pearls in the jewel caskets of fashionable women.

Literally the most prominent part of Mary's costume in the later portrait is the towering headdress called a *frelange*. This consists of a cap (largely hidden) to which layers of lace (here *point de France*, a fine French needle-lace, which Mary introduced into England in 1688) are attached, including the long lappets or streamers falling over the shoulders. Behind the lace are ribbon bows, the highest one known as the *fontange*. This elaborate confection (including the high-piled hair) was held up by a wire frame that was known as a *commode*; by the mid-1690s, the word *commode* was the term applied to the whole headdress.

32
MARY II
Sir Peter Lely,
1677.
Oil on canvas,
1254 x 1099mm
(49¼ x 40")
National Portrait
Gallery, London
(NPG 6214)

32.1
MARY II
John Smith after
Jan van der
Vaart, *c*.1690.
Mezzotint,
336 x 254mm
(13¼ x 10")

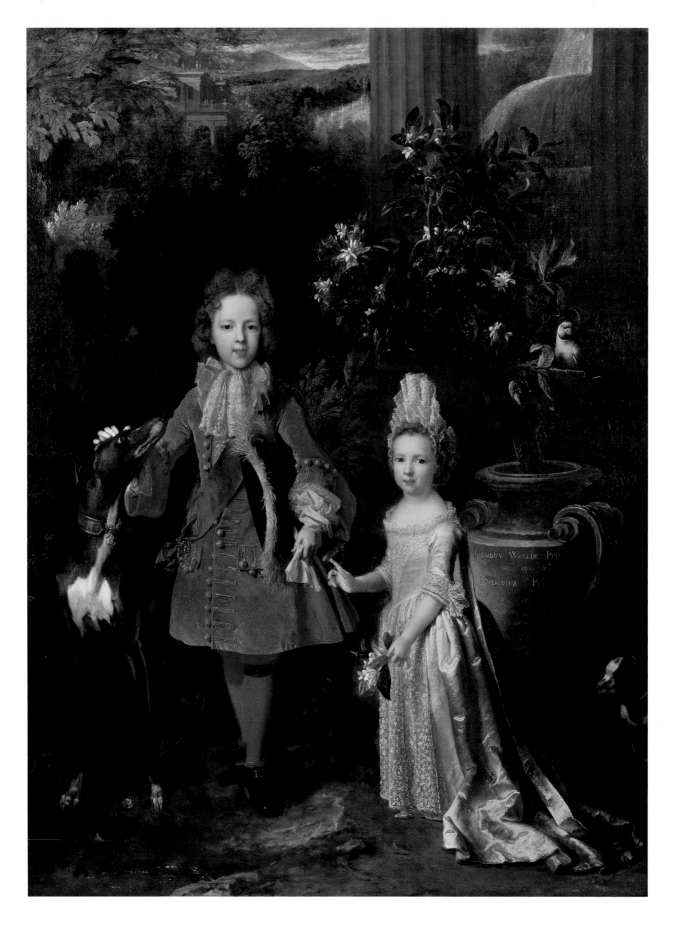

33 PRINCE JAMES FRANCIS EDWARD STUART (1688–1766) AND HIS SISTER LOUISA MARIA THERESA (1692–1712)

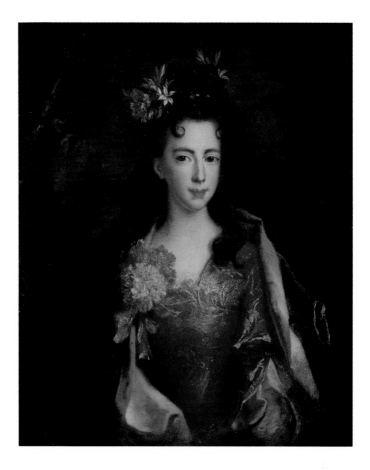

As befits a portrait of royal children in exile (after the revolution of 1688, James II and his family were given refuge in France), formality of pose and costume serves to underscore their status and their dynastic claims. The young Stuart prince (later to be known as the Old Pretender) wears a red velvet coat, with a gold brocade waistcoat, the cuffs of which turn over those of the coat. This coat, known as a *justaucorps* ('close to the body') is cut tight to the body, in the French style, the stiffened skirts flaring out over the hips. The Prince's rank and social position are underlined by insignia of the Order of the Garter, and by the formal pose he adopts – as taught by the dancing master – with one foot slightly in front of the other, and a plumed hat carried under the arm. We see that one kid-gloved hand holds the other glove; this motif is ultimately derived from Renaissance portraiture, as is the appearance of a large dog (here a grey-hound), which symbolises loyalty, a characteristic particularly appropriate in the political circumstances of the time. In close touch with the court at Versailles, the Prince's whole costume and demeanour are those of a miniature royal adult, from his curled wig and beribboned cravat, to his shoes of black leather with their red heels and diamond buckles.

The little Princess Louisa wears a costume that is a compromise between her age (she was three years old) and her rank. Her dress is of white satin, simple in style, with a back-fastening bodice, and long leading strings; white, the colour of innocence, is appropriate for a young girl, as is the orange blossom she holds, a symbol of virginity and traditionally carried by brides.

Her royal status is emphasised by the long train to her dress (implying the presence of attendants to wait on her) and the rich lace (*point de France*) of her apron. Matching lace trims her boned bodice and her *commode* headdress, which follows the fashionable adult style.

Some ten years later Princess Louisa was painted by an unknown French artist (*fig. 33.1*) in a fanciful dress of brocaded gold satin. Her hair is piled modishly high, two curls forming inverted commas on her forehead, and decorated with jasmine and carnations; a bunch of carnations is tied with a gold ribbon on her right shoulder. Carnations were admired for their smell and colour; they were traditionally linked with love and betrothal, a promise unfulfilled here, for the Princess, who inherited the Stuart grace and charm, died unmarried, of smallpox, in 1712.

33
PRINCE JAMES
FRANCIS
EDWARD
STUART
and his sister
LOUISA MARIA
THERESA
Nicolas de
Largillière, 1695.
Oil on canvas,
1928 x 1457mm
(75⅞ x 57⅜")
National Portrait
Gallery, London
(NPG 976)

33.1
PRINCESS
LOUISA MARIA
THERESA
STUART
Unknown artist,
c.1702–6.
Oil on canvas,
753 x 625 mm
(28⅝ x 24⅜")
National Portrait
Gallery,
Beningbrough
Hall, Yorkshire
(NPG 1658)

34 JOHN DRYDEN (1631–1700)

By the end of the seventeenth century it had become a well-established (even hackneyed) convention for artists, men of letters and musicians to be painted in loose gowns. These could be draped around the body in vaguely 'classical' folds, thus avoiding the necessity for depicting in detail contemporary fashion, which supposedly rendered a portrait the reverse of 'timeless'. Such gowns were the usual working costume of writers and scholars, so it is appropriate that Dryden (poet and author of heroic verse plays) should be shown in this instance dressed in a gown of yellow-lined blue silk. Fashion, however, does make an appearance here, for he wears rather stylish indoor footwear (blue silk mules with red heels and gold fringe, similar to those in *fig. 34.1*), and the periwig (from the French word for wig, *peruke*), which was *de rigueur* even when the sitter was informally dressed.

An alternative to Dryden's loose gown was a slightly more fitted garment, fastened with buttons or decorative clasps down the centre front, and called a vest; an example can be

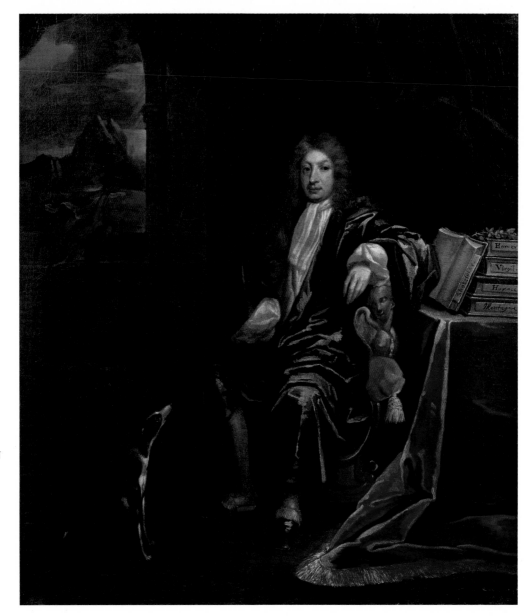

34
JOHN DRYDEN
James Maubert,
1695.
Oil on canvas,
572 x 502mm
(22½ x 19¾")
National Portrait
Gallery,
Beningbrough
Hall, Yorkshire
(NPG 1133)

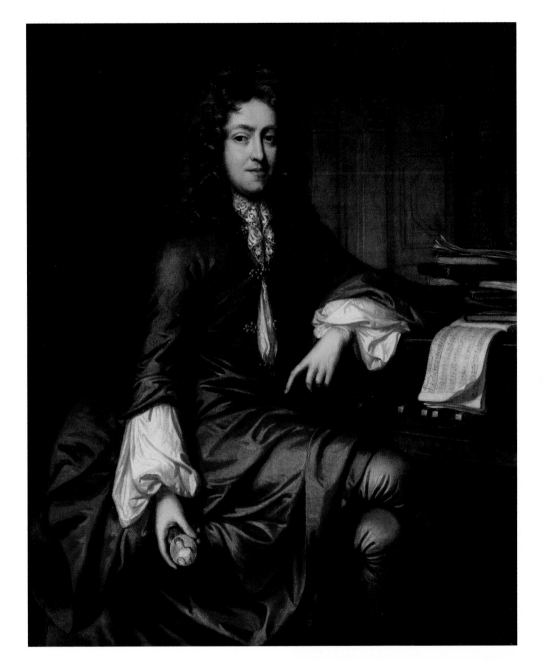

34.2
UNKNOWN
MAN
Attributed to
John Closterman,
1690s.
Oil on canvas,
559 x 470mm
(22 x 18½")
National Portrait
Gallery, London
(NPG 1463)

34.1
Man's velvet
and leather mule,
late seventeenth
century.
Length 245mm
(9⅝").
Ashmolean
Museum, Oxford

seen in the portrait of Thomas Killigrew
(*fig. 26*). A number of artists turned this vest
into a fanciful, invented garment which was
intended to look Roman; as the periwig added
decorum to the individual, so the vest gave
him a kind of classical dignity. The playwright
Richard Flecknoe referred to it as a 'civil vest',
and in the preface to his 1661 tragicomedy
Erminia he described it as 'wide-sleev'd and
loosely flowing to the knees'. This is what we
see in a portrait of the late 1690s attributed
to John Closterman (*fig. 34.2*) of an unknown
composer, once thought to be Daniel Purcell.

35 ELEANOR JAMES (fl.1685–1715)

35.1
Fashion plate,
French, *c*.1700.
Engraving,
246 x 174mm
(19¹¹⁄₁₆ x 6¹³⁄₁₆")
Victoria and
Albert Museum,
London

In a period dominated by portraits of élite women in modish *déshabillé*, it is rare to come across an image of a fashionably dressed middle-class woman, and particularly one of such independent spirit. Eleanor James, a redoubtable and strong-minded woman, ran her husband's printing firm in London, publishing pamphlets on political and religious subjects. The book open on the table refers to one of her most famous tracts, *Vindication of the Church of England* (1687), which provoked a satirical address from the Poet Laureate (and Catholic) John Dryden, and for which she was imprisoned in Newgate by the Catholic James II.

Eleanor James's costume is a modest interpretation of the rich and convoluted fashions emanating from France (*fig. 35.1*); as in this fashion plate, she wears the high *commode* headdress and a mantua but not the elaborately decorated petticoat in vogue

35.2
SARAH
CHURCHILL,
Duchess of
Marlborough
(1660–1744)
After Sir
Godfrey Kneller,
c.1702.
Oil on canvas,
1054 x 889mm
(41½ x 35")
National Portrait
Gallery, London
(NPG 3634)

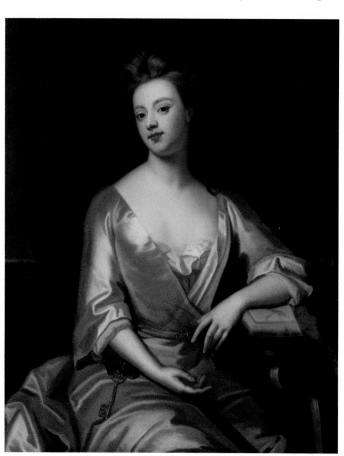

in high society. Her mantua is of golden-brown damask, worn with a matching petticoat (skirt), and laced over a yellow stomacher; the impressive *commode* is of fine French lace, with wide lappets falling over her shoulders. This kind of headdress reached its maximum height in the late 1690s, causing Joseph Addison to comment in the *Spectator* (22 June 1711): 'About Ten Years ago it shot up to a very great height … I remember several Ladies who were once very near seven Foot high.' He marvelled at such 'Female Architects who raise such wonderful Structures out of Ribbons, Lace and Wire'.

The detail of Eleanor James's dress is a rare contrast to the simplified styles and plain fabrics seen in so many contemporary portrait images, such as that of Sarah Churchill, Duchess of Marlborough, of about 1702 (*fig. 35.2*), in her satin dress with cross-over front (possibly a generalised version of real fashion), and unadorned hair. The key at her waist refers to her post from 1702 as Keeper of the Privy Purse (she was also Mistress of the Robes) to Queen Anne, whom the Duchess referred to in their correspondence as 'Mrs Morley' – she herself was 'Mrs Freeman'.

35
ELEANOR
JAMES
Unknown artist,
c.1695.
Oil on canvas,
1268 x 1035mm
(49⅞ x 40¼)
National Portrait
Gallery
Gawthorp Hall,
Lancashire
(NPG 5592)

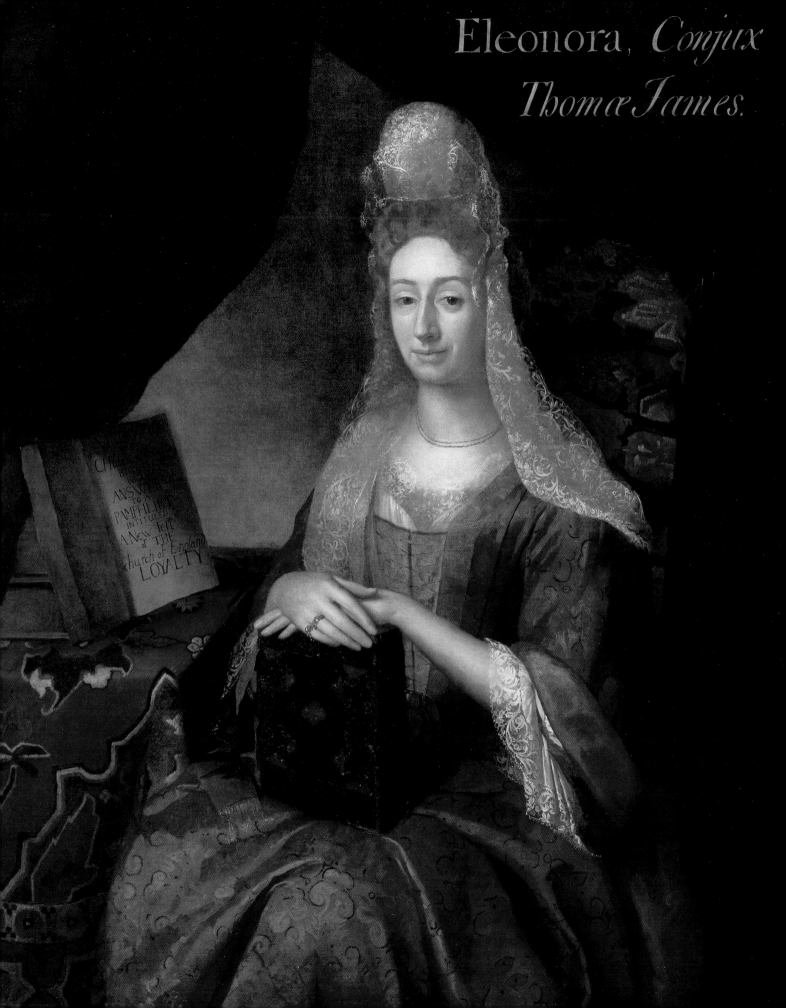

Eleonora, *Conjux*
Thomæ James.

Within the image:
CHURCH BELL
ANSWER TO A
PAMPHLET
INTITULED
A New Test of THE
Church of England
LOYALTY

THE EIGHTEENTH CENTURY

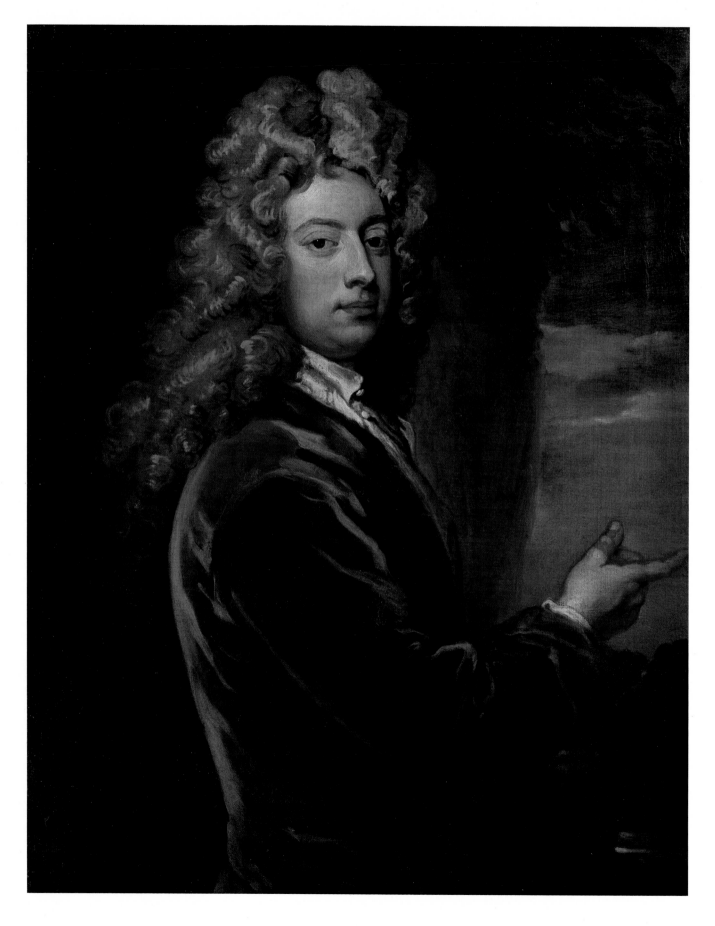

36 WILLIAM CONGREVE (1670–1729)

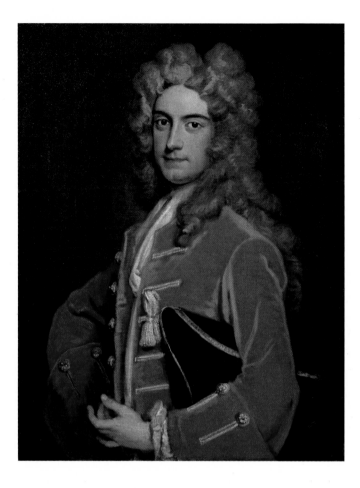

Although in his play *Love for Love* (1695), Congreve praised Kneller's ability to paint lifelike portraits, to a modern eye there can seem more uniformity than individuality in the artist's work, both in his strangely proportioned images of fashionable women with their heavy, costive faces and loose draperies, and his Kit-cat Club portraits of 'Whigs in wigs', two examples of which are illustrated here. The Kit-cat Club was an informal grouping of influential men – politicians, artists, writers and scholars – who had supported the Protestant succession and the 1688 Revolution. They met at Christopher Cat's tavern near Temple Bar in London, and included Kneller and Congreve, who held a number of government sinecures after his career as a playwright had ended.

Congreve is shown, in typical Kneller style, wearing an informal costume, a plain coat of murrey-coloured velvet over an open-necked shirt. As with the majority of Kit-cat Club portraits, the wig is the prevailing feature; here it is a large greyish-blonde periwig. The wig was such a dominant feature of male appearance – men of fashion are described in Congreve's last play *The Way of the World* (1700) as being 'beperiwigged' – that it comes as no surprise to find that there are more references to wigs than to any other item of clothing in the playwright's comedies of manners. The wig – an expensive arrangement of curled or frizzed hair (according to the French encyclopaedist Denis Diderot the best – strongest – hair came from beer-drinking countries) sewn onto a net cap – reached its maximum height and size towards the end of the first decade of the eighteenth century.

By the time that Kneller painted Richard Lumley, Earl of Scarborough, in 1717 (*fig.*

36.1), the wig had begun to be slightly reduced in size. Lumley, Master of the Horse to George II, wears a red velvet coat with silver buttons and has pulled his fringed cravat through one of his overlarge decorative buttonholes. This way of arranging the cravat was known as *à la steinkirk* after the Battle of Steinkerque (1692), when some French army officers, surprised by the enemy (soldiers of the Anglo-Dutch army) and with no time to tie their cravats, tucked the long ends through the buttonholes of their coats to keep them out of the way. Congreve refers to the popularity of the steinkirk cravat in *Love for Love*, and he himself is depicted thus attired in a portrait from the studio of Kneller of about 1709 (NPG 67). It became a popular fashion (even women adopted the style), and lasted well into the eighteenth century.

36
WILLIAM
CONGREVE
Sir Godfrey
Kneller, 1709.
Oil on canvas,
914 x 711mm
(36 x 28")
National Portrait
Gallery, London
(NPG 3199)

36.1
RICHARD
LUMLEY,
2nd Earl of
Scarborough
(1688?–1740)
Sir Godfrey
Kneller, 1717.
Oil on canvas,
914 x 711mm
(36 x 28")
National Portrait
Gallery,
Beningbrough
Hall, Yorkshire
(NPG 3222)

37 JAMES CRAGGS THE ELDER (1657–1721)

Politician, administrator and speculator (he was one of the promoters of the South Sea Company which crashed spectacularly in 1720), Craggs, who was a man of humble birth, is portrayed striking a genteel pose, hand on hip, and in rich and stylish costume. He wears a large, powdered periwig, the curls tight on top and loosening over the shoulders, a fringed linen cravat (the cuffs of his shirt sleeves are also finely fringed), a brown velvet coat and a sumptuous gold and silver waistcoat – the waistcoat was increasingly the focal point of male costume.

The design of Craggs's waistcoat – a large woven pattern repeat with curving, fantastic shapes – is one of the so-called 'bizarre' styles, which appeared in silks from the 1690s to about 1710. These designs, often with strange and exotic elements, represent both a love of experimentation and a taste for orientalism which had become an inspiration for many art forms by the late seventeenth century. They may have been influenced by the popular Indian chintzes (painted or printed cottons) that were being imported into Europe and acted as a spur to the development of the domestic cotton industries, notably those of England and France, in the eighteenth century.

37
JAMES
CRAGGS
THE ELDER
Attributed to
John Closterman,
c.1710.
Oil on canvas,
1270 x 1016mm
(50 x 40")
National Portrait
Gallery, London
(NPG 1733)

38 JOSEPH COLLET (1673–1725)

While in Madras (he was Governor there from 1717 to 1725), Collet had this statuette made by a Chinese artist from Amoy (a port in the south of the Fujian province of China frequented by European traders). It was a popular practice for Europeans in the East to commission such images of themselves; the diarist William Hickey, in Canton in 1769, visited 'a China man who took excellent likenesses in clay which he afterwards coloured'.

In a letter to his daughter in 1716, Collet described how the artist created: 'a sort of Picture or Image of my Self. The lineaments and the Features are Esteem'd very just, but the complexion is not quite so well hit; the proportion of my body and my habit is very exact.' Collet's 'habit' consists of a red coat embroidered in gold, buttoning from neck to hem, a flowered waistcoat and matching knee-breeches. The coat may be of silk, or of the woollen cloth that English merchants

38
JOSEPH
COLLET
Amoy Chinqua,
1716.
Painted plaster
statuette, height
838mm (33")
National Portrait
Gallery, London
(NPG 4005)

38.1
Back view of
fig. 38.

38.3
Detail of
pocket flap of
waistcoat in
fig. 38.4.

tried – largely unsuccessfully – to sell to China in return for silk, tea and porcelain. The waistcoat and breeches are probably of English silk; the pattern can be compared to contemporary designs for the flourishing Spitalfields silk industry in London (*fig. 38.2* is a pattern of about 1717 by James Leman, a well-known silk designer), and to surviving garments such as a silk waistcoat of about 1718–22 (*figs 38.3* and *38.4*).

Chinqua has taken great pains in the depiction of such details as the gold-braided hat carried under the arm, the fine pleats of the linen shirt and the metal studs and leather stitches on the heavy square-toed shoes. One of the advantages of this kind of three-dimensional art is that we can see all round the figure; note, for example, how the full-bottomed periwig looks at the back (*fig. 38.1*).

38.4
Sleeved waistcoat
of figured silk
with buttons
and buttonholes
embroidered in
metal thread,
1718–22.
Museum of
London

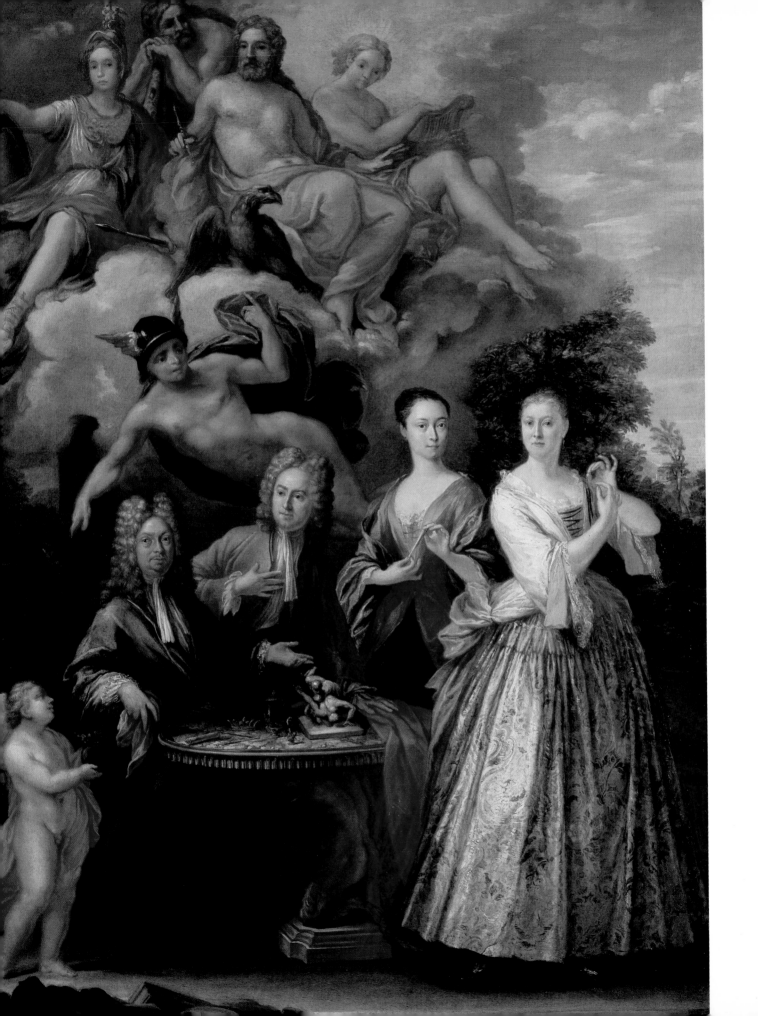

39 WILLIAM TALMAN (1650–1719)
AND HIS FAMILY

39
WILLIAM
TALMAN
and his family,
Giuseppe Grisoni,
c.1719.
Oil on canvas,
1024 x 724mm
(40⅜ x 28½")
National Portrait
Gallery,
Beningbrough
Hall, Yorkshire
(NPG 5781)

William Talman is portrayed with his family against an allegorical background that was probably intended to represent the gods' blessing on the marriage of his son John to Frances Cockayne in 1718. A full-bottomed periwig frames Talman's pop-eyed and choleric visage, that of a man conscious of his status and achievements – a famous architect (the dividers on the table allude to his profession), he had been Comptroller of the King's Works to William III. The loose gown (Talman's is blue lined with white, a

39.1
Panel of
brocaded silk
damask, English,
1707–8.
Museum of
London

39.3
Man's silk
damask dressing
gown, *c.*1720.
Museum of
Costume, Bath

39.2
MATTHEW
PRIOR
(1664–1721)
Thomas Hudson
after Jonathan
Richardson,
*c.*1718.
Oil on canvas,
1016 x 864mm
(40 x 34")
National Portrait
Gallery,
Beningbrough Hall,
Yorkshire
(NPG 562)

pink silk sash wound round the waist) continued to be the preserve of professional practitioners of the arts and sciences, but some younger men by this time chose to replace the heavy and cumbersome wig with a soft cap worn over a shaven head. In the portrait of Matthew Prior (*fig. 39.2*), the poet, diplomat and picture collector wears a black velvet cap trimmed with a red silk tassel; his red silk damask gown is lightly padded for extra warmth. A similar padded gown of dark pink silk damask, dating from about 1720, is also illustrated (*fig. 39.3*).

It is interesting to note that William Talman's wife, Hannah, occupies the greatest amount of space. Her white mantua lined with gold (the bustle effect of the back drapery can clearly be seen), reveals a beautiful petticoat of flowered silk, worn over a hoop. The design of the petticoat is similar to a surviving dress panel of white silk damask brocaded with semi-naturalistic flowers (*fig. 39.1*).

Next to Hannah Talman stands her daughter-in-law Frances, in a rather subdued cross-over gown of plain red silk lined with blue, worn over a dark red skirt. John Talman, who was a connoisseur of the arts (he invited Grisoni to England) and the first Director of the newly formed Society of Antiquaries, stands deferentially next to his father in a more up-to-date, shorter version of the full-bottomed wig.

40 CATHERINE DOUGLAS, DUCHESS OF QUEENSBERRY (1700–77)

A famous beauty (the poet Matthew Prior celebrated her as 'Kitty beautiful and pretty'), her wit and repartee ensured her a place in the letters and diaries of her time; even her death (reputedly from a surfeit of cherries) was commented on as typically eccentric.

In a literary and artistic climate when Arcadian themes were in vogue (even gardens were thus landscaped), the Duchess is depicted enjoying a rustic idyll, with real milkmaids milking cows in the background. She is careful not to dress as a milkmaid or a shepherdess herself, but wears simple yet stylish costume suitable to the pastoral mood. Her pale brown silk dress is plain and front-fastening, worn over a modest

40
CATHERINE DOUGLAS, Duchess of Queensberry
Attributed to Charles Jervas, *c*.1725–30.
Oil on canvas, 1270 x 1010mm (50 x 39¾")
National Portrait Gallery, London (NPG 238)

40.1
CATHERINE
DOUGLAS,
Duchess of
Queensberry
Charles Jervas,
*c.*1725–30.
Pastel on
brown paper,
351 x 287mm
(13¹³⁄₁₆ x 11⁵⁄₁₆")
Courtauld
Institute
Galleries, London

40.2
Plates from
Bernard Lens,
*The Exact Dress of
the Head*, 1725.
Ink and wash.
Victoria and
Albert Museum,
London

hoop; an apron of fine linen or silk gauze is tied round her waist – an aristocratic affectation of the functional aprons of sturdier fabrics worn by working women.

With the notion that simplicity in attire is the best foil to a pretty woman (beauty is, in the words of the early seventeenth-century philosopher Francis Bacon, 'like a rich stone, best plain sett'), the Duchess has chosen a headdress complementary to her dress, a plain linen cap with the lappets pinned up at the sides (see also *fig. 40.1*, related to the portrait). From a contemporary collection of drawings by Bernard Lens (*fig. 40.2*), it is possible to see how such headdresses were arranged on the head; the cap held the hair gathered up into a bun, and the lappets were either pinned up or left to fall over the shoulders.

V. A. M.

V. A. M.

41 FREDERICK, PRINCE OF WALES (1707–51), AND HIS SISTERS

The setting for this informal group (sometimes known as '*The Music Party*') is the Dutch House at Kew, where Anne, Princess Royal (probably the one playing the harpsichord – the identities of the sisters have not been firmly established), lived before her marriage to Prince William of Orange in 1734.

'Anne' and her sisters – 'Caroline' plays the lute and 'Amelia' reads from Milton – are dressed with an almost bourgeoise sobriety; they wear morning costume, simple 'closed gowns', that is, made all-in-one with a front-fastening bodice, white linen kerchief round the neck and plain caps with lappets that either pin on top, fall to the shoulders or fasten under the chin.

In contrast to the modest *hausfrau* look adopted by his sisters, Frederick's more formal clothes proclaim his status as heir to the throne (he died before his father, but his son became George III). The Prince wears a red coat and waistcoat, black knee-breeches and the insignia of the Order of the Garter. The fashionable tye wig (the back hair tied back either in a knot or a ribbon) had by this time largely replaced the periwig which was increasingly limited to the elderly, the conservative and professional men such as physicians, clerics and lawyers – it exists today in the formal costume of High Court Judges and QCs.

41
FREDERICK, PRINCE OF WALES, and his sisters, Philip Mercier, 1733.
Oil on canvas, 451 x 578mm (17¾ x 22¾")
National Portrait Gallery, London (NPG 1556)

41.2
FREDERICK,
PRINCE OF
WALES
Philip Mercier,
*c.*1735–6.
Oil on canvas,
1238 x 1003mm
(48¾ x 39½")
National Portrait
Gallery,
Beningbrough Hall,
Yorkshire
(NPG 2501)

41.1
FREDERICK,
PRINCE OF
WALES
Jacopo Amigoni,
*c.*1735.
Oil on canvas,
1283 x 1064mm
(50½ x 41⅞")
Royal Collection

Unlike his father George II, Frederick was a connoisseur of the arts – perhaps the most accomplished prince in this respect since Charles I, claimed the antiquary and engraver George Vertue, who was employed by the Prince to catalogue the royal collections. Prince Frederick patronised a number of artists, both English and foreign, including the German-born Mercier and the Italian Jacopo Amigoni, whose delicate rococo portrait of the Prince of about 1735 (*fig. 41.1*) shows him with his hand resting on a copy of Alexander Pope's translation of Homer while two putti hold symbols of the arts and sciences.

In Amigoni's portrait the Prince wears a pinkish-red coat with gold frogged fastenings, a yellow waistcoat embroidered in gold, and his lightly powdered wig is tied back simply. A slightly later portrait by Mercier (*fig. 41.2*) shows him more formally dressed in a gold-embroidered red velvet coat over a court waistcoat trimmed with gold fringe; he wears the most formal wig of the period, a heavily powdered bag wig, where the back hair is tied back in a black silk bag. The grandeur of this costume is reinforced by the pose that Prince Frederick adopts, right hand holding a cane and left hand (three-cornered hat kept in place under the arm) inserted in the side opening of the coat, on the hilt of his sword.

42 PRINCE HENRY STUART, CARDINAL YORK (1725–1807)

The young Prince, brought up with his elder brother Charles Edward (Bonnie Prince Charlie) in Rome, was a beautiful child, serious, studious, over-pious and music-loving, with a highly developed taste for luxury and splendour in costume – a trait that his career as a prince of the Church served only to enhance.

The young Stuart princes were brought up in the European tradition, that is, with more attention paid to ceremony and rank than was the case in England. This formal image shows Prince Henry with his left hand pointing towards the horizon and his right hand inserted at mid-chest level under the waistcoat. This pose, along with the equally conventional stance of one foot slightly in advance of the other, would have been taught by the dancing master, whose brief in the eighteenth century included not just lessons in dancing but also in elegance of manners, gesture and deportment, and general civility.

As well as upholding the rank due to his birth, the young Prince's personal taste for formality and finery is reflected in his perfect poise, pride in the insignia of the Garter which he displays, his powdered wig (the long curls of which are tied back with black silk ribbon) and in the richness and formality of his clothes. The most prominent part of his costume is his coat – literally so, for the side skirts are heavily stiffened (lined with layers of coarse wool, horsehair or buckram), creating an almost theatrical air, heightened by his dramatic gesture and balletic stance. This coat is of a deep red velvet liberally decorated with silver lace, as is his blue satin waistcoat. Such silver lace, made of strips of real silver foil (*fig. 42.1*) created a sumptuous effect, especially when set against velvet; a costume like this, worn on formal occasions, would glitter in candlelight.

42
PRINCE HENRY STUART, Cardinal York Louis-Gabriel Blanchet, 1738. Oil on canvas, 1886 x 1403mm (74¼ x 55¼") National Portrait Gallery, London (NPG 5518)

42.1
Silver metal lace on red velvet, eighteenth century.
114mm at widest x 355mm long
(4½ x 14")
Courtauld Institute, London

43 BURKAT SHUDI (1702–73) AND HIS FAMILY

Of Swiss origin, Burkat Shudi was a leading
harpsichord maker; he is shown here with
his wife Catherine and his sons Joshua and
Burkat at their house in Great Pulteney
Street, London. His elder son, Joshua,
directs our attention to Shudi, who tunes a
harpsichord, wearing an elegant blue silk
morning gown lined with pink; his ease *chez
soi* is indicated by the fact that one of his
red leather indoors shoes has been trodden
down at the heel. A professional man of
middling status, Shudi does not wear the tye
or bag wig of high fashion, but a long bob
wig (the modest successor to the periwig),
which is curled at the sides and reaches
his shoulders.

Catherine Shudi's dress is a plain,
middle-class version of the *sacque*, still fairly
loose fitting and with short, wide sleeves; it
is lifted at the side to show her pink silk
petticoat – perhaps in conscious harmony

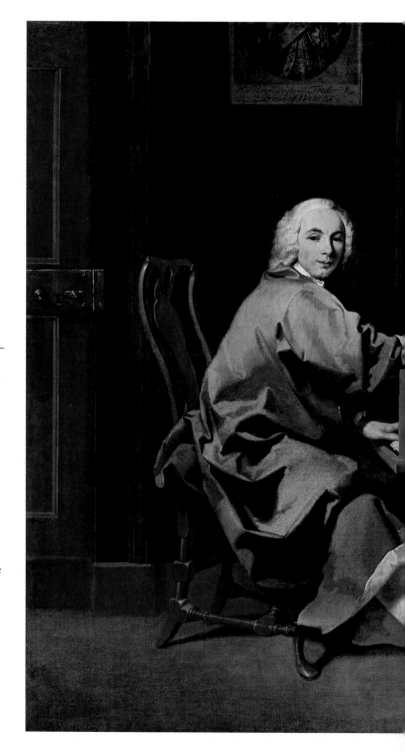

43
BURKAT SHUDI and his family,
Marcus Tuscher, *c.*1742. Oil on canvas,
834 x 1415mm (32¼ x 55¾")
National Portrait Gallery, London (NPG 5776)

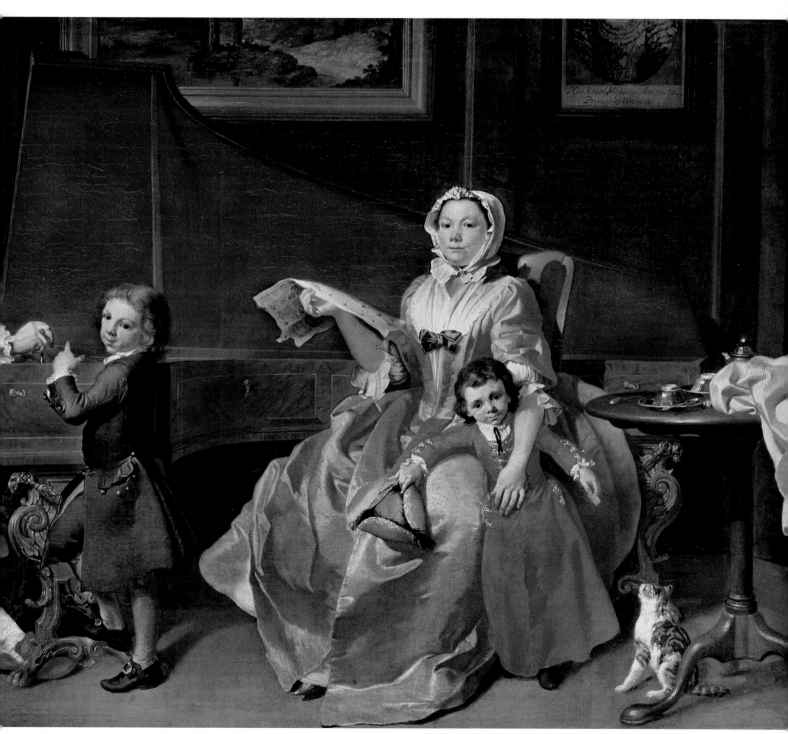

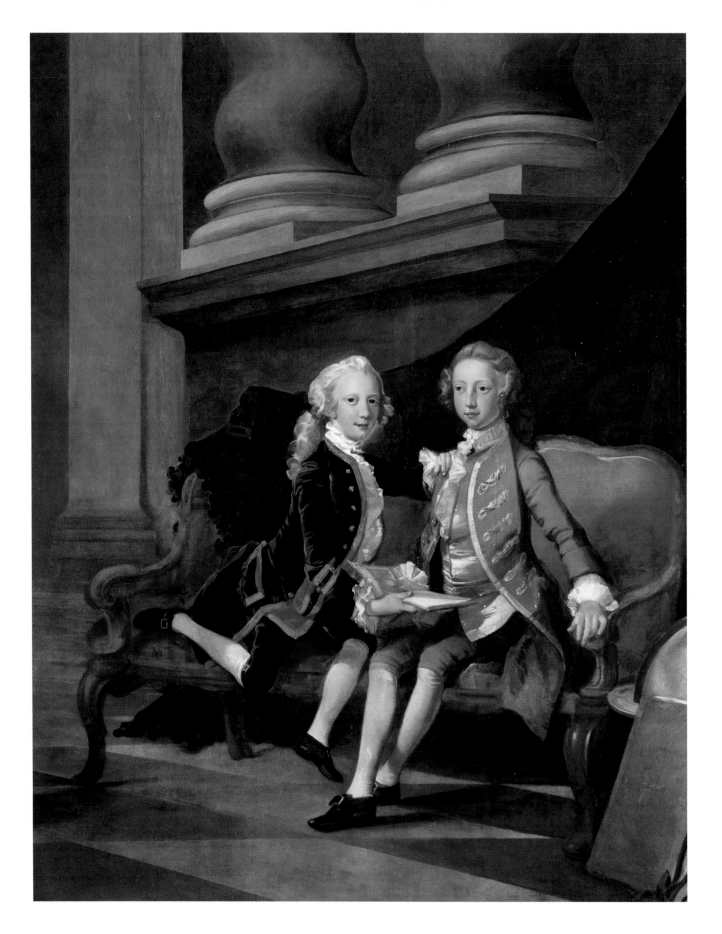

43.1
FRANCIS
AYSCOUGH
with PRINCE
GEORGE (later
George III;
1738–1820) and
PRINCE
EDWARD,
DUKE OF
YORK AND
ALBANY,
(1739–67)
Richard Wilson,
c.1749 (detail).
Oil on canvas,
2070 x 2578mm
(81½ x 101½")
National Portrait
Gallery,
Beningbrough
Hall, Yorkshire
(NPG 1165)

with the hem of her husband's gown which defies gravity by showing its pink lining. The informality of the family setting and notions of bourgeois propriety dictate her choice of accessories – a kerchief covering the low neckline of the dress and kept in place by a blue silk bow, and a white morning cap and hood tying under the chin.

The images of the two small boys show how even a slight difference in age is reflected in their clothing. The younger son, Burkat, born in 1737 (like his father, he became a harpsichord maker) still wears his baby clothes, a gown or long coat trimmed with gold loops; his hat – traditional symbol of masculinity – which he clutches in his right hand, is of pale brown beaver trimmed with black feathers.

In the middle of the eighteenth century, boys were breeched at about the age of five, being put into a simplified version of adult male costume; this often took the form of a plain coat with practical slit cuffs of the kind that Joshua Shudi (b.1736) wears. His frilled shirt collar was a distinctively English style (it turned into the open collar seen in Zoffany's *Sharp Family*, 1779–81, *fig. 52*). It was the custom for young boys to wear their own hair as it grew naturally. Richard Wilson's portrait of Prince George and Prince Edward (sons of Frederick, Prince of Wales) of about 1749 (*fig. 43.1*) depicts the young royal sitters wearing their own hair tied back with a ribbon. Prince George (the future George III) wears a grey silk suit trimmed with silver braid and a white satin waistcoat; Prince Edward (Duke of York and Albany) – his less elevated rank allows him to assume a livelier pose – is in blue velvet trimmed with gold. Instead of the usual adult male neckwear, the formal stock (a made-up neckcloth fastening at the back), the young princes have a black silk ribbon which ties at the neck and keeps the frilled shirt collar in place.

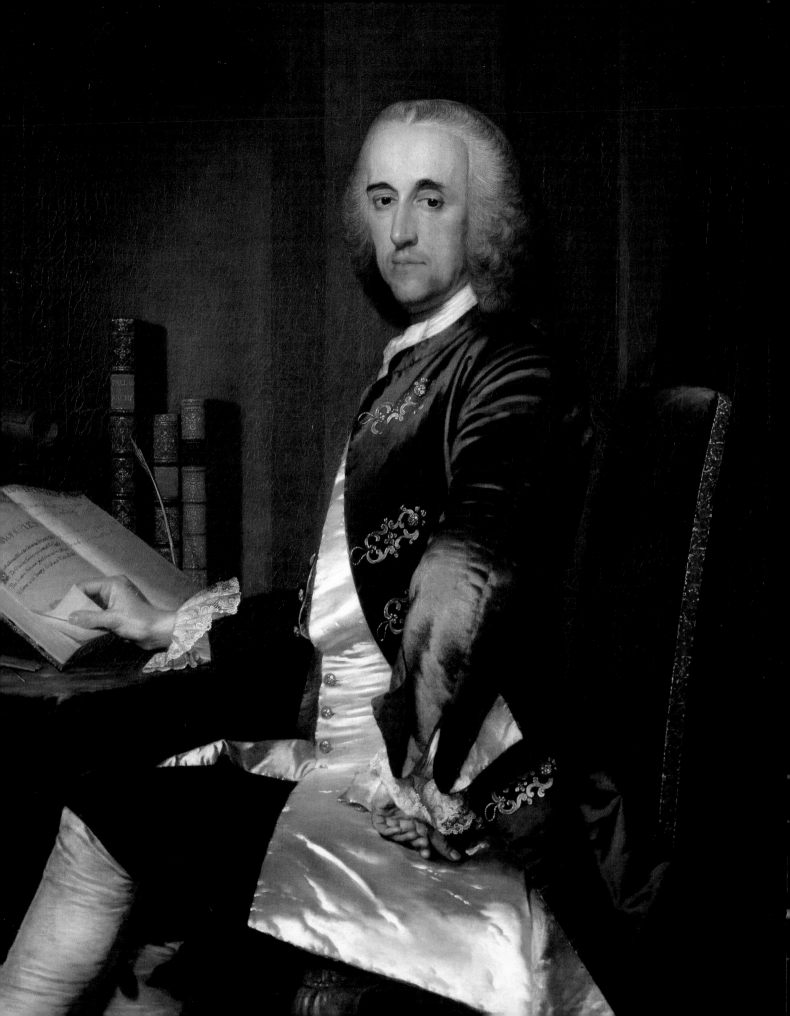

44 SIR THOMAS ROBINSON (1700?–77)

**44
SIR THOMAS
ROBINSON**
Frans van der
Mijn, 1750.
Oil on canvas,
1267 x 1019mm
(49⅞ x 40⅛")
National Portrait
Gallery,
Beningbrough
Hall, Yorkshire
(NPG 5275)

In the eighteenth century the pursuit of pleasure often went hand in hand with intellectual interests and informed connoisseurship. Sir Thomas Robinson, whose pose and costume indicate a man of refinement with a taste for luxury, was noted for his extravagant life-style; after an unsuccessful posting as Governor of Barbados (1742–7), he returned to England, where he helped to organise the entertainments – concerts and masquerades – held at Ranelagh Gardens in Chelsea, one of the great pleasure gardens of eighteenth-century London. Like many wealthy members of the élite, he was particularly knowledgeable about architecture; having made a study of Palladio's work in Italy, he rebuilt Rokeby, his house in Yorkshire.

Hand on hip, Robinson is painted wearing a stylish, informal ensemble. His coat is of blue satin lined with white, with the sleeve slit along the seam at the wrist and turned back to form a cuff; the effect is relaxed and unstructured without the stiffened side pleats of a more formal garment. His white satin waistcoat with its gold buttons is opened to the waist so that the fine lace on the shirt could be seen. Because of his pose, it is not possible to see what kind of lace it is, but it was customary for this to match that of the shirt ruffles – here they appear to be of Brussels. Very popular in the mid-eighteenth century were the fine bobbin laces of Flanders, such as Mechlin (*fig. 44.1*) and Brussels. As part of the informality of his appearance, Robinson's black velvet breeches are unfastened at the knee, giving greater ease when seated, but causing the white silk stockings to wrinkle, no longer being held taut by the breech buckle. By this time, men's knee-breeches were fastened under the knee and over the hose, whereas before – especially in formal costume (see *fig. 42*) – the stockings were often worn rolled up over the breeches.

44.1
Border of
Mechlin bobbin
lace, Flemish,
eighteenth
century.
Victoria and
Albert Museum,
London

45 MARGARET (PEG) WOFFINGTON (1714?–60)

Peg Woffington was a celebrated Irish comic actress, famed for her wit and charm (David Garrick, illustrated in *fig. 49*, was among her lovers); she was particularly noted for her Shakespearean roles. This is an unusual portrait of an actress, for she is shown neither in a theatrical role nor as a woman of fashion (as the century progressed, many actresses set styles that élite women copied), but dressed informally, out-of-doors and painted with a directness and intimacy that engages the spectator.

By the early 1750s the prevailing influence in French fashion, the rococo, had crossed the Channel and affected English costume; the *sacque* gown was the most famous example, but there were also accessories, such as the delicate hooded shoulder-length mantle of blue silk trimmed with lace

seen in this portrait. The hat, however, is English in style, a most insubstantial piece of silk decorated with blue ribbons; it is worn, as was customary, over an indoors cap of white linen edged with lace. Also English (and Irish) was the vogue for women to wear their hair simply styled, curling to the shoulders and unpowdered. Frenchwomen tended to have their hair powdered and tightly curled like the fleece of a sheep (a style called *tête de mouton*); this kind of hairdressing was less frequently seen in England, and then usually on more formal occasions, particularly later, in the 1760s.

Peg Woffington was stricken by palsy in 1757 and remained bedridden until her death. A portrait of her in her last years (NPG 650) by an unknown artist shows her in bed, only her head visible, and wearing a lace-edged cap tying under the chin; it is decorated with a blue ribbon, a defiant assertion, perhaps, of femininity and individuality in lamentable circumstances.

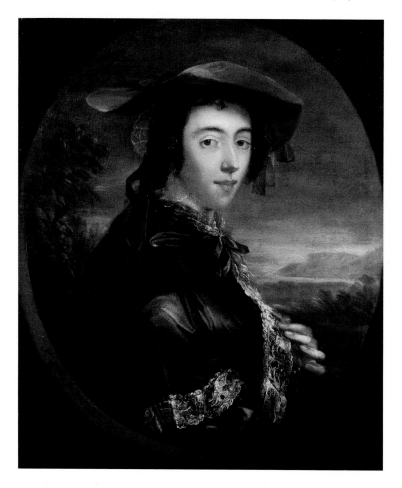

45
MARGARET (PEG)
WOFFINGTON
John Lewis, 1753.
Oil on canvas,
feigned oval,
760 x 633mm
(29⁷/₈ x 24⁷/₈")
National Portrait
Gallery, London
(NPG 5729)

46
ROBERT
WOOD
Allan Ramsay,
1755.
Oil on canvas,
991 x 749mm
(39 x 29½")
National Portrait
Gallery,
Beningbrough
Hall, Yorkshire
(NPG 4868)

46 ROBERT WOOD (1716–71)

Ramsay, with his French style, has captured the refinement as much as the intelligence of the sitter, a scholar and writer whose travels in Mesopotamia, Greece, Egypt and Syria resulted in the important and influential publications *The Ruins of Palmyra* (1753) and *The*

Ruins of Balbec (1757). In 1753 he accompanied the Duke of Bridgewater as his tutor on the Grand Tour, and this portrait was painted in Rome. On his return to England Wood entered politics, not altogether successfully – Horace Walpole, the dilettante and

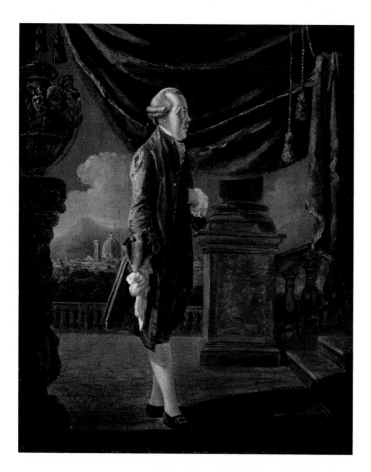

46.1

JOHN KER,
3rd Duke of
Roxburghe
(1740–1804)
Thomas Patch,
c.1761.
Oil on canvas,
654 x 521mm
(25¾ x 20½")
National Portrait
Gallery, London
(NPG 724)

46.2

FREDERICK
NORTH, 2nd
Earl of Guilford
(1732–92)
Pompeo Batoni,
1752–6.
Oil on canvas,
934 x 756mm
(36¾ x 29¾")
National Portrait
Gallery, London
(NPG 6180)

Duke of Roxburghe (*fig. 46.1*), painted in Florence in about 1761. The Duke was a well-known connoisseur and book collector; he also held various appointments in the royal household. It is as a courtier that we see him, standing in the conventional pose decreed by etiquette – a pose that showed off a well-turned leg as well as the fine lace of the shirt sleeve ruffle. His suit is of grey silk damask, cut in a slimmer line with less fullness in the skirts of the coat; his stockings are of white silk, and his black leather shoes are fastened with diamond buckles. In his right hand he holds a handkerchief.

Both Robert Wood and the Duke of Roxburghe wear the bag wigs appropriate to their formal costume, contrasting with the simpler clothes and hairstyle of Frederick North, 2nd Earl of Guilford, painted in Rome in the mid-1750s (*fig. 46.2*). North wears his own hair, albeit arranged in the style of a fashionable wig, with loose, horizontal side curls; the hair is tied back with a black ribbon, the ends of which tumble over his shirt front. The sitter, a high-rising politician (Prime Minister from 1770 to 1782), was renowned for his ugliness; Horace Walpole averred that his prominent eyes, thick lips, wide mouth and 'inflated visage' gave him 'the air of a blind trumpeter'. The artist Pompeo Batoni, adept at flattering his élite clientele, may have tried to mitigate the unprepossessing appearance of his sitter by painting him in fairly casual dress: an elegant sage-green frock coat with coral-coloured collar and cuffs, which he wears with a buff silk waistcoat, and brown knee-breeches. Here (a useful detail for the dress historian) the opening of the pocket in the outside seam of the breeches can clearly be seen.

gossipy letter writer, commented that his 'character was much higher in the literary than in the political world'.

In his portrait by Ramsay, Wood is formally dressed, *à la française*, in a matching coat and waistcoat of cinnamon-coloured silk with fine gold embroidery. His crisp white powdered wig complements the ordered luxury of his costume, being worn *en solitaire*, that is, with the black ribbon tying the bag of the wig brought round to the front, forming a contrast to the delicate French lace of the shirt ruffle.

Equally formal in dress and pose is another gentleman in Italy, Thomas Patch's slightly sardonic image of John Ker, 3rd

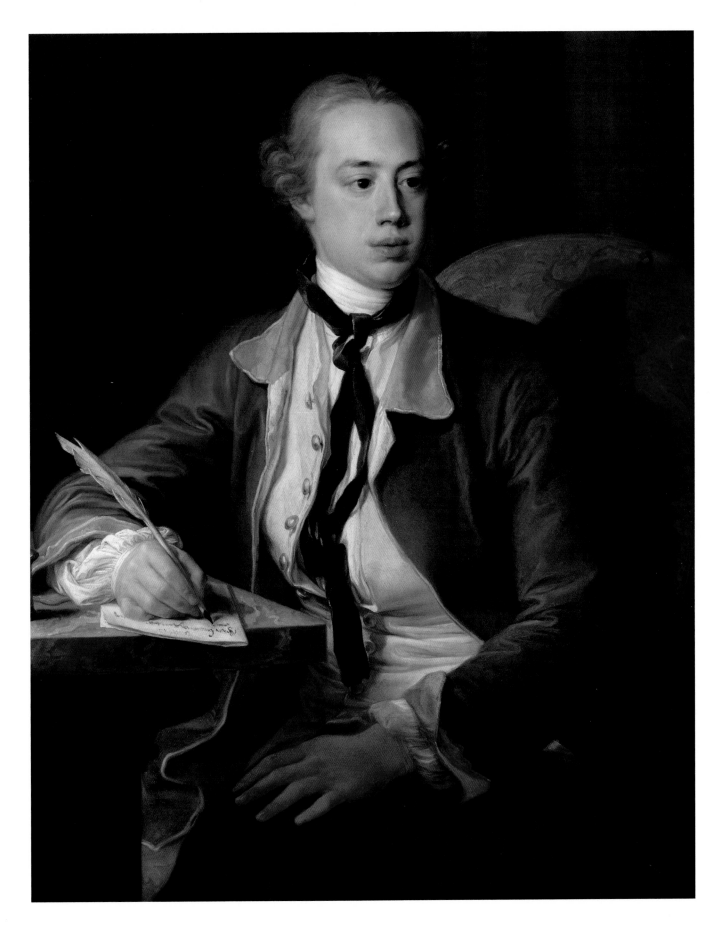

47 WARREN HASTINGS (1732–1818)

Warren Hastings joined the East India Company in 1750, and through his talents as a great administrator, transformed it into a military and naval power as well as an important political force. Most portraits of Hastings (and there are over sixty) show him later in his career, after his final return to England and the seven-year trial for corruption (1788–95) that nearly ruined him, even though he was acquitted. It is therefore something of a rarity to see the future Governor-General of India as a relatively young man, whose rather preoccupied look is emphasised by his thinning and slightly dishevelled hair, cut short on top for greater ease in the Indian climate.

By the later 1760s fashion itself had become less formal, and it was perfectly possible for men to wear coat, breeches and waistcoat of different colours and fabrics. A stylishly trimmed frock coat was, by now, acceptable as 'half-dress' or semi-formal attire, and this is what Hastings wears; it is made of a blue silk and woollen mixed cloth, with shining gold-thread buttons and buttonholes, and has a velvet collar. His breeches are made of black velvet and fasten with a small gold buckle at the knee. As for the waistcoat, this is possibly of Indian manufacture, a printed cotton. Hastings wished to promote Indian goods, for philanthropic reasons as well as for the purposes of trade (the Ashmolean Museum in Oxford, for example, has some knitted woollen hose and gloves that he brought back to England), and like a number of British expatriates, he incorporated elements of native manufacture into his wardrobe.

In hot weather in India many men dispensed with the pleated linen stock round the neck, as the sitter does here, allowing us to see his shirt collar turned down, and more of the frothy lace ruffle that edged the front opening of the shirt.

47
WARREN
HASTINGS
Sir Joshua
Reynolds,
1766–8.
Oil on canvas,
1264 x 1010mm
(49¾ x 39¾")
National Portrait
Gallery, London
(NPG 4445)

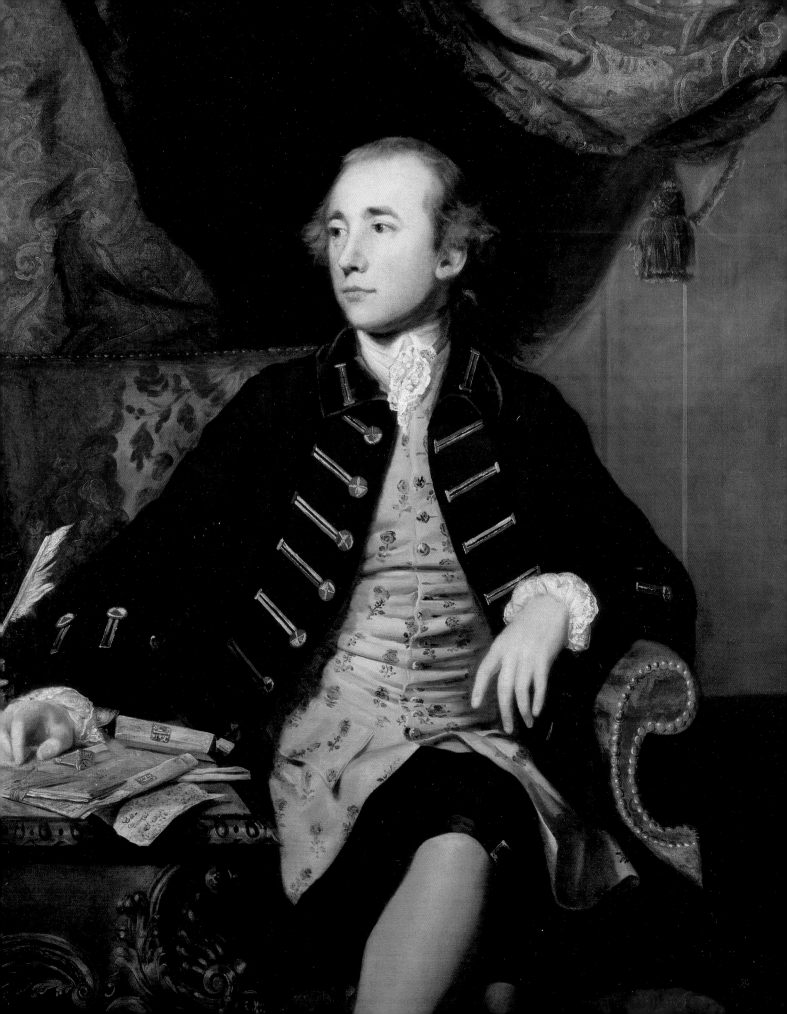

48 FRANCIS OSBORNE, 5TH DUKE OF LEEDS (1751-99)

Youngest son of the 4h Duke of Leeds, Francis Osborne pursued the conventional path of a member of his caste – an education at Oxford (Christ Church), followed by a career in politics, serving under William Pitt in 1783; he also held office at court, as Lord Chamberlain of the Queen's Household, and succeeded his father as Duke of Leeds in 1789. In addition to his life as politician and courtier, he was a man of some cultivation in the arts and was a writer of letters, comedies and political reminiscences. He was a member of the Society of Dilettanti, which had been formed in 1732 by a group of young men who had visited Italy on the Grand Tour and wished to promote the arts in general, and in particular to foster an interest in the remains of classical antiquity through sponsoring archaeological research (Robert Wood – see *fig. 46* – was also a member).

Elizabeth Montagu, famous blue-stocking and writer, described Osborne as 'the prettiest man in his person, the most polite and pleasing in his manners' – traits of appearance and character that the artist tries to

48
FRANCIS
OSBORNE,
5th Duke of
Leeds
Attributed to
Benjamin West,
*c.*1770.
Oil on canvas,
692 x 889mm
(27½ x 35")
National Portrait
Gallery, London
(NPG 801)

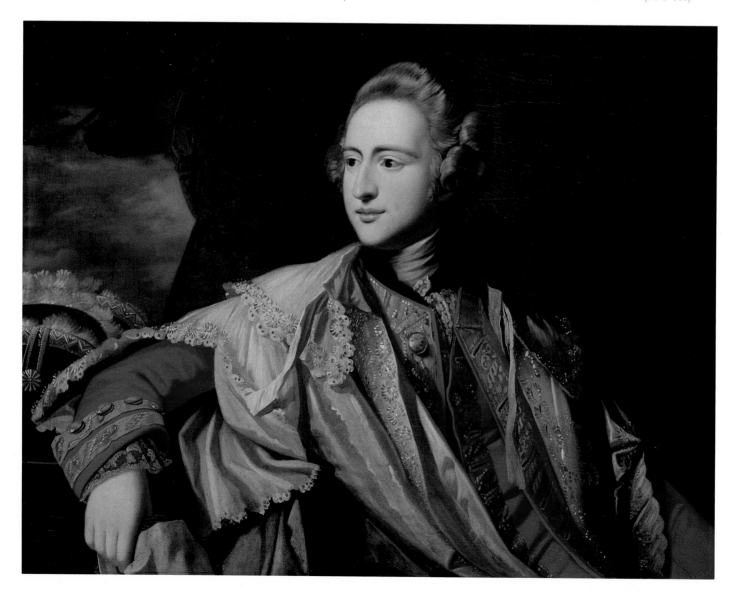

48.1
Invoice from
Brackstone's
Warehouse,
1773.
British Museum,
London

convey in this portrait. He is dressed for a
masked ball; masquerades, held either in the
public pleasure gardens of London or in pri-
vate houses, were among the most popular
forms of entertainment in the eighteenth
century. He holds a mask by the silk frill
that hid the chin and provided an
effective incognito when worn with the three-
cornered hat and the voluminous domino
gown that covered the fashionable costume
underneath. Osborne's domino is
of white silk trimmed with gold lace; it
could either be his own, or have been hired
from the many theatrical costumiers in
the Covent Garden
area of London
(see *fig. 48.1*). It
is worn over a

red silk suit decorated with gold lace, and on
a table by his side is his black hat decorated
with gold braid and white ostrich feathers (see
fig. 48.2). By this time, many young men of
fashion were beginning to wear their own
hair, styled as a wig; even wigs themselves
were meant to look more 'natural', and pow-
der was reserved for formal occasions, such as
attendance at court, the opera or grand balls.
Although it is not always easy to distinguish
real hair from a wig, it is probable that
Osborne has adopted the former, the front
hair combed over a roll
into a toupee, or
foretop, and
tied at the
back with
black silk.

48.2
Three-cornered hat
trimmed with gilt-
metal lace
and feathers,
eighteenth century.
Museum of
London

49 DAVID GARRICK (1717–79) AND HIS WIFE EVA MARIA VIEGEL (1724–1822)

The most famous actor of the eighteenth century – from his debut on the London stage in 1741 until his retirement in 1776 – is portrayed with his wife Eva, a Viennese dancer whom he married in 1749, in the garden (landscaped by Capability Brown) of their house by the Thames at Hampton.

The ageing actor – vain, rubicund and rather portly – wears a suit of red corded velvet, the coat and waistcoat lined with white. By this time it was rather old-fashioned to wear a suit where the three constituent garments were made of the same fabric, but it was a style favoured by Garrick as one that had been in vogue in his youth. A suit belonging to Garrick, of about the same date (*fig. 49.1*) has coat, waistcoat and breeches made of reddish brown velvet; the waistcoat is lined with cream silk and the coat is lined with wool at the back, giving

49
DAVID GARRICK and his wife EVA MARIA VIEGEL
Sir Joshua Reynolds, exhibited 1773.
Oil on canvas, 1403 x 1699mm (55¼ x 66⅞")
National Portrait Gallery, London (NPG 5375)

49.1
Velvet suit
worn by David
Garrick, 1760s.
Museum of
London

49.2
Detail of flounce
and petticoat
from satin
sack-back dress,
1760s.
Museum of
London

extra warmth to its elderly wearer.

In keeping with the formality of his appearance, Garrick wears fine French needle-lace (possibly *Alençon*) and a powdered wig with high toupee and rigid side curls; such curls were called 'buckles' (from the French *boucles*), and a 'well-buckled' wig was a contemporary term of approval.

By eighteenth-century standards Eva Garrick is still youthful-looking, perhaps because of the professional secrets of self-presentation gained from the theatre and the skilful use of cosmetics – her skin has been artificially whitened, rouge added to her cheeks and her lips reddened. She is dressed in white satin (an open gown, possibly with the fashionable looped-up overskirt – see *fig. 51.3*), with an informal unstructured front-fastening bodice (*compère*, from the French word meaning 'intimate') and the recently introduced long sleeves to the wrist. Her appearance is almost too feminine, from her lightly powdered piled-up hair topped with a dainty lace cap, the 'butterfly' ruff under her chin and the embroidered scarf of silk gauze crossed over her breast, to the sumptuous satin of the dress with its padded 'robings' (ornamented borders sewn on in a decorative pattern to the sides of an open gown) and large flounce on the skirt. A similar large flounce and a robing that forms a curving, serpentine line can be seen in a detail from a 1760s dress of white satin in the Museum of London (*fig. 49.2*).

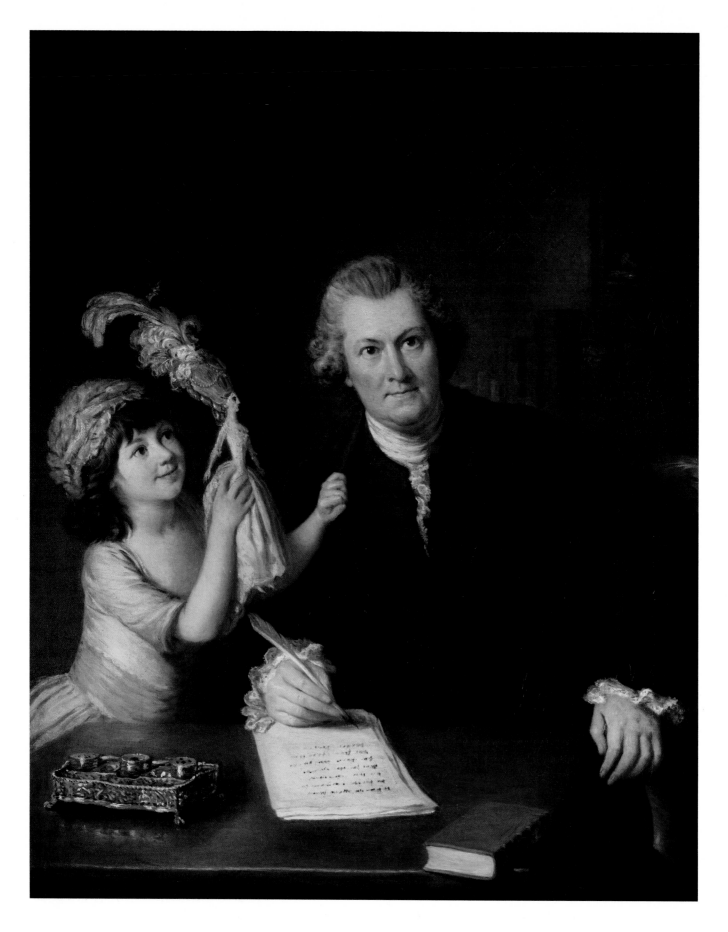

50 CHRISTOPHER ANSTEY (1724–1805) WITH HIS DAUGHTER MARY

Christopher Anstey was a Cambridgeshire squire and the author of light verse, most successfully *The New Bath Guide* (1766), a humorous poetic satire on fashionable life in Bath. In his portrait by an artist resident in Bath (many artists, including Gainsborough, enjoyed lucrative stays in this fashionable resort, and Anstey himself moved there in 1770) we note a somewhat conventional frock suit of dark blue cloth. The lightly powdered hair is probably his own; by this time even middle-aged men were beginning to abandon the wig except for formal occasions, and the rigid side curls of the early 1770s were giving way to a less structured

and more 'natural' style. The new intimacy that characterises English family life in the late eighteenth century is reflected in portrait groups such as this, where open displays of affection between parent and child are recorded. Here, Mary Anstey tries to catch the attention of her father by holding up her doll (*fig. 50.1*); such dolls were known as 'babies' and often feature in portraits of young girls (see *fig. 50.2*). She wears a simple white frock tied round the waist with a pink sash – a paradigm image of innocence. The word 'frock', hitherto used for a man's informal coat with turned-down collar, encompasses the dress of young girls,

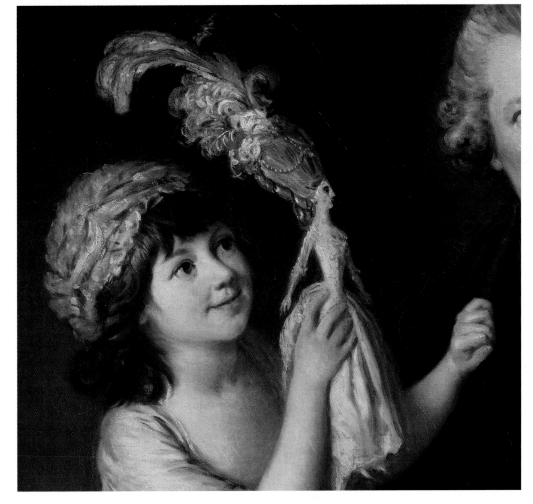

50
CHRISTOPHER ANSTEY with his daughter MARY
William Hoare, *c.*1776–8.
Oil on canvas, 1260 x 997mm (49⅝ x 39¼")
National Portrait Gallery, Beningbrough Hall, Yorkshire (NPG 3084)

50.1
Detail of *fig. 50*.

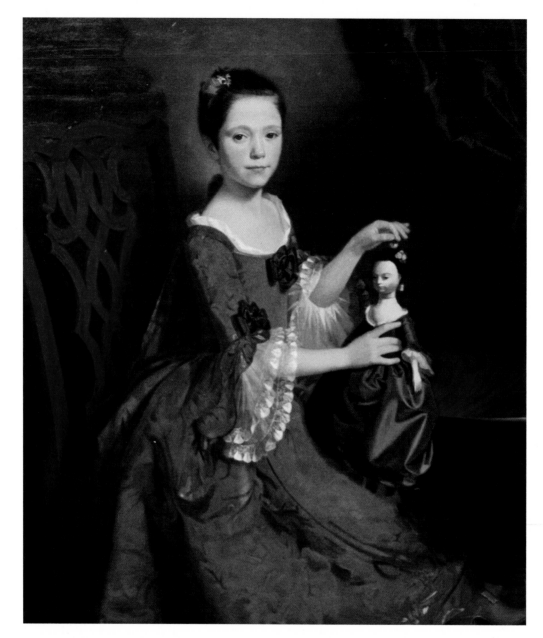

50.2
POLLY
PATTERSON
(?Pattison) of
Lancaster,
Christopher
Steele, *c.*1765.
Oil on canvas
Private collection

and in the same way that their clothing anticipates that of adult women at the end of the century, so the frock now is another word for dress.

A cap of ruched silk gauze is placed on Mary's naturally curling hair, cut with a fringe across the forehead; this simple hairstyle forms an amusing contrast to the towering coiffure sported by the doll. This feathered hairstyle (women's headdresses reached their greatest heights in the late 1770s – see *fig. 51.2*) is possibly intended as a satire on the extreme fashion of the time popularised by such society leaders as Georgiana, Duchess of Devonshire. Anstey himself poked fun at such plumed and elaborate female hairstyles in *The Election Ball* (1776), by likening them to those worn by the inhabitants of Tahiti, and possibly the painting was inspired by this. The doll, dressed in a pink silk open gown and matching petticoat, copies the fashions of the late 1770s, possibly inspired by a fashion plate of the period. From the early 1770s illustrated fashion journals began to appear on a regular basis, largely replacing the dressed dolls costumed by metropolitan dressmakers and milliners as guidance for those who wished to appear *à la mode*.

51 JOHN WILKES (1727–97) AND HIS DAUGHTER MARY (1750–1802)

Wilkes was a well-known radical politician and champion of liberty, especially that of the press, founding in 1762 an anti-government newspaper, the *North Briton*. In the following year Hogarth published a famous etching showing him as a squinting demagogue holding a cap of liberty on a staff.

Wilkes, a complex personality, was almost as notorious for his turbulent private life and spectacular ugliness as for his politics. Zoffany has tactfully played down the squint, although Horace Walpole found the image still 'horridly like', and wondered, seeing the portrait in the artist's studio, 'why … they

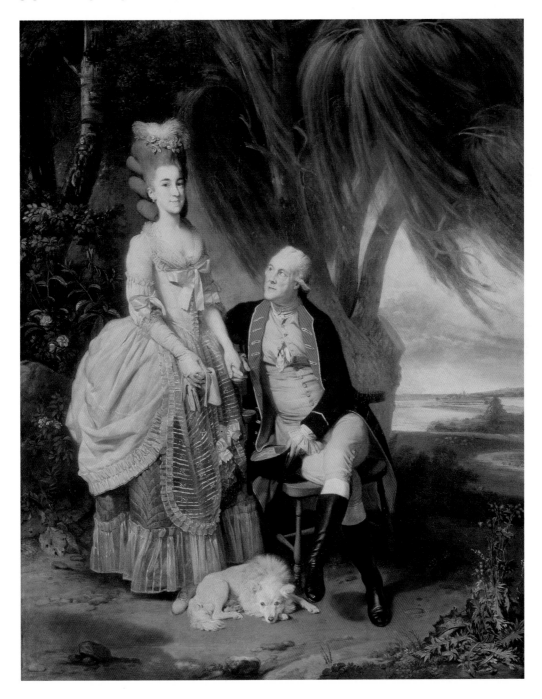

51
JOHN WILKES
and his daughter
MARY
Johan Zoffany,
exhibited 1782.
Oil on canvas
1264 x 1003mm
(49¾ x 39½")
National Portrait
Gallery, London
(NPG 6133)

are under a palm tree, which has not grown in a free country for some centuries'. Wilkes and his daughter were very close, and when he was Lord Mayor of London in 1774, she acted as his Lady Mayoress (he had separated from his wife, a rich heiress ten years older than himself, in 1756).

Wilkes wears a quasi-military riding costume, comprising a coat of blue woollen cloth lined with red, a striped waistcoat and breeches of nankeen (buff-coloured cotton); he wears top-boots (these were increasingly in fashion for indoors as well) and his own hair dressed like a wig, with a single side roll. The ruffles at his wrist are of Dresden work, embroidered linen or cotton (a cheaper and less formal alternative to lace), and the artist shows us clearly how they attach to the shirt.

Zoffany was an artist who paid meticulous attention to all the details of costume, and his images of women, in particular, are as informative as fashion plates, as we can see when comparing his portrait of Mary

51.3
'Le Rendez-vous
pour Marly'
Carl Güttenburg
after a drawing
by Jean-Michel
Moreau le
Jeune, 1777.
Engraving,
409 x 319mm
(16⅛ x 12⅝")
Victoria and
Albert Museum,
London

Wilkes with a contemporary engraving of 1778 (*fig. 51.1*). Mary seems fussily over-dressed and lacking in any innate sense of style. Her hair is arranged in the high-piled style with the stiff sausage-like side curls in vogue in the late 1770s (*fig. 51.2*); it is decorated with ostrich feathers, pink silk roses and foliage.

Unlike the more generalised interpretations of fashion seen in most portraits by British artists, Zoffany shows his sitter dressed in a very specific way. Her dress is a pink-and-white-striped silk *polonaise* gown, a style characterised by looped-up back drapery (*fig. 51.3*); here it is worn over a green quilted satin petticoat bordered with a flounce of striped silk gauze at the hem. All her accessories get equal billing with the dress, from the decorative apron of silk gauze embellished with similar pink satin bows to those on the bodice, to the net kerchief at the decolletage, the long kid gloves and the pink shoes with their silver buckles.

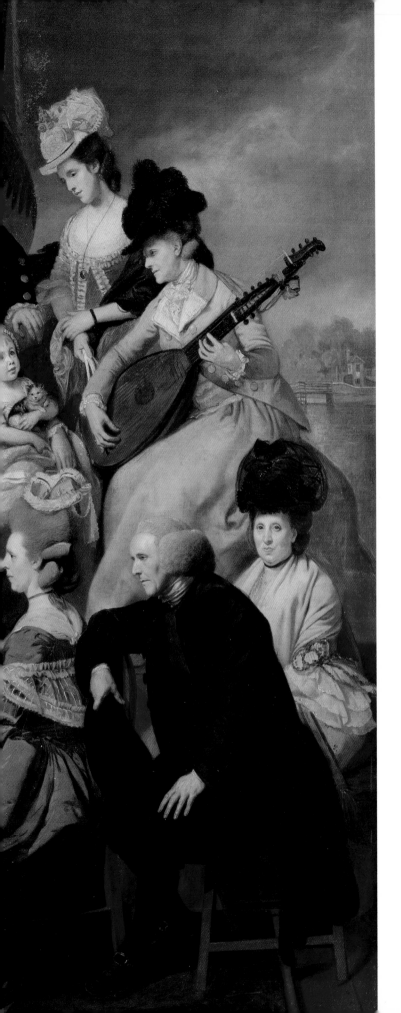

52 WILLIAM SHARP (1729–1820) AND HIS FAMILY

The Sharp family, famous for their music-
making on the Thames, perform a concert
on William Sharp's yacht, *The Union*; old
Fulham church can be seen in the back-
ground. As with many of Zoffany's paintings
of large groups, some artistic licence is evi-
dent, both in the arrangement of the figures
and in the fact that a piano would be
unlikely to be taken on board. What the
artist wishes to convey – as well as recording
the images of the individual musicians and
their listeners – is the idea of a musical con-
versation piece. (Zoffany has, incidentally,
included his dog in the foreground of the
painting, as a kind of signature – it also
appears, in the same pose, in his portrait of
John Wilkes and his daughter, *fig. 51*).

The painting was commissioned by
William Sharp, surgeon to George III, who
stands at the tiller, wearing the Windsor uni-
form (established by the King in 1776 for
members of the royal family and selected
court officials). At the bottom right is his
brother Dr John Sharp in the black costume
adopted by medical men and the 'physical'
wig, which also denotes his profession.
Seated by the piano is Granville Sharp, a
well-known philanthropist, wearing a green-
ish-yellow coat and waistcoat, with black
knee-breeches. To the left of the painting,
holding a musical instrument called a
serpent, is James Sharp, an engineer by
profession, who is rather old-fashioned in

52
WILLIAM
SHARP and
his family
Johan Zoffany,
1779–81.
Oil on canvas,
1156 x 1257mm
(45⅓ x 49½")
National Portrait
Gallery, London
(NPG L169)
On loan from the
Trustees of the
Lloyd-Baker
Settled Estates

52.1
Detail of *fig. 52*.

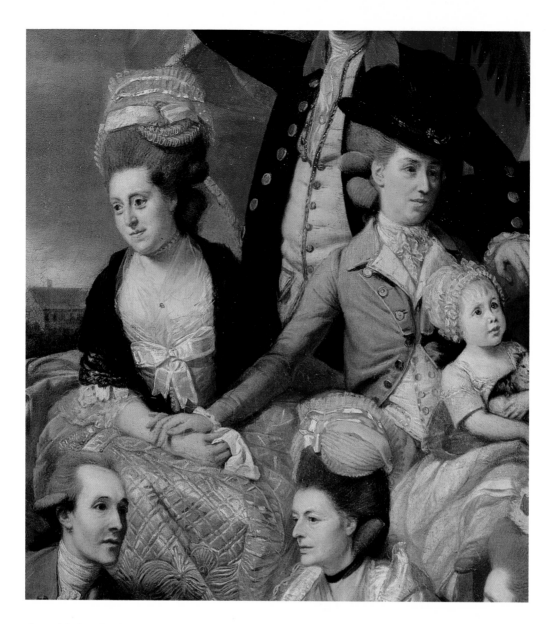

dress, his hat firmly placed on his bewigged head, wearing a coat of brown woollen cloth with brass buttons. Behind him is the barge-master, distinguished from the rest of the men (their middle-class and professional status signified through their powdered hair or wigs) by his short, natural hair, which gives him a greater modernity of appearance. Next to him is a small boy, whose long hair waving naturally to the shoulders, dark blue coat and open, frilled shirt collar are all features of the clothing of young boys in the late eighteenth century.

The three Sharp sisters also take part in the musical entertainment. Elizabeth, ready to play the piano, wears a *sacque* dress of rich reddish-brown (a colour known as 'carmelite') and a small, hooded, white satin shoulder mantle. To the right is Frances, music in her hand and perhaps about to sing, in a blue silk *robe à l'anglaise* (the dog places a paw on her train) and matching petticoat. Judith, playing the theorbo (a kind of lute) at the top right, is wearing a riding habit, a fashionable costume adapted from the male suit, and popular for all kinds of outdoors activities. Just in front of William Sharp is his wife, who also wears a riding costume, consisting of a pale blue jacket and matching skirt and a waistcoat of white silk trimmed with gold. She places her hand over that of Mrs James Sharp (*fig. 52.1*),

whose pale lavender dress is almost eclipsed by her beautiful petticoat of quilted white satin. Quite a number of these quilted skirts exist in museum collections (*fig. 52.2*); not only were they attractive, as well as being light and warm to wear, but they also helped to create the soft, rounded look that was such an essential part of women's fashion of the period.

Zoffany had an expert eye for the fabrics from which fashionable dress and accessories were created, as well as for the garments themselves. Through his eyes we appreciate, for example, the shine on satin and rustling silk taffeta, the soft, matte appearance of the sprigged white cotton worn by Catherine Sharp (standing next to her father, James), and the fine woollen shawl and Dresden sleeve ruffles worn by Mrs John Sharp (on the far right). We note the extraordinary variety of female headdresses, from the plumed and ribboned hats worn by the Amazons (as women in riding habits were often known, after the legendary female warriors), to the frilly confections of silk, gauze and net that perch on top of the powdered coiffures of the more formally dressed women in the painting.

52.2
Quilted satin petticoat, mid-eighteenth century. Museum of London

53 ROBERT POLLARD (1755–1838)

The sitter was a painter, but better known for his engravings (one of his best-known works was *The Trial of Warren Hastings in Westminster Hall*, 1789); in this portrait he is seated on a mossy bank under an oak tree, a landscape drawing in his hand. He is dressed in a coat of greyish buff, which is narrow in cut, sloping away down the sides and over the hips; his waistcoat, double-breasted, as was the vogue in the 1780s, is of a similar colour but with a gold stripe. His breeches are of black silk, with a small nod in the direction of fast disappearing luxury in the form of small, glittering paste (imitation diamond) buckles at the knee. The three-cornered hat – for so long an unchanging staple of the masculine wardrobe – has been replaced for everyday

53
ROBERT
POLLARD
Richard Samuel,
1784.
Oil on canvas,
1238 x 991mm
(48¾ x 39")
National Portrait
Gallery, London
(NPG 1020)

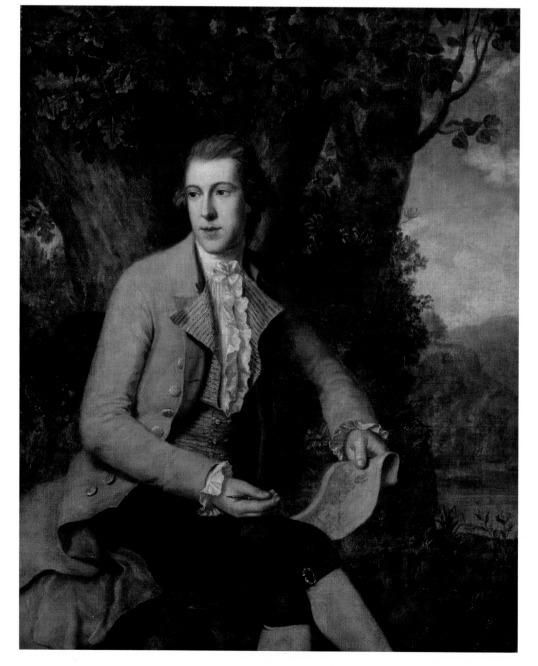

53.1
JOHN CARR
(1723–1807)
Sir William
Beechey, *c*.1791.
Oil on canvas,
1267 x 1006mm
(49⅞ x 39⅝")
National Portrait
Gallery,
Beningbrough
Hall, Yorkshire
(NPG 4062)

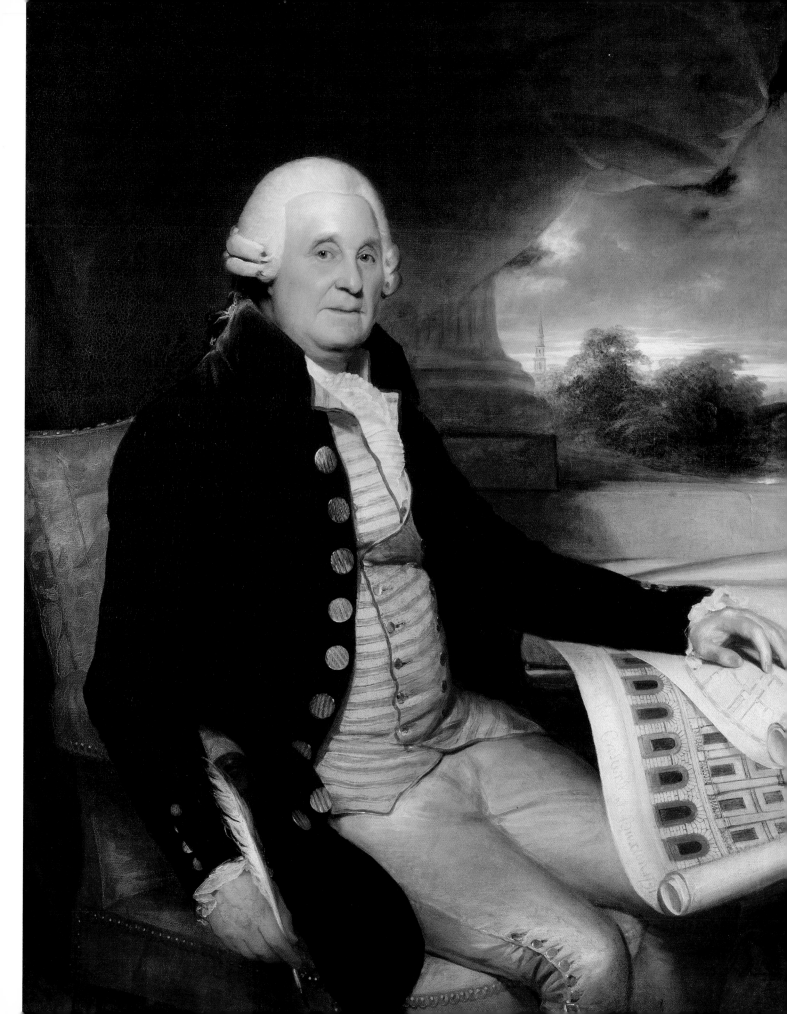

wear by a round uncocked hat with a wide brim; plain linen now forms the cravat, the shirt frill and the sleeve ruffles.

By the 1780s men's clothes were becoming less flamboyant and more understated in colour and materials; silk fabrics and rich decoration were no longer the norm (the exception was court wear), and for everyday men wore fine woollen cloth, especially for their coats. As coat and breeches became more muted in colour, the patterned waistcoat, often made of silk or cotton, became the focal point of attention, and stripes were particularly in vogue in the 1780s and 1790s. Striped waistcoats feature in

Beechey's portrait of the architect John Carr of the early 1790s (*fig. 53.1*), and in Lemuel Francis Abbott's portrait of the sculptor Joseph Nollekens of about 1797 (*fig. 53.2*). Nollekens's hair is his own (as is that of the bust of Charles James Fox that he models) but he may have powdered it, in which case he would have paid a fee of one guinea, a powder tax having been imposed by the government in 1795. In contrast, John Carr – although up-to-date in dress in his high-collared cut-away dark coat and nankeen breeches – retains a very old-fashioned, heavily powdered bag wig with rigid side rolls.

53.2
JOSEPH
NOLLEKENS
(1737–1823)
Lemuel Francis
Abbott, *c.*1797.
Oil on canvas,
749 x 603mm
(29½ x 23¾")
National Portrait
Gallery, London
(NPG 30)

54
HESTER
LYNCH PIOZZI
Unknown artist,
*c.*1785.
Oil on canvas,
756 x 629mm
(29¾ x 24¾")
National Portrait
Gallery, London
(NPG 4942)

54 HESTER LYNCH PIOZZI
(1741-1821)

A prolific diarist, the sitter was famous as a great friend of Dr Johnson, whom she entertained in the house at Streatham where she lived with her husband, Henry Thrale, a prosperous Southwark brewer by whom she had twelve children. After Thrale's death (1781) she fell in love with Gabriel Piozzi, her daughters' music master. There was considerable gossip about this relationship, and Dr Johnson, who had become almost domesticated in her household, was distraught at her marriage in 1784. The Piozzis travelled around Europe, and this portrait was painted in Italy during their honeymoon; they returned to England in 1787.

54.1
HESTER LYNCH
PIOZZI
George Dance,
1793.
Pencil on paper,
248 x 191mm
(9¾ x 7½")
National Portrait
Gallery, London
(NPG 1151)

The large hairstyles and headdresses of the 1780s often seem to make the head appear out of proportion to the rest of the body, a situation only partially rectified by the wide, spreading skirts of formal dress, worn over side hoops. Here, Mrs Piozzi's head is enlarged by her wide, frizzed hairstyle and big *dormeuse* cap (this was an indoors cap with a puffed-out crown and a frilled border).

Stripes were a popular design motif in the period, as we can see from Hester Piozzi's silk dress and large ribbon bows at her breast and in her cap. Equally fashionable was silk gauze, which forms her stiffened collar *à la Médici*, the tippet or scarf crossed over her bosom and her cap. Black net gloves protect the lower arms from the weather (especially from the sun – sunburnt skin denoted a working-class woman), and the black silk ribbon at the neck (another

revivalist 'Renaissance' style) draws attention to the whiteness of the skin.

Older women, on the whole, were slower to adopt new fashions, especially with regard to the hair – the most sensitive part of our appearance – and some years later we see Hester Piozzi in a drawing by George Dance (*fig. 54.1*) still with her wide, frizzed coiffure. However, the greater simplicity of English styles of dress of the period prevail here, and she wears a *robe à l'anglaise*, possibly of linen or cotton, with a tiny sprigged pattern; a starched kerchief, bunched up in front, crosses her breast. The large cap of the earlier portrait has been replaced by a tiny hat on the top of the head; a simple ribbon bandeau (the word entered the English language in 1790) is in keeping with the gradual trend towards the neo-classical in dress.

55 GEORGE, PRINCE OF WALES, LATER GEORGE IV (1762–1830)

In the golden age of satire in England, Gillray reigned supreme. There can be no more effective indictment of royal dissipation than his caricature of the extravagant lifestyle of the gross Prince of Wales. Sitting in a first-floor room of his new palace, Carlton House, the Prince is surrounded by half-eaten food, empty bottles (an overflowing chamberpot behind him) and unpaid bills. To emphasise the point, above his head is Tintoretto's portrait of Luigi Cornaro, who lived to be ninety-one by repenting and reforming his youthful excesses.

Had the Prince lived earlier in the century, his corpulence would have gone unremarked, but at this time the fashionable male

55
GEORGE, PRINCE OF WALES, later George IV 'A Voluptuary under the horrors of Digestion' James Gillray, 1792.
Coloured etching, 358 x 285mm (14⅛ x 11¼")
National Portrait Gallery, London, Reference Collection (RN 19011)

A VOLUPTUARY under the horrors of Digestion.

drawn from the life by
John Russell R.A. 1794

55.2
GEORGE,
PRINCE OF
WALES, later
George IV
Richard Cosway,
c.1780–82.
Miniature on
ivory, oval,
actual size
98 x 73mm
(3⅞ x 2⅞")
National Portrait
Gallery, London
(NPG 5890)

55.1
GEORGE,
PRINCE OF
WALES, later
George IV
John Russell,
1794.
Black and red
chalk,
485 x 344mm
(19²⁄₁₆ x 13⁹⁄₁₆")
Courtauld
Institute Galleries,
London

silhouette was slimmer and his embonpoint is cruelly recorded here, as he almost bursts out of his buff-coloured waistcoat and tight-fitting breeches; his blue coat, impossible to button across the chest, is cut away into tails at the back. Buff and blue were the colours associated with Charles James Fox, a Whig and a fellow crony in dissipated living, the Prince's association with whom was a source of irritation to King George III on both counts.

Gillray's image of the Prince of Wales as an obese dandy (the 'Prince of Whales') is probably not too far from the truth. He notes the beefy face that we also see in a fine sketch by John Russell 'drawn from the Life' in Brighton (a resort made fashionable by the Prince) in 1794 (*fig. 55.1*). In a few vigorous strokes, the artist has captured the Prince's mass of dishevelled curls and the high collar of his coat; the starched white cravat increasingly distinguished a man of style from his lowlier fellows.

From his earliest years, the Prince of Wales was interested in fashion. A miniature by Cosway of the early 1780s (*fig. 55.2*) shows a handsome youth – his fleshy, voluptuous features already evident – wearing a well-cut red double-breasted frock coat with the Star of the Order of the Garter on the chest, a black military cravat and a rather dashing 'wide-awake' hat slightly tilted to one side. In 1782 the Duchess of Devonshire noted: 'He is inclined to be too fat and looks too much like a woman in men's cloaths, but the gracefulness of his manner and his height certainly make him a pleasing figure.'

Later, in a more sarcastic vein, his estranged wife Caroline of Brunswick (see *fig. 59*) remarked on the Prince's fondness for clothes: 'He understands how a shoe should be made or a coat cut ... and would make an excellent tailor, or shoemaker, or hairdresser, but nothing else.'

56 MARY WOLLSTONECRAFT (1759–97)

Feminist writer and thinker (author of *A Vindication of the Rights of Woman*, 1792), Mary Wollstonecraft is portrayed here with ostentatious simplicity, in a high-waisted white cotton dress, a muslin kerchief ensuring a modest neckline, and a soft hat worn over her plainly styled auburn hair. Wollstonecraft's feminist principles dictated that 'an air of fashion is but a badge of slavery', and in her *Thoughts on the Education of Daughters* (1787) she states: 'Dress ought to adorn the person, and not rival it. It may be simple, elegant and becoming, without being expensive … The beauty of dress (I shall raise astonishment by saying so) is its not being conspicuous one way or the other, when it neither distorts nor hides the human form by unnatural protuberances.' Here she follows her own recommendation, for the dress reveals the body shape in a natural and discreet way; Mary Wollstonecraft, married to William Godwin, was pregnant at the time, and died shortly after giving birth to a daughter, later Mary Shelley.

At the time of this portrait, women's dress, under the influence of neo-classicism, was 'simple, elegant and becoming'. This is evident in many contemporary images, such as the delicate portraits by Henry Edridge. His pencil and wash drawing of Anne North, Countess of Sheffield, of 1798 (*fig. 56.1*) shows the sitter in a white muslin chemise dress, the folds of the airy fabric falling from a high waist to trail on the ground behind.

56.1
ANNE NORTH, Countess of Sheffield
(1764–1832)
Henry Edridge, 1798.
Pencil and wash on paper,
267 x 184mm (10½ x 7¼")
National Portrait Gallery, London
(NPG 2185a)

56
MARY
WOLLSTONECRAFT
John Opie, *c.*1797.
Oil on canvas,
768 x 641mm
(30¼ x 25¼")
National Portrait
Gallery, London
(NPG 1237)

THE NINETEENTH CENTURY

57 JOHN CONSTABLE (1776–1837)

57
JOHN
CONSTABLE
Self-portrait,
*c.*1800–1804.
Pencil and black
chalk, heightened
with white and
red chalk,
248 x 194mm
(9¾ x 7⅝")
National Portrait
Gallery, London
(NPG 901)

Constable's sensitivity and his slightly melancholy disposition can easily be detected in the intensity of this self-portrait, drawn perhaps shortly after the time he entered the Royal Academy Schools in 1799 or a few years later. The costume he wears is modest and unpretentious, a high-collared woollen coat over a waistcoat and the simplest white linen cravat. At this time, although most men buttoned their clothes left over right (and women vice versa), there was no fixed rule about 'masculine' or 'feminine' custom in this respect, and it does not necessarily indicate, as some art historians have suggested, that this portrait was drawn by the artist looking in a mirror.

By the end of the eighteenth century there was little scope for flamboyance in male clothing. Individuality was expressed in the style of hair (wigs had disappeared), and in such minor details as the different ways of tying the cravat. The visionary poet Samuel Taylor Coleridge, for example, in his portrait by Peter Vandyke (*fig. 57.1*) demonstrates his Romantic sensibility through his long curled hair and his rather fixed stare, but there is also a sense of incipient dandyism in his extravagantly bow-tied cravat, and his white satin waistcoat with fashionably wide revers. Constable's demeanour is more conventional, with his hair cut short and slightly tousled in the fashionable neo-classical mode; his cravat is merely a long strip of linen wound round his neck and fastened in a loose knot.

57.1
SAMUEL
TAYLOR
COLERIDGE
(1772–1834)
Peter Vandyke,
1795.
Oil on canvas,
559 x 457mm
(22 x 18")
National
Portrait Gallery,
London
(NPG 192)

58
MARY ANNE
CLARKE
Adam Buck, 1803.
Miniature on
ivory, actual size
102 x 83mm
(4 x 3¼")
National Portrait
Gallery, London
(NPG 2793)

58 MARY ANNE CLARKE
(1776–1852)

The sitter's main claim to fame is that she was the mistress (from 1803 to 1807) of Frederick, Duke of York (second son of George III), commander-in-chief of the army. In 1809 she was accused of trafficking in army commissions, and the Duke was forced to resign. In this miniature by Buck (a fashionable decorative artist and designer, who helped to popularise the vogue for the neo-classical), Mary Anne Clarke's nubile charms are on show in her high-waisted

dress of white muslin, cut in a style that emphasises the shape of the body. A blue Wedgwood cameo (a popular mass-produced manifestation of neo-classical taste) fastens the dress under the bust, and our attention is drawn to the sitter's pretty arms by a similar cameo which holds up the short sleeve on the shoulder.

The fashionable neo-classical style of dress often displayed a considerable amount of flesh – to the alarm of moralists – and it

58.1
*Two Young Ladies
on a Terrace*
Adam Buck, 1800.
Chalk, water-
colour and
body colour,
391 x 408mm
(15⅜ x 16⅛")
Courtauld
Institute Galleries,
London

58.2
MARY ANNE
CLARKE
Lawrence
Gahagan, 1811.
Marble bust,
height 641mm
(25¼")
National Portrait
Gallery, London
(NPG 4436)

demanded a slim but 'feminine' figure, rounded arms, good skin and a long neck (see *fig. 58.1*). A long neck best set off the 'classical' hairstyles in vogue; these were either cut short and curled (fashionable women could ring the changes with a wardrobe of wigs), or the hair was lightly oiled (so-called *huile antique* was a favourite) and gathered up in a loose bunch of curls at the back of the head.

It is as a discarded mistress that we see Mary Anne Clarke in the marble bust of 1811 by Lawrence Gahagan (*fig. 58.2*), where she is depicted as Clytie (the deserted lover of Apollo, the sun god) who was changed into a sunflower so she could follow his progress across the sky. She appears as if arising naked from a sunflower (symbol of constancy and of royal favour), and the petals of the flower double up to suggest the frilled collar of the popular white muslin dress of the period.

59 CAROLINE AMELIA ELIZABETH OF BRUNSWICK, PRINCESS OF WALES (1768–1821)

This is a direct and honest portrait of the unruly – many called her vulgar – wife of the Prince of Wales; they married in 1795 and separated a year later. (This ambiguity over her marital status may be indicated by the shadow over her left hand, where her wedding ring is hardly visible.) She took up residence at Montagu House in Blackheath, on the edge of London (where this portrait was painted), which was far enough away from the Prince at Carlton House, but close enough for both parents to share the

59
CAROLINE AMELIA ELIZABETH OF BRUNSWICK, Princess of Wales Sir Thomas Lawrence, 1804. Oil on canvas, 1403 x 1118mm (55¼ x 44") National Portrait Gallery, London (NPG 244)

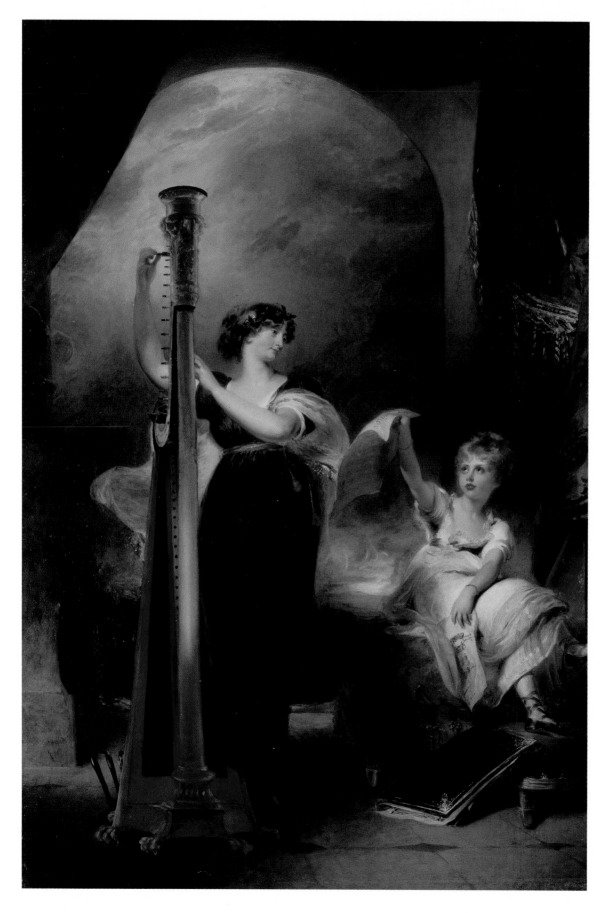

59.1
CAROLINE AMELIA
ELIZABETH OF
BRUNSWICK
Princess of Wales and
PRINCESS
CHARLOTTE
(1796–1817)
Sir Thomas Lawrence,
1800–01.
Oil on canvas,
3022 x 2032mm
(119 x 80")
Royal Collection

upbringing of their child, Princess Charlotte. This rather challenging image may indicate the sitter's possible dalliance with the artist, and also (as she holds a sculpting implement) her own artistic interests; she took lessons in sculpture from Peter Turnerelli, an Irish sculptor recommended by Lawrence, and in the background is a clay bust of her father, the Duke of Brunswick.

Whatever the Princess's relationship with Lawrence, he has not flattered his sitter, drawing attention to her bold complexion (heightened both by a liberal use of cosmetics and by the colour of her dress) and to her fleshy arms, which the effect of 'rolled-up' sleeves emphasises. Her dress is of red velvet, tight over the bust, her solid flesh being kept firmly under control by a heavily whaleboned corset. The colour and fabric of her dress, along with the high collar, which supports a ruff of fine muslin, signal the popularity of

the Renaissance as an influence on female costume of the period, as does the red velvet hat trimmed with bird-of-paradise plumes.

A few years earlier, when the vogue for the neo-classical was at its height, Lawrence painted Caroline of Brunswick (*fig. 59.1*) in more of a 'grand style' portrait, turning her into a towering and vaguely mythological presence. Playing the harp – a modishly Romantic female accomplishment – she wears a high-waisted black dress (loosely based on the lines of fashion), with a red-tasselled sash and a gauzy Indian silk shawl billowing around her; in her hair is a laurel wreath with red berries. In contrast, her daughter, the charming but hoydenish Princess Charlotte (who was to die in child-birth in 1817), wears real dress – a frock of white muslin with tucks at the hem – and blue satin shoes with ankle-straps, one of which has come undone.

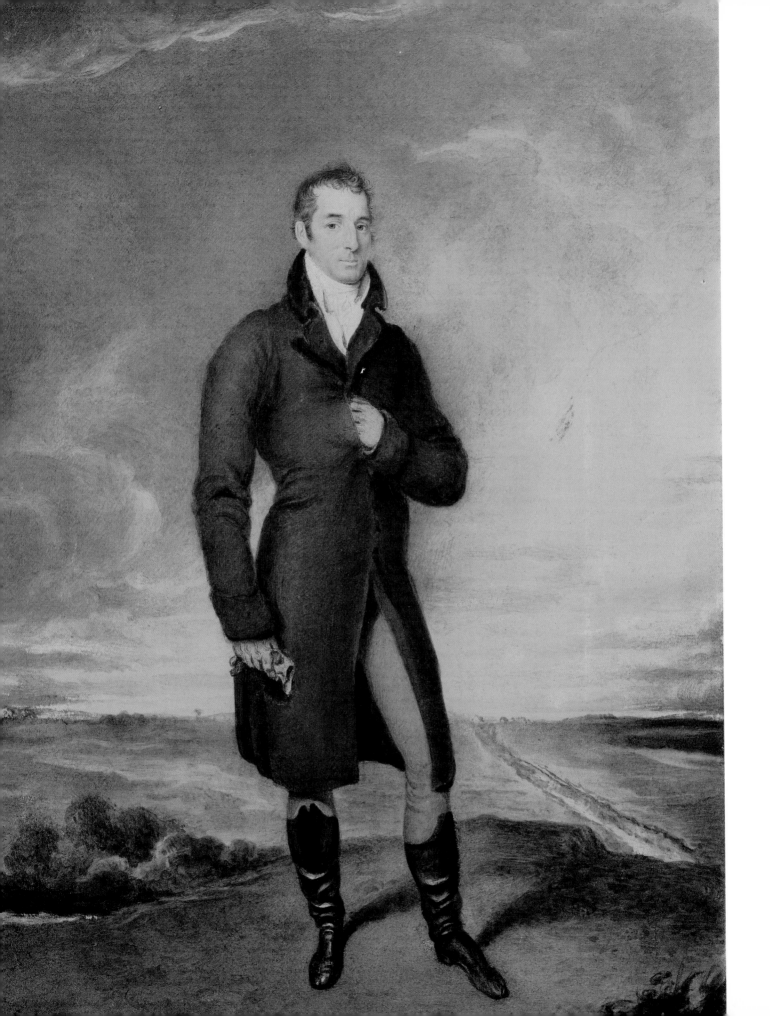

60 ARTHUR WELLESLEY, 1ST DUKE OF WELLINGTON (1769–1852)

This portrait was probably painted at Madrid, during the Peninsular War, when Wellington commanded the British troops against the French. Unusually for a military hero in wartime, Wellington wears civilian clothing, a fact that may be explained by his interest in fashionable dress; he was vain about his appearance, and particular about the cut, comfort (and cleanliness) of his costume. Wellington was a believer in the gospel according to Beau Brummell (as expounded by Max Beerbohm in *Dandies and Dandies*, 1896) that the aim of male dress

A WELLINGTON BOOT
or the Head of the Army

was to 'clothe the body that its fineness be revealed', and at the time of this portrait his usual costume was a single-breasted frock coat, tightish fitting to show off his slim and well-proportioned figure, and pantaloons (a style that had largely superseded knee-breeches by the early nineteenth century) worn with boots. Here his coat is dark blue with a velvet collar and with the extra-long sleeves characteristic of contemporary tailoring; with this he wears a high-collared white waistcoat, close-fitting pale grey pantaloons and black leather boots. These were the kind of boots that Wellington liked, for the back was cut away slightly, making it easier to bend the knee; the style most associated with him (then and now), however, was a boot coming to below the knee and cut straight around at the top (*figs 60.1* and *60.2*).

Wellington's appearance – short hair cut simply and brushed forward over the temples – and his plain, unadorned clothes, are notable for their practicality and understatement. However, the traditional gestures of an earlier and more flamboyant age are still retained here – the left hand inserted in the coat, and the right (gloved) hand clutching the other glove.

61 JOHN CLARE (1792–1864)

This portrait, probably commissioned by John Taylor, Clare's editor and publisher, was painted after the poet's first book, *Poems Descriptive of Rural Life and Scenery*, came out in 1820. The artist has captured his sitter's almost unbearable sensitivity – Clare became insane in 1837 and was committed to Northampton Asylum. Clare's poetry was inspired by the Northamptonshire countryside where he was brought up, the self-educated son of a cottage farmer, and where he worked as an agricultural labourer, living in great poverty with his wife and children. His poems caught the mood of the time, both in their subject – the countryside, which Romantic poets such as Wordsworth

61.1
JOHN KEATS
(1795–1821)
Joseph Severn,
1821–3.
Oil on canvas,
565 x 419mm
(22¼ x 16½")
National Portrait
Gallery, London
(NPG 58)

and Coleridge had used as inspiration and encouraged people to look at with new eyes, especially in light of the encroaching urbanisation generated by the industrial revolution – and in their treatment, which was intensely personal and moving.

Clare wears the Sunday best clothes of a respectable working man, a rough-textured brown woollen coat, greyish-brown trousers and a buff-coloured cotton waistcoat. His shirt collar is slightly rumpled, and instead of the starched white linen cravat that was part of fashionable menswear – and that we see, for example, in Joseph Severn's portrait of the poet John Keats (*fig. 61.1*) – Clare has a printed silk scarf tied loosely round his neck (*fig. 61.2*), a fashion, incidentally, that was to be taken up by artists and intellectuals at the end of the nineteenth century.

Keats wears the black suit – double-breasted, cut-away morning coat, waistcoat and trousers – that was the everyday 'uniform' of the upper, middle and professional classes. By 1820 trousers – of varying widths from narrow to voluminous – were the accepted style; tight pantaloons were no longer in fashion and knee-breeches were retained only for wear at court.

61.2
Scarf thought to have belonged to John Clare. Block-printed silk, embroidered in silk with the initials J.T.C., 914 x 863mm (36 x 34") Stamford Museum, Lincolnshire

61
JOHN CLARE
William Hilton,
1820.
Oil on canvas,
762 x 635mm
(30 x 25")
National Portrait
Gallery, London
(NPG 1469)

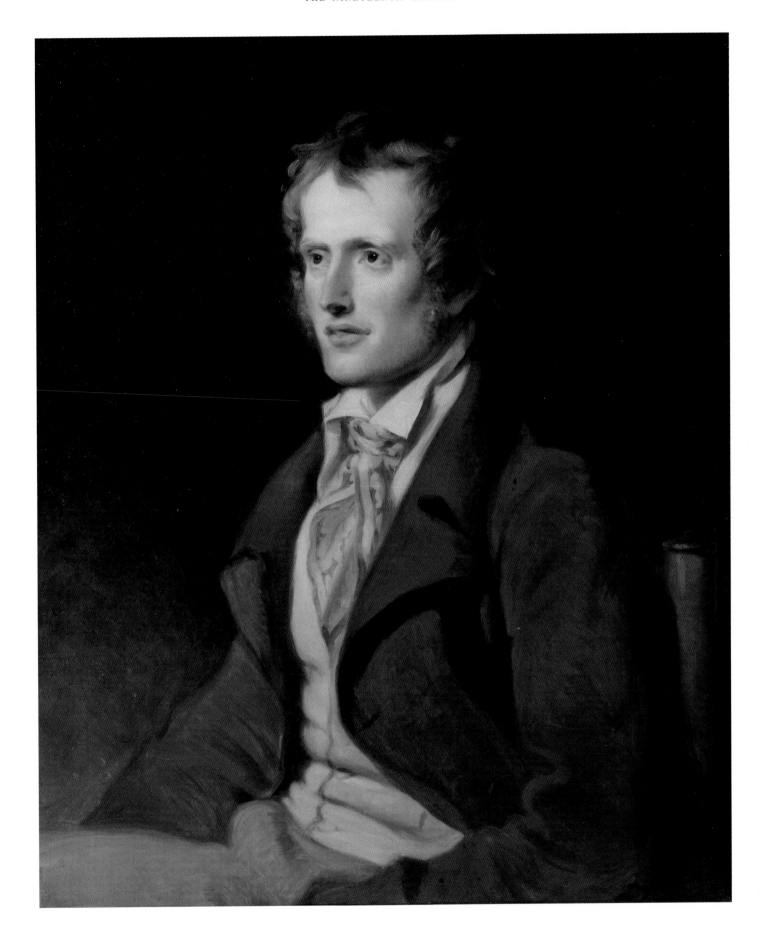

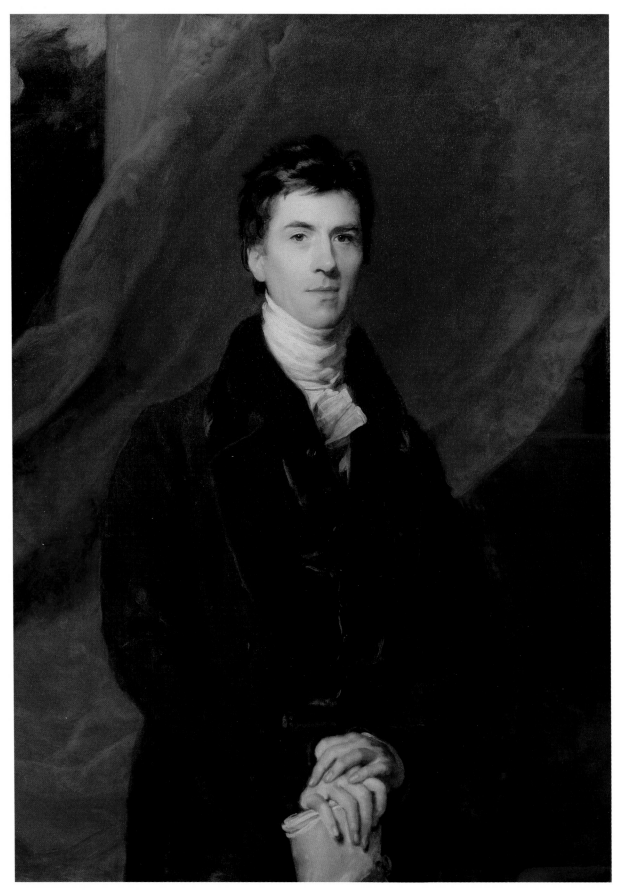

62
HENRY
BROUGHAM,
1st Baron
Brougham and
Vaux,
Sir Thomas
Lawrence, 1825.
Oil on panel,
1143 x 819mm
(45 x 32½")
National Portrait
Gallery, London
(NPG 3136)

62 HENRY BROUGHAM,
1ST BARON BROUGHAM AND VAUX
(1778–1868)

The glossiness and bravura of Lawrence's portrait captures the essence of the brilliant and mercurial Scottish lawyer who famously defended Queen Caroline at her trial for adultery in the House of Lords in 1820. A champion of legal and social reform, Brougham became Lord Chancellor in 1830, and had a leading role in passing the Reform Bill of 1832, an Act that redistributed parliamentary seats on a more rational basis, and introduced a modest extension of the franchise.

Lawrence portrays Brougham both as a lawyer – holding a brief tied up with red ribbon – and as a man of individuality and style, even within the constraints of the prevailing black and white of the upper-class professional; the only touch of colour is a blue ribbon at the waist which holds his seals. His hair is cut short and slightly ruffled; it gives his face an air of vivacity and modernity, especially when set against his stiff white starched linen stock or neckcloth. Lawrence was an expert at depicting textiles, not only painting their appearance but their tactility as well. Not only does he record the details of the costume – Brougham's fine black woollen morning coat and trousers, the rich black velvet of the coat collar and the waistcoat – but also the behaviour and feel of the fabrics – the sculptural qualities of the broadcloth, the pile of the velvet and the abrupt movement of the semi-transparent shirt ruffle. The painting of this ruffle, the hem clearly visible, is one of the many *tours de force* of this accomplished portrait.

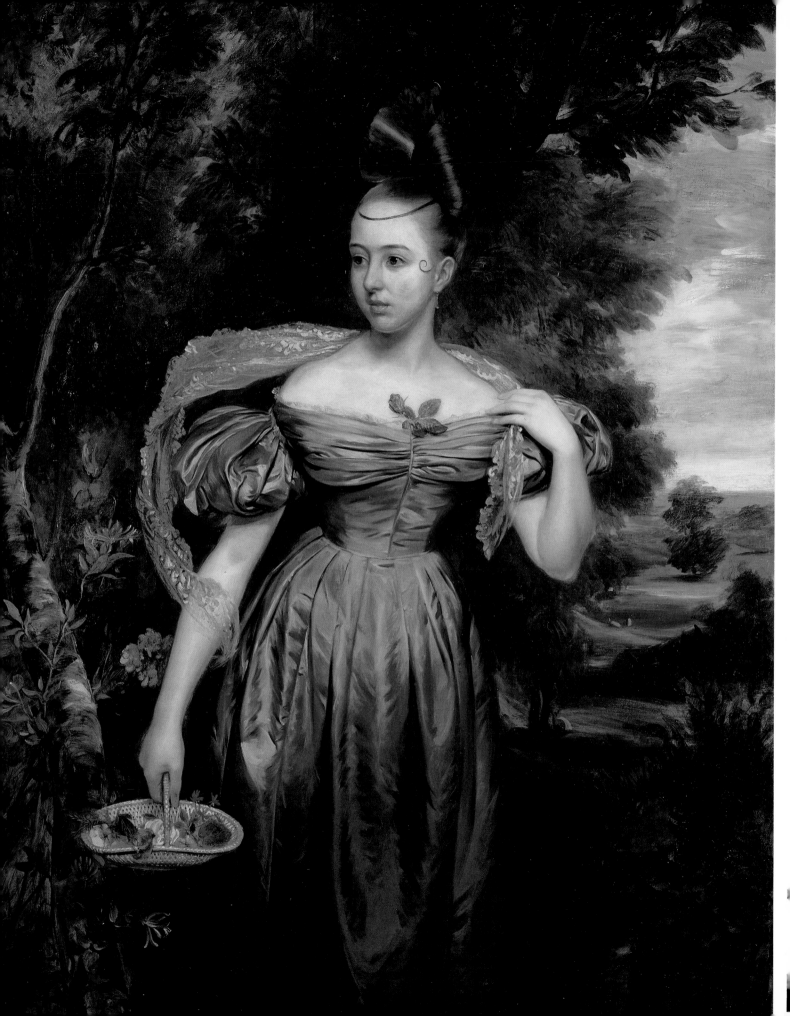

63 CLARA NOVELLO (1818–1908)

Clara Novello came from a famous musical family; she was the daughter of Vincent Novello, organist, composer and music publisher and she stands on his right as he plays the piano in a slightly earlier family group, also by Edward Novello (NPG 5686). Clara's soprano voice was praised by such composers as Mendelssohn and Schumann; she was the original soprano soloist in the first Italian performance of Rossini's *Stabat Mater* (1842), and acclaimed all over Europe.

The 1830s was a decade of extremes in women's fashions, especially, perhaps, when compared to the neo-classical simplicities of the early nineteenth century. Dresses had tiny waists, widening skirts, and – the most characteristic feature of all – large, rounded sleeves, either padded or incorporating a framework of cane, and set well over the shoulder, making it difficult to raise the arms. Hairstyles were particularly elaborate, the hair being gummed into gravity-defying shapes, and often trimmed with ribbons or combs. Silhouettes – like caricatures – are especially good at emphasising the salient forms of such exaggerated styles (*fig. 63.1*).

Clara has clearly followed these fashion dictates and adopted the Apollo-knot coiffure, very much *à la mode*, in which the hair was swept up into stiffened loops. Her forehead is adorned with a *ferronnière* of black silk; this was a band (or bands) of silk or jewellery named after a style seen in a portrait called *La Belle Ferronnière*, attributed

to Leonardo (Paris, Louvre); these delicate forehead decorations were particularly popular in the 1820s and 1830s, part of the continuing vogue for sartorial inspiration taken from the Renaissance.

Clara's dress (formal wear, possibly for a concert performance) is turquoise silk, fitted tightly over the torso, with a low neck and short puffed sleeves; a scarf of *blonde* (silk lace) floats over her shoulders.

63
CLARA NOVELLO
Edward Novello, 1833.
Oil on canvas, 1425 x 1126mm (56⅛ x 44⅜")
National Portrait Gallery, Bodelwyddan Castle, Denbighshire (NPG 5685)

63.1
'Elizabeth Knight by Mr. Gapp of Brighton', 1832. Cut silhouette, height 242mm (9½"), paper on card, 279 x 146mm (11 x 5¾") Private collection

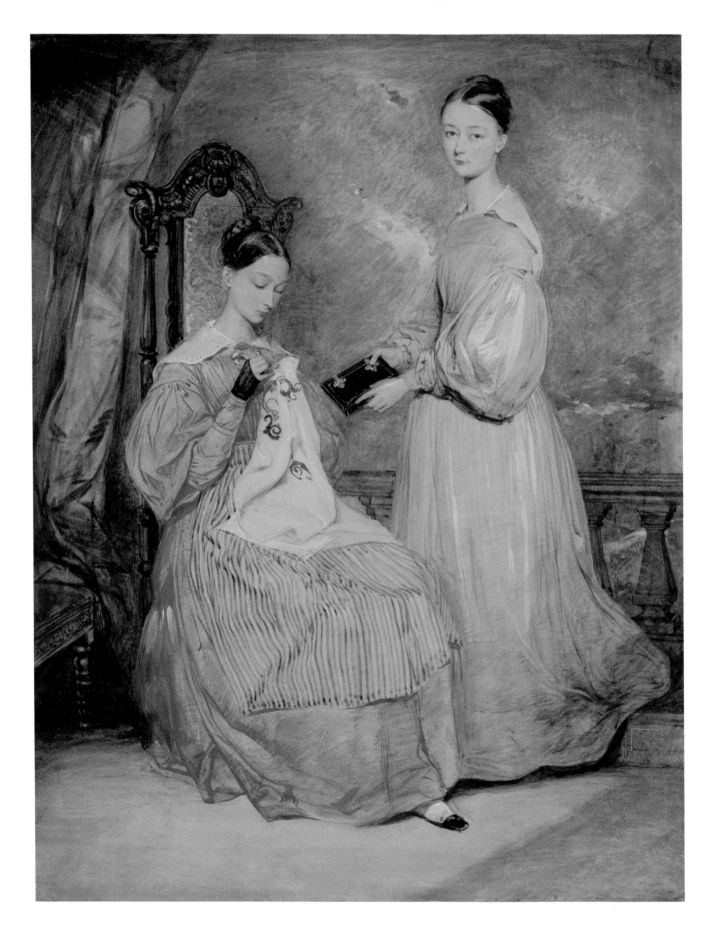

64 FLORENCE NIGHTINGALE (1820–1910) AND HER SISTER PARTHENOPE (d.1890)

64
FLORENCE
NIGHTINGALE
and her sister
PARTHENOPE
William White,
c.1836.
Watercolour,
451 x 349mm
(17¾ x 13¾")
National Portrait
Gallery,
Bodelwyddan
Castle,
Denbighshire
(NPG 3246)

One of the paradoxes of female dress in the 1830s is the way in which a kind of Biedermeier demureness and prettiness can be seen alongside the body-deforming styles of high fashion. In William White's attractive watercolour of the Nightingale sisters, we see them engaged in the archetypally feminine pursuits of reading and sewing. It is hard to foresee the ferociously reforming spirit and steely determination of the future founder of the nursing profession created out of the battlefields of the Crimean War, in the young Florence seated at her embroidery.

The two sisters – Florence in pink and Parthenope in yellow – wear modest versions of the fashion, similarly styled day dresses, made all-in-one, and fastening at the back. The plain, shining silks, large white collars and softly rounded sleeves help to create the effect of a portrait by Van Dyck, an artist who inspired later painters (such as Gainsborough and Lawrence) and was also an inspiration for fancy dress (especially in the eighteenth century), and for mainstream fashion in the 1820s and 1830s.

The Nightingale sisters' large *gigot* (leg-of-mutton) sleeves are typical of the decade; each style was given a name – sleeves full to the wrist (as Parthenope wears) were known as 'imbecile', and those full to the elbow (Florence's choice) were operatic in flavour, known as the 'Donna Maria'. Both Florence and Parthenope have styled their hair simply (no exaggerated Apollo-knot coiffures here), parting it in the centre and arranging it in a small coiled bun towards the back of the head. These neat, smooth and modest hairstyles are echoed by the small, dainty feet clad in black leather square-toed pumps. Such footwear emphasised an elegant instep and a slim ankle clad in knitted white stockings, just as the black net mittens that Florence wears draw attention to the white skin of the hands. She is also wearing a striped apron.

When occasion demanded it – formal afternoon visits or evening wear – women would reveal more neck and bosom, sometimes bare their arms, and adopt more elaborate hairstyles. In John Linnell's 1834 portrait of Sarah Austin (*fig. 64.1*), the sitter (writer, translator and editor of historical works) wears her hair in a modest, unstiffened version of the Apollo knot. Her dress with its horizontally pleated bodice has similar *gigot* sleeves to those worn by the Nightingale sisters, but with the addition of more elaborate and costly lace undersleeves.

64.1
SARAH AUSTIN
(1793–1867)
John Linnell,
1834.
Chalk and pencil,
521 x 416mm
(20½ x 16⅜")
National Portrait
Gallery, London
(NPG 672)

65 CHARLES DICKENS (1812–70)

65
CHARLES
DICKENS
Daniel Maclise,
1839.
Oil on canvas,
914 x 714mm
(36 x 28⅛")
National Portrait
Gallery, London
(NPG 1172)

The young author (*Sketches by Boz,* 1836, and *Pickwick Papers,* 1837, had already appeared) cultivates an almost flashy image here – Dickens's contemporaries remarked on his vanity – with shoulder-length wavy hair, wide-collared black coat and waistcoat, and trousers with foot-straps to preserve an unwrinkled line over his elegant and shining square-toed boots. His expansive black satin cravat is kept in place with two diamond studs.

The artist has captured his sitter's penetrating intelligence and vivacity, as well as his nervous tension. Dickens liked the portrait, as did his friends and fellow-writers. Thackeray claimed that 'a looking glass could not render a better facsimile', and Carlyle, who met Dickens shortly after the portrait was finished, commented on his 'face of most extreme mobility' (he also remarked on the sitter's dandified costume).

Maclise was one of Dickens's closest friends, part of a group that included the aesthete and amateur artist, Alfred, Count d'Orsay, whose portrait by George Hayter (*fig. 65.1*) was painted in the same year. D'Orsay's costume consists of a cut-away black morning coat, two waistcoats (one white, one black), grey trousers and – like Dickens – a black satin cravat. His hair is curled, and his side-whiskers, which look theatrically unreal, reach almost to the middle of his chin.

Whereas, in the portrait of Dickens, the novelist assumes the guise of dandyish man of letters, d'Orsay's whole *raison d'être* was that of the dandy, a type described by Carlyle as a being 'whose trade, office and existence consists in the wearing of clothes'. His world revolved around fashion – the cut of a coat lapel or a trouser leg, the perfection of patent-leather boots, the correct cravat for each occasion and to suit every mood, the best jasmine essence to perfume his primrose-coloured gloves. Such topics were elevated to works of art and discussed with the same seriousness in the salon that he held jointly with Margaret Power, Lady Blessington (famous hostess and writer of trashy novels), where high society mingled with artists and writers. Hayter's portrait, once owned by Lady Blessington, conveys d'Orsay's languid elegance and affectations of manner, as he poses, little finger crooked, with a silver-topped cane decorated with a red tassel.

65.1
ALFRED,
COUNT
D'ORSAY
(1801–52)
Sir George
Hayter, 1839.
Oil on canvas,
1273 x 1016mm
(50⅛ x 40")
National Portrait
Gallery,
Bodelwyddan
Castle,
Denbighshire
(NPG 5061)

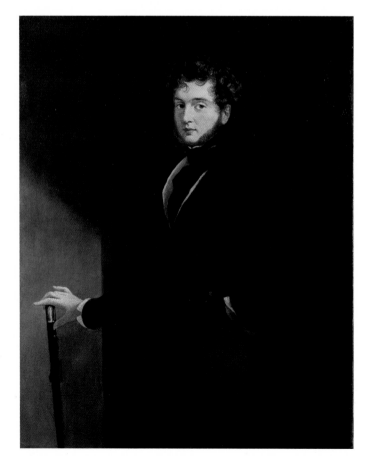

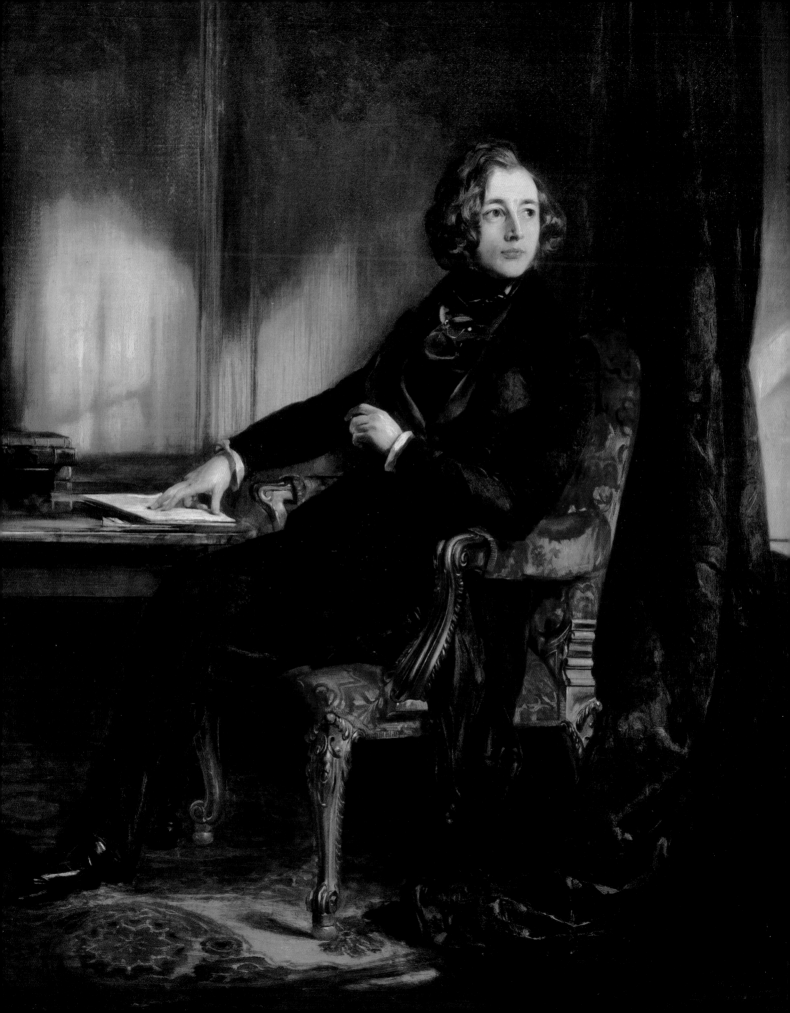

66 GEORGE PAYNE (1803–78) AND HENRY JOHN ROUS (1795–1877)

Nothing is known of the Nottingham artist, George Thompson, who almost certainly copied these portraits from caricatures by Richard Dighton – probably in the 1840s. Such profile portraits – like silhouettes – are both decorative and informative; here they serve to pick out some of the key features in men's costume of the mid-nineteenth century.

Payne and Rous were great friends, united by their love of racing. Payne (on the left) owned racehorses – he was also an unsuccessful gambler. Rous had served in the Royal Navy, retiring from active service in 1835 to devote himself to horse-racing; he became an expert on the sport (he was known as the 'Dictator of the Turf') and a steward of the Jockey Club.

Both men have similar side-whiskers, top hats, and printed silk cravats. Payne is the more formal in dress, wearing a black frock coat and grey trousers; his hands are gloved and he carries the fashionable cane. Rous – perhaps because of his naval background – has chosen comfort rather than formality, wearing a black pea-jacket (or pilot coat) over a double-breasted waistcoat and beige trousers. Rous was famous for his preference for the pea-jacket, an informal, short, square-cut coat associated in particular with sporting occasions. It can also be seen in Richard Dighton's portrait of Henry William Paget, 2nd Earl of Uxbridge and 1st Marquess of Anglesey, at Cowes, in 1845 (*fig. 66.1*).

66
GEORGE
PAYNE and
HENRY JOHN
ROUS
George
Thompson, n.d.
Oil on millboard,
375 x 292mm
(14¾ x 11½")
National Portrait
Gallery,
Bodelwyddan
Castle,
Denbighshire
(NPG 2957)

66.1
HENRY WILLIAM
PAGET, 2nd Earl
of Uxbridge and
1st Marquess
of Anglesey
(1768–1854),
at Cowes.
Richard Dighton,
1845.
Watercolour and
gum over pencil,
254 x 190mm
(10 x 7½")
Private collection

67
ANGELA
GEORGINA
BURDETT-
COUTTS,
Baroness
Burdett-Coutts
Sir William
Charles Ross,
*c.*1847.
Miniature
on ivory,
419 x 292mm
(16½ x 11½")
National Portrait
Gallery,
Bodelwyddan
Castle,
Denbighshire
(NPG 2057)

67 ANGELA GEORGINA BURDETT-COUTTS, BARONESS BURDETT-COUTTS (1814–1906)

Angela Georgina Burdett-Coutts inherited money from her mother Sophia, daughter of Thomas Coutts (founder of the eponymous bank), and a sense of reforming zeal from her father Sir Francis Burdett, a politician of liberal and progressive views. A great philanthropist, Burdett-Coutts used much of her wealth to aid good causes, for which she received a peerage in her own right in 1871. A hint of her educated tastes and good works can perhaps be seen in the book lying on the chair and the papers on her desk, but the overall image is that of a woman with a taste for luxury in dress (later in life she patronised the house of Worth); her costume is the reverse of saintly abnegation, and she led a liberated existence with a number of famous lovers, including the Duke of Wellington (*fig. 60*).

The artist – the last great miniaturist of the nineteenth century, famous for his fine draughtsmanship and colouring – has depicted a woman with a tall, slim and elegant figure (playing down her bad complexion – she suffered from eczema), in pale green silk. Her dress is demure (a characteristic of the 1840s), but with a carefully calculated touch of sexuality in the way that the neckline is cut to suggest it could slide easily off the shoulders. By the second quarter of the nineteenth century, lace was back in favour; it had never been ousted from the wardrobe of fashionable women, but it had suffered a decline during the period of neo-classical informality and simplicity. Both the traditional hand-made needle and bobbin laces were in vogue (Burdett-Coutts collected old lace), as well as the newer machine-made versions (*fig. 67.1*). In Ross's miniature, the sitter's dress is trimmed with a double lace flounce on the bodice, and wound round her is a large stole, probably of *blonde* bobbin lace on a machine-net ground (*fig. 67.2*), one end of which falls over the back of the red cut-velvet chair on which she leans.

Her dark glossy hair ('like a raven's wing' was a popular phrase of approbation) is parted in the centre, looping over the ears and coiled at the back into a large plaited bun. The black velvet bracelets (the right one has a large pink topaz pinned to it) draw attention to her elegant hands; the fingers of her left hand touch her chin in the traditional gesture of contemplation.

67.1
Shawl of appliqué bobbin lace on machine-net ground, Brussels, *c.*1850. Victoria and Albert Museum, London

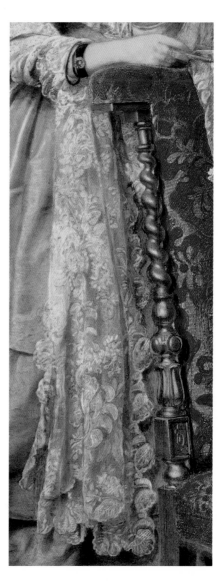

67.2
Detail of *fig. 67*.

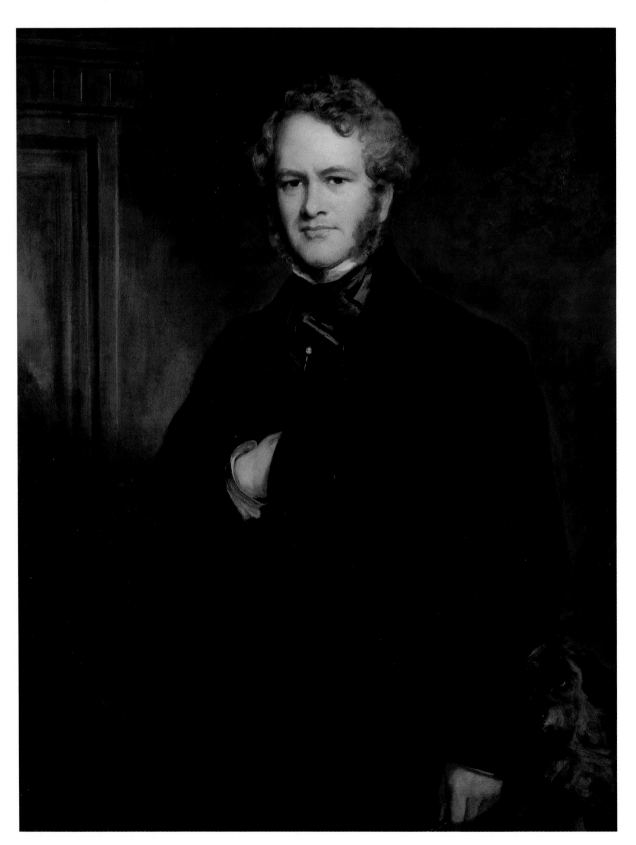

68
SIR EDWIN
HENRY
LANDSEER
Sir Francis
Grant, 1852.
Oil on canvas,
1143 x 892mm
(45 x 35⅛")
National Portrait
Gallery,
Bodelwyddan
Castle,
Denbighshire
(NPG 834)

68 SIR EDWIN HENRY LANDSEER (1802–73)

In Grant's portrait, the popular artist and famous animal painter (he designed the lions for Nelson's monument in Trafalgar Square) is the epitome of what the Victorians called 'a handsome figure of a man'. He wears an all-embracing, tightly buttoned black woollen frock coat, and the only other features of his clothing that can be seen are the stiffened wing collar of his shirt and a black satin cravat kept in place by a pearl pin. The formal monotony of the costume is only slightly lightened by the traditional gesture of the hand placed mid-chest between the buttons of the coat; here there is also a glimpse of linen shirt cuff set against the prevailing black.

As an artist patronised by royalty and the Establishment, Landseer dressed appropriately as a stylish and prosperous professional man; his views on the subject of 'artistic' clothing echoed those of John Everett Millais (Millais in his maturity, that is), whose son wrote: 'He hated the affectation of the long-haired and velvet-coated tribe, whose exterior is commonly more noticeable than their art, and just dressed like other men according to circumstances of time and place.'

For most artists who painted for an upper- and middle-class clientele and who worked in a climate of conformity and uniformity in male formal costume (especially strong in the middle decades of the nineteenth century), there was little that could be made in the way of revolutionary sartorial gestures, and only modestly unconventional touches can be observed in images of artists. For example, Frank Holl's fine 1863 self-portrait (*fig. 68.1*) shows only mild defiance of the prevailing codes of dress and appearance in his soft shirt collar, purple silk cravat and longish hair. By the end of the century, in a mood of *fin-de-siècle* challenge to authority, more artists were becoming self-consciously 'artistic' in their costume (this was what Millais and those who thought like him disliked as 'affectation'). However, many artists continued to dress conventionally, and in Ernest Borough Johnson's portrait of Hubert von Herkomer (portraitist, social realist and stage designer) of 1892 (*fig. 68.2*), we can still see the customary dark coat and waistcoat, with only the smallest touch of artistic eccentricity in his choice of a yellow necktie.

68.1
FRANCIS
MONTAGUE
(FRANK) HOLL
(1845–88)
Self-portrait,
1863.
Oil on canvas,
508 x 406mm
(20 x 16")
National Portrait
Gallery,
Bodelwyddan
Castle,
Denbighshire
(NPG 2531)

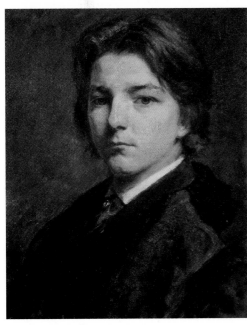

68.2
SIR HUBERT
VON
HERKOMER
(1849–1914)
Ernest Borough
Johnson, 1892.
Oil on paper,
340 x 235
(13⅜ x 9¼")
National Portrait
Gallery,
Bodelwyddan
Castle,
Denbighshire
(NPG 3175)

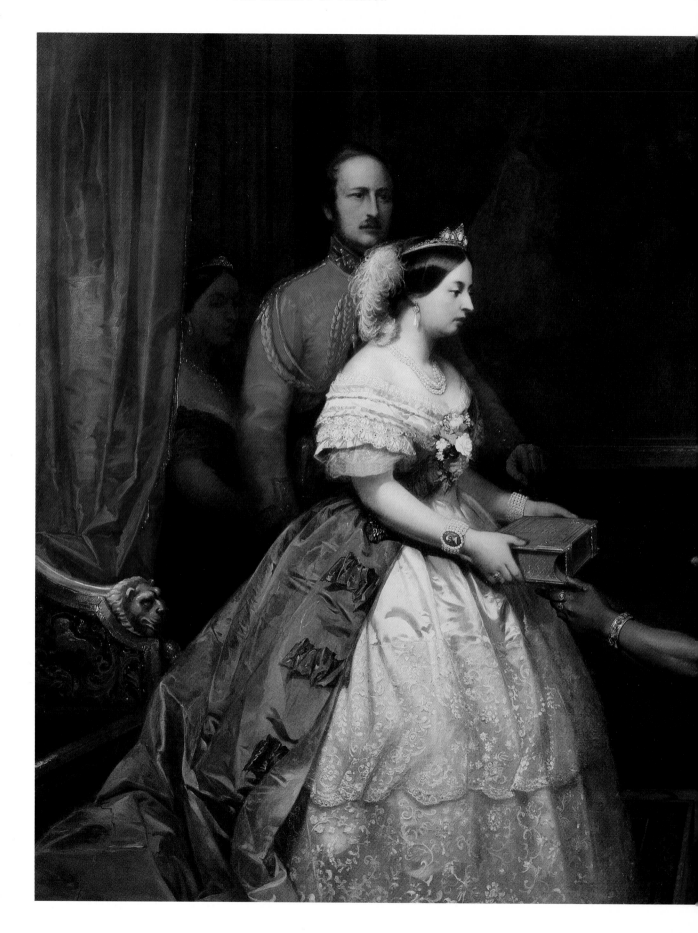

69

The Secret of England's Greatness (Queen Victoria Presenting a Bible in the Audience Chamber at Windsor)
Thomas Jones Barker, early 1860s.
Oil on canvas, 1676 x 2138mm (66 x 84⅛")
National Portrait Gallery, London (NPG 4969)

69 QUEEN VICTORIA (1819–1901)

It is unlikely that this puzzling painting (there is some dispute over the date) refers to a specific occasion; it was probably intended as an allegory of Empire – the costume of the kneeling African potentate, is largely theatrical and imaginary. The scene is the audience chamber at Windsor Castle; on the left we see Queen Victoria attended by Prince Albert and the distant figure of a lady-in-waiting, and on the right the shadowy figures of Lord John Russell and Viscount Palmerston in Royal Household levee dress.

The dominant figure – inevitably, in view of her regal dignity, and literally in terms of her vast crinolined costume – is that of Queen Victoria, wearing court dress. This consists of an evening dress of white satin liberally festooned with lace (*blonde* on the bodice and two large flounces of bobbin appliqué on machine-made net on the skirt), to which is attached a court train of blue watered silk decorated with large ribbon bows down the sides. Feathers were traditionally worn with court dress and Victoria has a white ostrich feather in her hair, held in place by a delicate opal tiara. Her other jewellery comprises the star of the Order of the Garter pinned to the blue sash of the Order, pearl earrings, necklace and bracelets – the one nearest to the viewer contains a miniature of the Prince Consort. Queen Victoria, although interested in clothes – at least, until she became a widow at the end of 1861 – had little sense of style, her personal taste being a

179

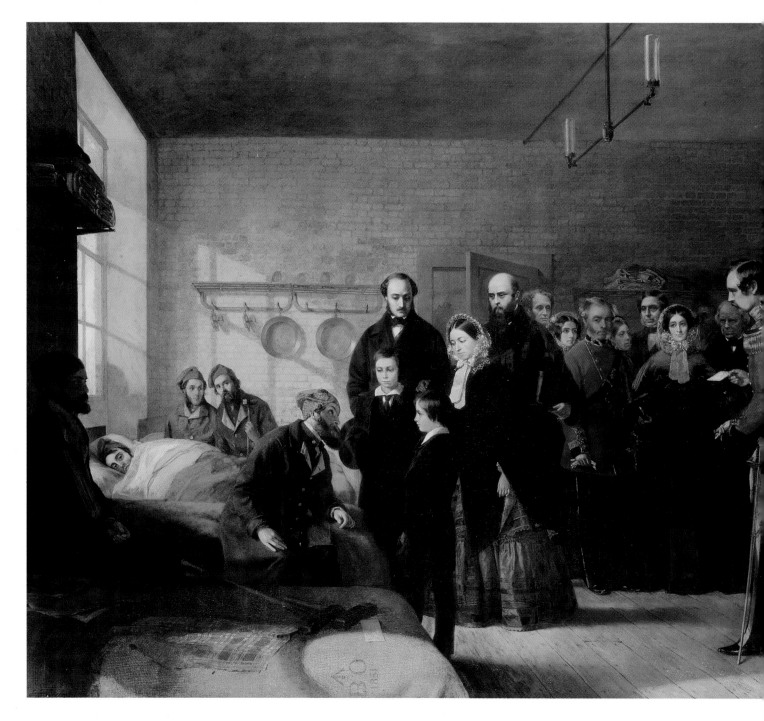

mixture of the bourgeois and the grandiose; the bell-shaped skirts of the 1850s and 1860s, adorned with frills and flounces, did not suit her small and increasingly plump figure.

In Jerry Barrett's painting of the Queen (*fig. 69.1*), accompanied by Prince Albert and their two eldest sons, visiting soldiers wounded in the Crimea at the Brompton Hospital in Chatham, Victoria's style of dress is equally fussy and cluttered. She wears a flounced blue taffeta day dress, striped in black and white, under a black velvet *visite* (a loose, sleeved mantle) and on her head is a cap of *blonde* lace from Caen beneath a pink silk bonnet.

As many people do, Queen Victoria became more critical of fashion as she grew older; in a letter to the Prince of Wales in 1858 she described it as 'a trifling matter', but she noted that 'it gives also the one

69.1
*Queen Victoria's First Visit to her
Wounded Soldiers*
Jerry Barrett, 1856.
Oil on canvas,
1419 x 2133mm (55⅞ x 84")
National Portrait Gallery, London
(NPG 6203)

69.2
*The Opening of the Royal Albert Infirmary
at Bishop's Waltham*
Unknown artist (signed F. W.), c.1865.
Oil on canvas,
838 x 1143mm (33 x 45")
Natonal Portrait Gallery, Bodelwyddan
Castle, Denbighshire (NPG 3083)

outward sign from which people in general can and often do judge upon the *inward* state of mind…' These feelings were reinforced by the death of Prince Albert in 1861 (there is some evidence that the Queen – both consciously and unconsciously – blamed her eldest son's love of extravagance and fashion for the early death of her husband), after which she wore mourning for the rest of her life. The royal children were urged to avoid the very latest fashions, and to wear modest interpretations of current modes, especially on public occasions. In the painting by 'F. W.' (*fig. 69.2*), which records a concert held at the Royal Albert Infirmary at Bishop's Waltham, Hampshire, in 1865 in honour of the Prince Consort, the Princesses Helena and Louisa are dressed alike in simple brown woollen jackets and skirts, white bonnets trimmed with blue silk ribbons and matching sealskin muffs.

70 ANN MARY NEWTON (1832–66)

The sitter moved in artistic and intellectual circles. She came from an artistic background (being the daughter of Joseph Severn, who painted John Keats, *fig. 61.1*), and was an artist herself, studying in Paris and exhibiting several times at the Royal Academy. She was married to the archaeologist Charles Newton, Keeper of Classical Antiquities at the British Museum. Her dress is made of embroidered peacock-blue silk, with shoulder 'epaulettes', in a style reminiscent of Renaissance costume; her hair is parted in the centre and combed back into a net, which is held in place by a ribbon; her jewellery is simple, comprising a jet necklace and a gold and garnet bracelet.

This is one of the earliest images of a woman artist in 'artistic' costume, a concept foreign to earlier periods, when female self-portraits either depict high fashion in order to underline social and professional status, or show invented draperies (see *fig. VII*). Artistic dress arose in the mid-nineteenth century in reaction to a materialistic age dominated by the over-consumption of finery, and such technological innovations as the chemical dyes of the late 1850s, which critics claimed made women's clothing a brightly coloured and vulgar display. Artistic dress was basically a simpler version of fashion without its excessive artifice (omitting, for example, the wearing of the crinoline), and in more subtle, muted colours. It often incorporated 'historical' features, in the belief that the dress of the past was intrinsically more beautiful than that of the present. Under the influence of the Pre-Raphaelite artists in particular, many women moving in similar circles to Ann Mary Newton wore clothing inspired by the Middle Ages and the Renaissance.

In a similar vein, the portrait by Pauline, Lady Trevelyan (*fig. 70.1*), of her friend Emilia Pattison, who later married Sir Charles Dilke (see *figs 73* and *73.1*) shows the sitter in a dress, the square neckline and large pattern of which (printed or embroidered in imitation of a cut velvet of the Renaissance) indicates the influence of sixteenth-century costume, as does her puffed hairstyle. The sitter's husband remarked that the costume in this portrait 'is that of the Venetian colour revival, inaugurated by Dante [Gabriel] Rossetti and his friends'.

70.1
EMILIA
FRANCES
PATTISON,
later Lady Dilke
(1840–1904)
Pauline Trevelyan
and Laura Capel
Lofft (signed
L. Capel Lofft),
*c.*1864.
Oil on millboard,
254 x 181mm
(10 x 7⅛")
National Portrait
Gallery, London
(NPG 1828A)

70
ANN MARY
NEWTON
Self-portrait,
*c.*1862.
Oil on canvas,
610 x 521mm
(24 x 20½")
National Portrait
Gallery,
Bodelwyddan
Castle,
Denbighshire
(NPG 977)

71 ALEXANDRA, PRINCESS OF WALES (1844–1925)

Unlike many women of the British royal family, the Danish-born Princess Alexandra had a sense of style and enjoyed fashion. In this respect she anticipated a later Princess of Wales, Princess Diana; both women also knew instinctively how to pose for the camera, the results often being more appealing than their painted images.

At the time of this photograph, Princess Alexandra's clothes usually came from Elise in Regent Street, but from 1878 she also patronised Worth. Here she wears a day dress of spotted and plain silk, cut in the flattering style later known as *en princesse*, named by Worth in her honour in 1875. This was a dress consisting of a bodice cut in one with the skirt (there was no waist seam, the smooth fit being achieved by long darts from bust to hip), and with the back drapery looped up to create a bustle (a revival of the *polonaise* style seen in *fig. 51*). It was worn over another skirt, usually plain, as we can just see from the photograph. Here, the pleated cotton ruff and matching cuffs give a slight historical touch to the costume. In an unconscious echo, perhaps, of the bustle, women's hair in the 1870s was pulled back to reveal the ears, piled high on the head and gathered into a large chignon at the back. Women whose own hair was scanty wore false hair to achieve the desired height and bulk.

Again – like Princess Diana – Princess Alexandra was tall and slim, and looked good in all types of costume, formal and informal. In an age when photography ensured a more rapid dissemination of the latest modes than hitherto, Alexandra was the first member of the royal family to have fashions named after her, and to set trends in informal wear, which (as noted earlier) is where novelties and experimental styles usually first appear. The Prince and Princess of

Wales, who were the real leaders of society (Queen Victoria taking on the role of the 'Widow of Windsor'), were fond of visiting Cowes on the Isle of Wight for the annual naval regatta, and in a photograph of Princess Alexandra of about the same time (*fig. 71.1*), she wears another version of the princess line, inspired by naval uniform, and carries a beribboned straw hat like those worn by men for rowing. Her costume might have been made by the firm of Redfern, which began as a draper's in Cowes, and by the 1870s was making 'yachting and sea-side costumes'; they also made riding habits and the tailored suits that had become an essential part of the female wardrobe by the end of the century.

71
ALEXANDRA, PRINCESS OF WALES
Photograph by Maull & Co., London, 1873. Toned bromide cabinet print, 130 x 90mm (5⅛ x 3½") National Portrait Gallery, London (NPG x33252)

71.1
ALEXANDRA, PRINCESS OF WALES
Photograph by Russell & Sons, Chichester, *c.*1873. Museum of London

72 ADELINA PATTI (1843–1919)

72
ADELINA PATTI
James Sant,
exhibited 1886.
Oil on canvas,
1099 x 851mm
(43¼ x 33½")
National Portrait
Gallery, London
(NPG 3625)

72.1
ADELINA PATTI
Barraud, 1889.
Carbon print,
246 x 178mm
(9¾ x 7")
National Portrait
Gallery, London
(NPG Ax5451)

The great Spanish-born *coloratura* soprano made her London debut at Covent Garden in 1861, in Bellini's *La Sonnambula*; she married three times, became a naturalised Briton in 1898, and retired to Wales. She was not famed for her looks (early photographs of her as a young woman show how plain she was); middle age and slight embonpoint suited her better. Here she is portrayed, not in an operatic role (although her gesture with the fan does have a slight touch of theatricality about it, and she is more heavily made up than was usual in England), but in a fashionable and luxurious ensemble of ruched and pleated chiffon. Sant, a fashionable society artist, has skilfully captured the shifting, cobwebby feel of the fine silk, and recorded the intricate dressmaking with its convoluted layers and asymmetrical draperies.

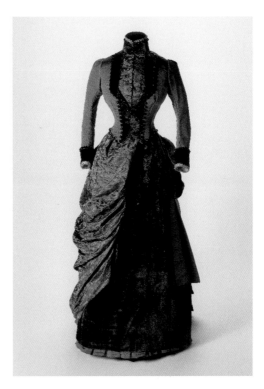

72.2
Velvet and silk
dress, mid-1880s.
Museum of
London

Patti's whole appearance pays tribute to the conspicuous consumption of a very wealthy and fashionable woman, from the ermine wrap behind her, the dress itself and the harmonising pale pink swansdown fan, to the jewellery she wears, pearls round her neck, and diamonds scattered liberally – in her ears, in her tightly curled hair, in the bracelet on her gloved wrist, in the brooch on her bodice and the clip that holds the small posy of flowers at her shoulder. She spent lavishly on clothes, both on and off the stage, and she was a valued customer of Worth, who may well have created the dress in the Sant portrait. Worth's signature-note at this time – a love of cunningly contrived, asymmetrical draperies – can also be seen in a photograph by Barraud, taken a few years later (*fig. 72.1*); here she wears a very tight-sleeved dress of printed silk with a design of thistles and sunflowers, a belt of moiré silk round her tightly corseted waist. The complex dressmaking of the period can be seen in a dress of blue silk and velvet plush dating from the mid-1880s (*fig. 72.2*); this consists of a very tightly fitting bodice with a mock waistcoat front, and a layered skirt with asymmetrical drapery.

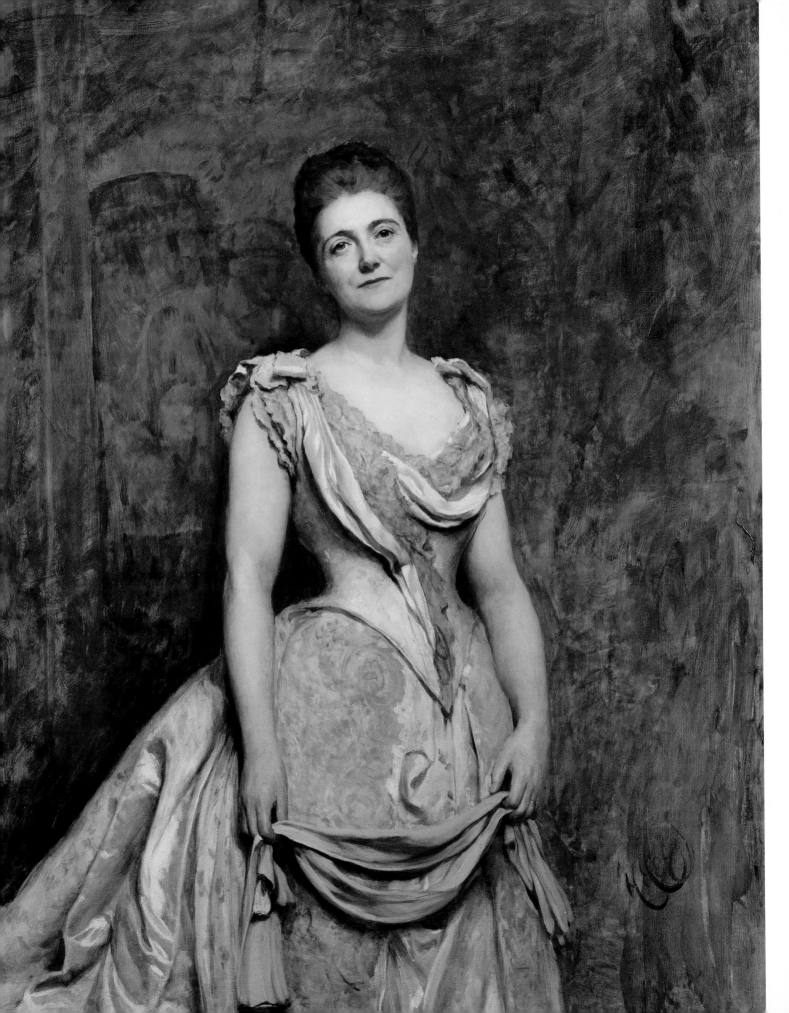

73 EMILIA FRANCES, LADY DILKE (1840–1904)

This portrait was painted shortly after the sitter's second marriage to the Liberal politician Sir Charles Dilke. Lady Dilke was a writer and art historian; she was also active in the reform of women's working conditions and in the movement for female suffrage. Here she has chosen to be painted neither in the kind of artistic costume of an earlier portrait (*fig. 70.1*), nor in the tailor-made suit that many progressive and professional women wore, but in a fashionable evening dress of heavy greyish-white satin trimmed with lace. Never a beautiful woman in the conventional sense, she is not flattered by the artist, but her intelligence and engaging personality are clearly shown. A middle-aged woman, her figure owes more to art than to nature, enhanced as it probably is by the new steam-moulded corset, which was advertised as giving the best fit and exceptionally curvaceous lines.

As in all fashionable female costume of the period, under-structures of various kinds (known as 'dress-improvers') were worn under the skirt to help create the back fullness in vogue. Under her dress, Lady Dilke wears a bustle (referred to in the fashion magazines as a *tournure*) of wire and/or horsehair, which helps to create the heavy, sculptural folds characteristic of the formal toilette with its train. Herkomer has solved the problem of what to do with the hands by making a feature of Lady Dilke's long pale yellow evening gloves, which she holds in an echo of the pleated and swagged drapery on her bodice.

No doubt her art-historical knowledge would make her particularly aware and appreciative of the way in which – by the 1880s – the eighteenth century had begun to influence fashionable dress. It can be seen, very subtly, in the draping of the bodice, and the lace decoration on her dress. It can also be seen in the costume that she wears in a miniature portrait by Charles Camino of 1882 (*fig. 73.1*). Here the sitter's velvet over-dress is gathered up at the back in imitation of the *polonaise* gowns of the 1770s and 1780s (see *figs 51* and *51.3*, for example), and the lace collar, large buttons of the dress, jabot and sleeve ruffles, as well as the diamond aigrette in her hair, all indicate a revival of interest in *ancien-régime* taste and luxury.

73
EMILIA
FRANCES,
LADY DILKE
Sir Hubert von
Herkomer, 1887.
Oil on canvas,
1397 x 1092mm
(55 x 43")
National Portrait
Gallery,
Bodelwyddan
Castle,
Denbighshire
(NPG 5288)

73.1
EMILIA
FRANCES,
LADY DILKE
Charles Camino,
1882.
Miniature
on ivory,
140 x 195mm
(5½ x 3¾")
National Portrait
Gallery, London
(NPG 1828)

74 SIR ARTHUR SULLIVAN (1842–1900)

Inextricably linked with W. S. Gilbert in the famous partnership that produced the Savoy light operas (although he wished to be equally remembered for his choral works and orchestral music), Sullivan appears here every inch the successful, conventionally dressed professional man. He could equally be, say, a prosperous solicitor, a banker or a businessman in terms of his appearance. His image is a study in black, grey and white, an undemanding foil to the personality of the sitter – Sullivan liked the portrait, finding it 'a vivid likeness and a splendid picture'. His hair is centrally parted and oiled (probably with macassar oil from Makasar in Indonesia, hence the need for anti-macassars to protect furniture where the head rested), and he wears a black frock coat, the collar faced with silk, tightly buttoned across his chest. A white shirt with a starched wing collar, a loosely knotted black silk tie and grey trousers complete his appearance. The only touches of personal taste in the costume are the gold cuff-links on the starched cuffs of his shirt and a monocle (a form of eye-glass popular since the middle of the nineteenth century) hanging from a black string round his neck.

74
SIR ARTHUR
SULLIVAN
Sir John Everett
Millais, 1888.
Oil on canvas,
1156 x 870mm
(45½ x 34¼")
National Portrait
Gallery, London
(NPG 1325)



75.1
JOSEPH
CHAMBERLAIN
John Singer Sargent,
1896.
Oil on canvas,
1619 x 914mm
(63¾ x 36")
National Portrait
Gallery,
Bodelwyddan Castle,
Denbighshire
(NPG 4030)

include the monocle, the orchid, the gold pin in the dark printed silk neck-tie, the gold signet ring on the little finger of the left hand. They are set against the formal, deliberately characterless costume that custom dictated for a man of Chamberlain's class, the severe rectangular frock coat, black waistcoat and grey trousers.

In Hall's portrait Balfour's languid manner is especially noticeable, as befits a man who was a leading member of the 'Souls' – a dilettante group of élite men and women who dabbled in the arts – and his attire is slightly less formal than that of Chamberlain. The suit is conventional enough, the lapels of the frock coat faced with silk, his pince-nez dangling on a gold chain round his neck, but his shirt collar is unstarched and turns over a discreet bow-tie.

76 AUBREY VINCENT BEARDSLEY (1872-98)

One of the strands that made up the aesthetic movement of this period was a love of the eighteenth century, a feature already noted in women's costume (see *fig. 73.1*). In Blanche's portrait of Beardsley (painted in Dieppe, whence the sitter had fled in order to avoid the adverse publicity resulting from the trial of Oscar Wilde), the artist depicts

not just the foppish figure of a Regency dandy, but an aristocrat of the *ancien régime* as well.

Blanche thought that Beardsley looked like the young viscount in Hogarth's *Marriage à la Mode*, and to underline this image of elegant depravity, has given him two black beauty spots (in the Hogarth painting these

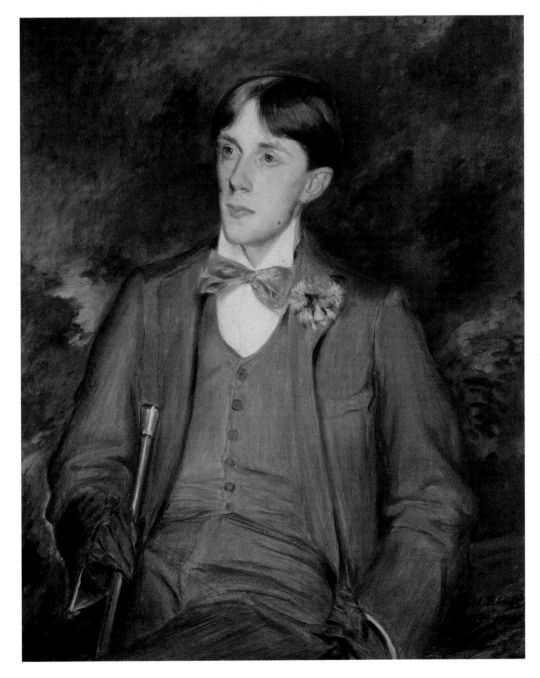

76
AUBREY
VINCENT
BEARDSLEY
Jacques-Emile
Blanche, 1895.
Oil on canvas,
902 x 718mm
(35½ x 28¼")
National Portrait
Gallery, London
(NPG 1991)

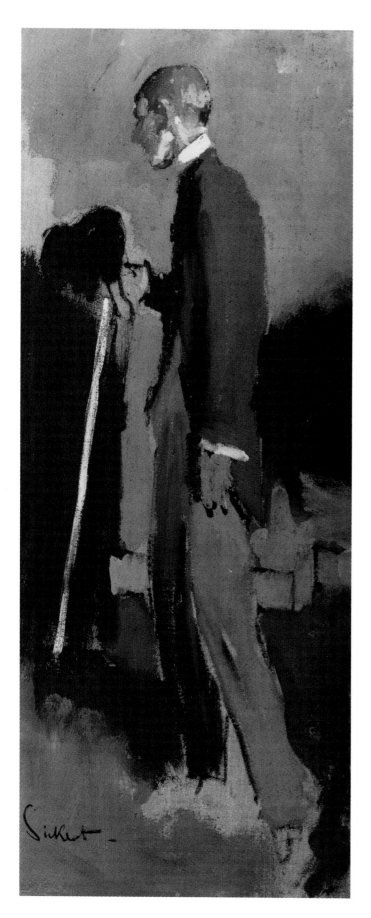

'beauty spots' are patches covering the effects of venereal disease).

Beardsley's highly stylised graphic art – French eighteenth-century fashion plates were among the many influences on his work – and erotic imagery made him a prominent figure in the *fin-de-siècle* artistic and literary world. It was almost as if he had been invented by Oscar Wilde, and – like Wilde – his death was suitably 'artistic', even Romantic, for he died of consumption. Like Wilde, he liked to wear light colours – thus cocking a snook at the funereal clothes of the Establishment, and here he wears a suit of light grey with a matching waistcoat, a bow tie of shot silk and a pink carnation in his buttonhole; he always wore gloves and carried a cane, as dandies such as Count d'Orsay (*fig. 65.1*) had done.

Blanche records the costume and appearance of his sitter, especially Beardsley's delicate bone structure, his fine floppy hair and his aesthetic manner, but it is left to Sickert (*fig. 76.1*) to capture his personality, the thin, attenuated figure of the consumptive, and his extraordinary gait. Sickert saw Beardsley at the – very appropriate – unveiling of a memorial to Keats in Hampstead Church in 1894, and painted him in 'semi-dress' wear appropriate for such an occasion – a black cut-away morning coat, grey trousers and a black silk top hat. Close to a caricature, Sickert has exaggerated the tight line of the coat, the trouser legs, and the stiff high collar, but succeeded in conveying the essence of his character, as his friends knew him. Among them was Max Beerbohm, who found Beardsley 'more like a ghost than a living man', recalling: 'the thin face, white as the gardenia in his coat, and the prominent harshly-cut features, the hair, that always covered his whole forehead in a fringe, and was of so curious a colour – a kind of tortoiseshell, the narrow angular figure, and the long hands that were so full of power.'

76.1
AUBREY
VINCENT
BEARDSLEY
Walter Sickert,
1894.
Oil on canvas,
762 x 311mm
(30 x 12¼")
Tate Gallery,
London

77 GERTRUDE ELIZABETH, LADY COLIN CAMPBELL (1858–1911)

Boldini's particular expertise lay in painting fashionably stylised images of *fin-de-siècle* society women, whose often rather risqué lives are epitomised here by Lady Colin Campbell. Divorced in 1886 by her husband on the grounds of her multiple adulteries, she counter-claimed adultery on his part, and during the trial, which attracted immense publicity, she sat to Whistler in a white satin dress by Worth (the portrait, *Harmony in White and Ivory*, is either lost or destroyed). As a result of the scandal surrounding the divorce, Lady Colin was ostracised, resuming her place in society only after her ex-husband's death in 1895. She wrote books on

77
GERTRUDE
ELIZABETH,
LADY COLIN
CAMPBELL
Giovanni
Boldini, *c*.1897.
Oil on canvas,
1822 x 1175mm
(71¾ x 46¼")
National Portrait
Gallery, London
(NPG 1630)

77.1
ALICE
HELLEU, the
artist's wife
Paul Helleu,
*c.*1892.
Three-colour
crayon drawing
Private collection

etiquette, and became an art critic for
The *Art Journal* and the *World*, bequeathing
this portrait to the National Portrait Gallery.

Sickert famously referred to Boldini's
talents in 'the wriggle and chiffon school of
portraiture', of which this must be a prime
example. Lady Colin's impossibly attenuated
anatomy is emphasised by her evening
dress of black satin (doubtless, what contem-
porary fashion magazines called '*distinguée*'),
which clings to her body. Her figure and
skin are set off by her dress, by the black
chiffon scarf, by her black silk stockings and
patent leather shoes; the roses draw atten-
tion to her plunging décolletage and the
long pointed bodice shows off her tiny waist
and curving hips. With such a costume,
Lady Colin has little need of jewellery, and
wears only the simplest bangles, which

emphasise the beauty of her arms. She is
all curves and sinuous art-nouveau lines,
stylishly exaggerated like a fashion plate
or a drawing by Helleu (*fig. 77.1*).

A not too dissimilar dress – but a world
removed in its treatment and mood – is seen
in the replica of Fildes's portrait of Princess
Alexandra of 1894 (*fig. 77.2*), in which the
Princess wears a low-necked dress of black
silk with sleeves of chiffon and a gold snake
bracelet set with rubies, pearls and dia-
monds. In addition, she wears her character-
istic pearl choker (she had a scar on her
neck which she wished to hide, and in so
doing set the fashion for this form of neck-
lace) and a double rope of pearls pinned
to her bodice. The small black-and-white
Japanese dog that she holds complements
her dress and the white colour of her skin.

77.2
ALEXANDRA,
PRINCESS OF
WALES
(1844–1925)
After Sir Luke
Fildes, 1920
(1894).
Oil on canvas,
1283 x 1029
(50½ x 40½")
National Portrait
Gallery, London
(NPG 1889)

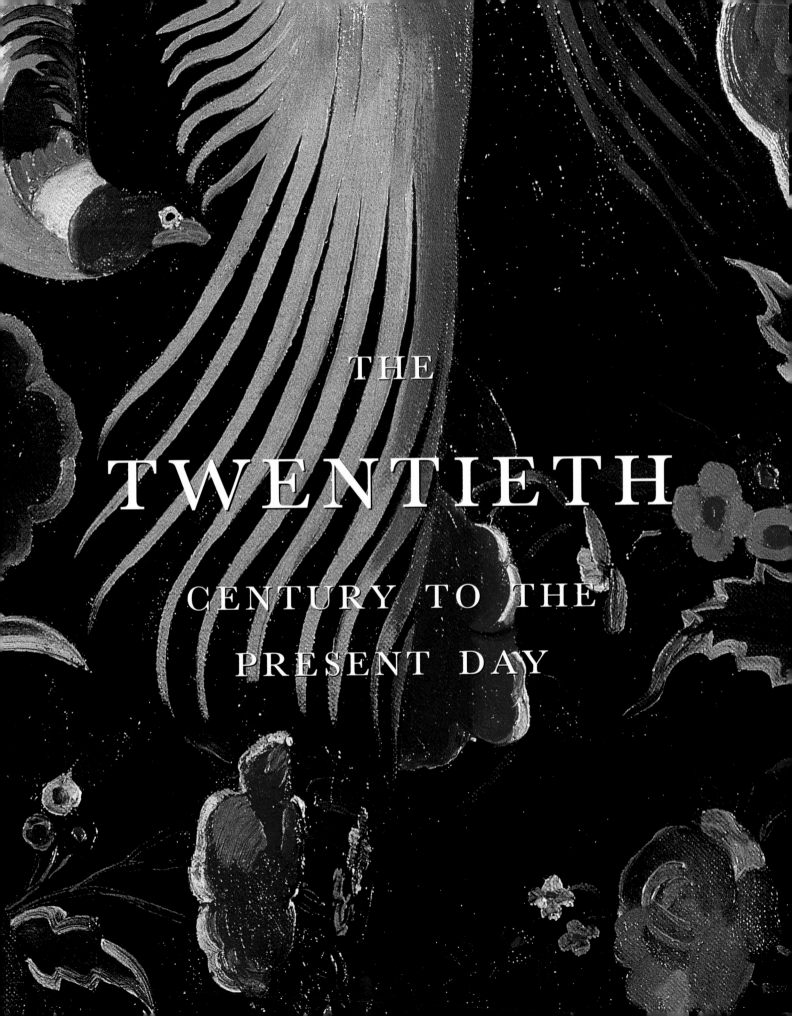

THE TWENTIETH

CENTURY TO THE PRESENT DAY

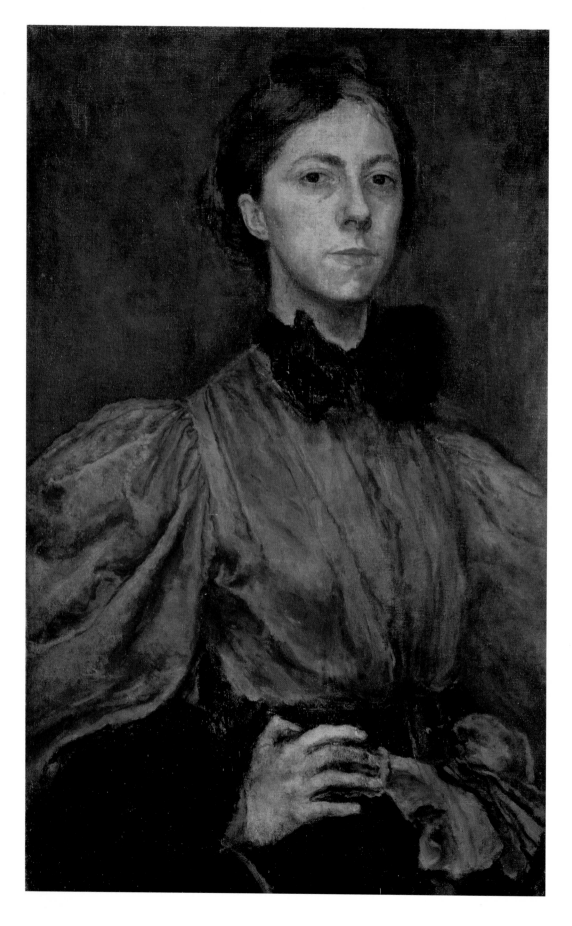

78
GWEN JOHN
Self-portrait,
*c.*1900.
Oil on canvas,
610 x 378mm
(24 x 14⅞")
National Portrait
Gallery, London
(NPG 4439)

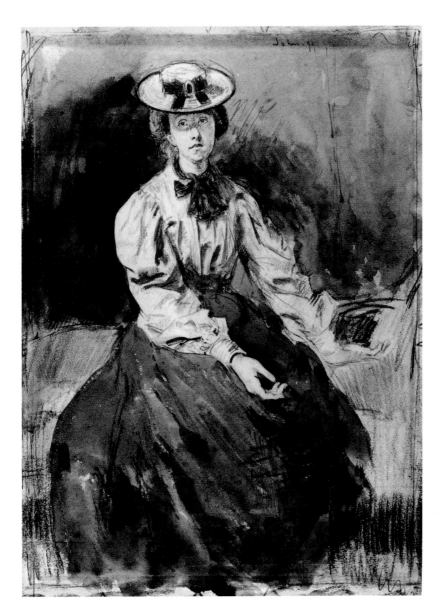

78.1
GWEN JOHN
Augustus John,
1899.
Watercolour
on paper,
338 x 243mm
(13⁵/₁₆ x 9⁹/₁₆")
British Museum,
London

78 GWEN JOHN (1876–1939)

The artist – principally famous for her quiet and almost obsessive still-lifes, interiors and portraits – was trained at the Slade School of Art in London from 1895 to 1898, and then studied in Paris until 1899, where she was taught by Whistler. She lived permanently in France after 1903, and was an intimate friend of Rodin.

This portrait was painted in London, the sitter depicting herself in a bronze-coloured 'Russian' blouse, belted at the waist over a black skirt. A soft black silk bow at her neck complements the wide black belt and the mantle or shawl over her arm, and her hair is gathered up into a large, loose bun which falls over the back of her head. It is a strong, challenging and self-confident image, with a bravura more typical of her brother's portraits. Augustus John drew Gwen a year or so earlier (*fig. 78.1*) in a similar costume (a kind of art student uniform), with the addition of a straw hat perched rather unconvincingly on the top of her head; here the sitter looks less assured, and has the kind of introspection and abstracted gaze typical of many of her portraits.

79 SIR MAX (HENRY MAXIMILIAN) BEERBOHM (1872–1956)

The writer and cartoonist Max Beerbohm was part of an artistic circle that included Oscar Wilde and Beardsley (*fig. 76*). His image, inspired by his hero Beau Brummell, was that of a dandy of taste and refinement. The artist William Rothenstein met him at Oxford in 1891 and noted: 'A baby face, with heavily lidded light grey eyes shaded by remarkably thick and long lashes, a broad forehead, and sleek black hair parted in the middle and coming to a queer curling point at the neck; a quiet and finished manner; rather tall, carefully dressed; slender fingered, with an assurance and experience unusual in one of his years.'

In this portrait Nicholson has emphasised

79
SIR MAX
(HENRY
MAXIMILIAN)
BEERBOHM
Sir William
Nicholson, 1905.
Oil on canvas,
502 x 400mm
(19¾ x 15¾")
National Portrait
Gallery, London
(NPG 3850)

79.1
WALFORD
GRAHAM
ROBERTSON
(1866–1948)
John Singer
Sargent, 1894.
Oil on canvas,
914 x 711mm
(36 x 28")
Tate Gallery,
London

the bone structure of the head, with the hair plastered to the skull; he has caught the gleam on the top hat, the silver top of the cane and the shine on the patent leather shoes. Beerbohm wears a long double-breasted Chesterfield coat, a slightly fitted overcoat, usually with a velvet collar, popular since the 1840s (it developed out of the frock coat), when it was named after the 6th Earl of Chesterfield, who was a fashionable society figure.

It was this coat that largely helped to create the fashionably elongated and tubular male figure of the 1890s and the first decade of the twentieth century. An artist such as Sargent, with a natural eye for fashion, quickly saw the artistic possibilities of such a garment, and in his portrait of the writer, artist and theatre designer Walford Graham Robertson of 1894 (*fig. 79.1*), it is the Chesterfield coat that dominates the painting. The sitter recalled the discomfort of posing for Sargent (it was summer), who 'used to pull and drag the unfortunate coat more and more closely round me until it might have been draping a lamp post'.

Like Beerbohm, Robertson holds a cane (it has a jade handle), for this was a fashionable *fin-de-siècle* accessory, a revival of the dandy fashions of the early nineteenth century that Beerbohm did much to encourage. Even in his old age, Beerbohm was often portrayed in the austere black-and-white palette associated with the dandy, along with a cane and gloves (*fig. 79.2*).

79.2
SIR MAX
(HENRY
MAXIMILIAN)
BEERBOHM
Cecil Beaton,
1930s.
Bromide print
on white card
mount,
187 x 235mm
(7⅝ x 9¼")
National Portrait
Gallery, London
(NPG x14022)

80 CAMILLE CLIFFORD,
MRS LYNDHURST HENRY BRUCE
(1885–1970)

Camille Clifford was a popular light comedy actress, famous for her likeness to the American artist Charles Dana Gibson's handsome and statuesque women (see *fig. x*), whom she personified on the stage as the 'Gibson' girl.

The early years of the twentieth century saw the last gasp of exaggerated and body-deforming high fashion for women, as typified here by Camille Clifford. Her high piled hair, crowned by a vast feathered hat, is counterbalanced by a spreading trumpet-

80.1
White ostrich feather fan with mother of pearl monture, 1890–1900. Fan Museum, London

80
CAMILLE CLIFFORD, MRS LYNDHURST HENRY BRUCE
Draycott Galleries, *c.*1904.
Sepia postcard
National Portrait Gallery, London
(NPG x27516)

80.2
CAMILLE
CLIFFORD,
MRS LYNDHURST
HENRY BRUCE
Bassano, 1916.
Whole-plate glass
negative
National Portrait
Gallery
(NPG x22156)

shaped skirt curving round from the knees to create a striking art-nouveau line. Her figure is formed into an hour-glass shape reliant on a corset that pushed the full bosom forward and the bottom to the back, producing what was called the S-bend shape. The resulting image of paradigm feminine curves – even allowing for the slight exaggeration of costume worn on the stage – is heightened by accessories such as the feathered fan (*fig. 80.1*), which is held up in a gesture of practised coquetry. In Aldous Huxley's novel *Eyeless in Gaza* (1936), the narrator opens the book by looking at old photographs, including one of his mother in 1901: 'Those swan-like loins. That long, slanting cascade of bosom – without any apparent relation to the naked body

beneath. And all that hair, like an ornamental deformity on the skull …'

Just a few years later, however, women's appearance and dress had undergone a sea change. A new mood of greater naturalism and simplicity was engendered by the First World War. Bassano's portrait of the same sitter, taken in 1916 (*fig. 80.2*), shows Camille Clifford with her hair simply styled, curled under at the back and sides and held in place by a ribbon bandeau. Her evening dress, although incorporating an embroidered, fringed and beaded over-tunic or tabard, follows the shape of the body, the ferocious corset having possibly been abandoned in favour of the lightly boned bust-bodice or brassière, which helps to create a slightly more relaxed posture.

81
DAME LAURA
KNIGHT
Self-portrait,
1913.
Oil on canvas,
1524 x 1276mm
(60 x 50¼")
National Portrait
Gallery, London
(NPG 4839)

81 DAME LAURA KNIGHT
(1877–1970)

Most famous for her scenes of gipsy life, the theatre and the circus, Laura Knight took the opportunity – hitherto denied to women artists before the twentieth century – to paint nudes. The juxtaposition between the two back views, the nude figure of a fellow artist, Ella Naper, and the comfortable but shapelessly dressed figure of the artist, makes this a striking image. Knight wears a black felt hat decorated with a hatband made from brightly coloured twisted wool braid and a striped black-and-white scarf round her neck, but the dominant feature of her costume is the scarlet, knitted woollen cardigan, which she had bought in a jumble sale in Penzance for half-a-crown – this was a favourite garment, and appears in a number of other paintings.

Bright colours, and red in particular, were popular with many women artists; this was possibly as a result of the impact made on the English art scene by such Fauve artists as Derain, Matisse and Dufy, in the years before the First World War. In Duncan Grant's portrait of Vanessa Bell of about 1918 (*fig. 81.1*), bright red is the colour of her printed cotton summer dress, the colours of its pattern being reflected in the opaque glass beads of her necklace. Grant (who lived with Vanessa Bell from 1913) painted her three times in this dress; one version (in a private collection) has a piece of the actual dress fabric attached to the portrait, at the bodice. Vanessa Bell complained that English people stared at her because of the bold colours of her clothes. This may have been one of the reasons for the failure of similar designs and colours of fabrics – clearly influenced by Post-Impressionism – when they were made up into the dresses sold by the Omega Workshops, founded by Roger Fry in 1913. From 1915 Vanessa Bell designed dresses for the Omega Workshops, but not only were they badly made, but – according to Virginia Woolf – the colours, 'reds and yellows of the vilest kind', were far too gaudy.

81.1
VANESSA BELL
(1879–1961)
Duncan Grant,
c.1918.
Oil on canvas,
940 x 606mm
(37 x 23⅞")
National Portrait
Gallery, London
(NPG 4331)

82 MARGUERITE RADCLYFFE HALL (1880–1943)

82.1
DAME ETHEL
WALKER
(1861–1951)
Self-portrait,
*c.*1925.
Oil on canvas,
613 x 508mm
(24⅛ x 20")
National Portrait
Gallery, London
(NPG 5301)

The famous lesbian author (her friends called her John) achieved notoriety when her book *The Well of Loneliness* (a *succès de scandale* at its publication in 1928) was banned in Britain. The largely autobiographical novel describes in some detail the masculine clothes worn by the protagonist, 'Stephen' (daughter of a wealthy couple who had longed for a boy) whose upbringing was sexually confused. Sometimes Stephen would appear in 'a suit of rough tweeds surreptitiously ordered from the excellent tailor in Malvern', or a flannel suit – 'grey with a little white pin stripe' – which she wore with a

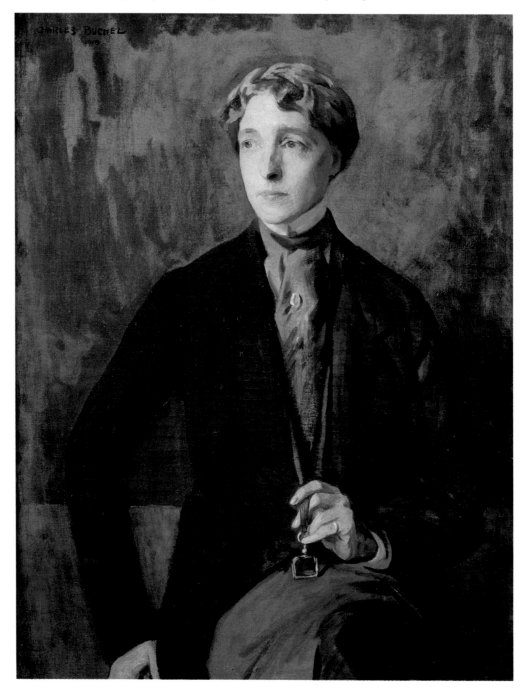

82
MARGUERITE
RADCLYFFE
HALL
Charles Buchel,
1918.
Oil on canvas,
914 x 711mm
(36 x 28")
National Portrait
Gallery, London
(NPG 4347)

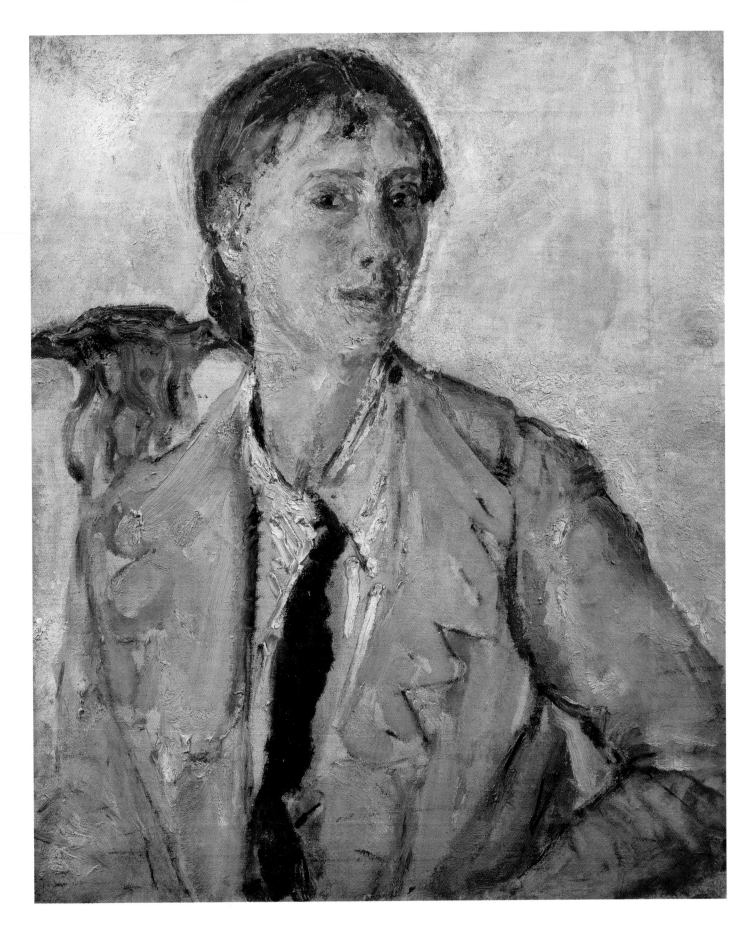

82.2
DOROTHY
LEIGH SAYERS
(1893–1957)
Sir William
Hutchison,
*c.*1949–50.
Oil on canvas,
762 x 667mm
(30 x 26¼")
National Portrait
Gallery, London
(NPG 5146)

grey tie. Eventually Stephen goes to London, becomes a novelist, wears men's clothes and cuts her hair short like a man (Hall patronised gentlemen's outfitters and hairdressers herself), and smokes heavily (Hall, in fact, ordered smokers' requisites from Dunhill).

In Buchel's portrait (bequeathed by Hall's lover Una, Lady Troubridge), the sitter wears a black jacket cut along masculine lines, a grey silk cravat kept in place with a gold and agate pin, and a grey skirt (she never carried a handbag, and had pockets made in her skirts). Hanging from a black ribbon is a square gold-rimmed eye-glass. Although Hall's choice of costume is a statement of intent, a declaration of war against the constraints of convention, she is dressed in a way that would not be thought unusual at the time for progressive and intellectual women, who, since the late nineteenth century, had increasingly incorporated elements of the masculine wardrobe into their own, as being more practical and professional, and less fussily 'feminine'

Two other examples of feminine adoption/adaption of male clothing are illustrated here. The masculinity of the shirt and tie in Dame Ethel Walker's fine self-portrait of the mid-1920s (*fig. 82.1*) is offset by the zigzag collar of her yellow jacket, and her long hair coiled into a bun at the nape of her neck. More overtly 'masculine' is the costume worn by the novelist and playwright Dorothy Sayers in William Hutchison's direct and honest portrait of the late 1940s (*fig. 82.2*). Here we see a large woman in a strictly tailored blue suit, white shirt and black tie, with a gold watch chain with a cornelian seal, but there are also feminine touches – for example the rings she wears and the fringed blue scarf over her shoulders.

83 LADY OTTOLINE MORRELL (1873–1938)

This brilliant, idealistic and eccentric woman (wife to a Liberal Member of Parliament who shared her aesthetic tastes and progressive views) was the patron of artists and writers at her home in Garsington, Oxfordshire, and at her London house in Gower Street, where this portrait was eventually displayed. Those attending her salon included Aldous Huxley, Lytton Strachey, Duncan Grant and Bertrand Russell.

Lady Ottoline was noted for her striking face – her large nose and jutting 'Habsburg' chin (a 1913 portrait by Duncan Grant now in a private collection originally had a wooden chin added to emphasise this prominent feature of her appearance) – and for her highly individual dress sense. She features as Hermione Roddice in D. H.

Lawrence's novel *Women in Love* (1921) as 'a tall, slow, reluctant woman with … a pale, long face', wearing eccentric garments in luxurious fabrics (probably by Fortuny), and in the same year she appears as the 'dowagerish' and 'theatrical' Priscilla Wimbush in Aldous Huxley's *Crome Yellow*: 'Her voice, her laughter, were deep and masculine. Everything about her was manly. She had a large, square, middle-aged face, with a massive projecting nose and little greenish eyes, the whole surmounted by a lofty and elaborate coiffure of a curiously improbable shade of orange.'

Augustus John (with whom Lady Ottoline had a brief affair some ten years earlier) depicts her in a greenish-black velvet dress in 'Renaissance' style with a square neck and puffed upper sleeves; draped over her bosom are large ropes of pearls (painted with toothpowder, giving a rather chalky effect), which give a somewhat Edwardian touch to the ensemble, as does her large black velvet hat trimmed with feathers, placed firmly over her henna-ed hair. The artist was – understandably perhaps – worried about his sitter's reaction to the portrait, hoping that she would not find it 'ill-natured'. The critics were divided in their opinions, the *Star* (11 March 1920) attacking 'this grotesque travesty of aristocratic, almost imbecile hauteur', while the *Manchester Guardian* (1 March 1920) found it 'like one of the queer ancestral portraits you see in a scene on the stage … done by a man of genius'.

Looking at contemporary photographs of Lady Ottoline, it is clear that John's portrait was not a caricature, but an honest, intelligent and perceptive image. In 1928 Cecil Beaton photographed Lady Ottoline for *Vogue* (*fig. 83.1*), supposedly 'in the Goya manner', emphasising her strong features and her penchant for the dramatic in dress and pose; he pulled down the shoulders of her dress for a 'historical' effect, and to show off her necklace – what Huxley calls her 'customary' pearls. Ottoline Morrell collected exotic and historic fabrics, which were then made up by her maid into long, flowing, 'artistic' dresses; in Beaton's portrait, her dress is of

83
LADY
OTTOLINE
MORRELL
Augustus John,
1919.
Oil on canvas,
690 x 511mm
(27⅛ x 20⅛")
National Portrait
Gallery, London
(NPG 6095)

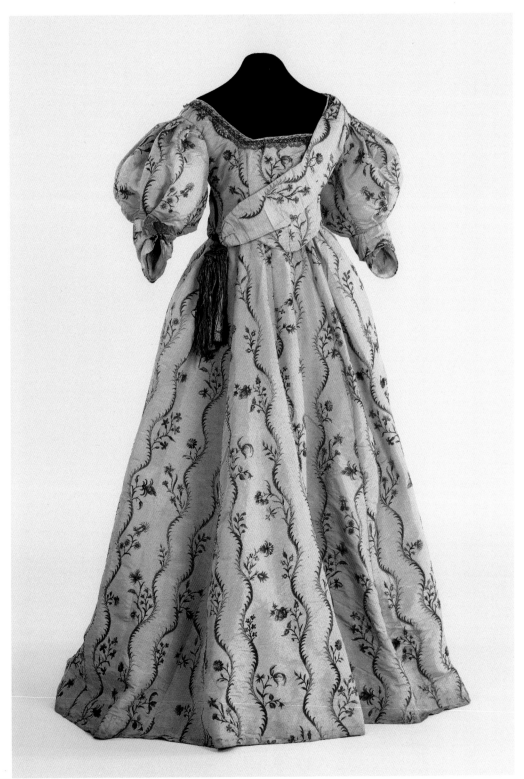

83.2
Dress worn by
Lady Ottoline
Morrell, made
of an eighteenth-
century-style silk
embroidered
with silk and
metal thread,
early 1900s.
Museum of
Costume, Bath

83.1
LADY
OTTOLINE
MORRELL
Cecil Beaton,
1928.
Bromide print,
239 x 179mm
(9¾ x 7")
National Portrait
Gallery, London
(NPG x402290)

eighteenth-century-style silk – yellow with
flowers embroidered in mauve and silver (*fig.
83.2*) – but hinting at the Renaissance in its
cut and construction. Adding to the won-
drous confusion of artistic influences in
Beaton's photograph, the sitter is posed against
a kind of swirling Vorticist backdrop (either
fabric or wallpaper), and holds a Japanese
paper fan, the abstract design of which also
owes something to Cubism.

84 WINIFRED RADFORD, MRS DOUGLAS ILLINGWORTH (1901–92)

The artist was clearly attracted to the youthful charm of his subject – the portrait with its heightened sense of reality, love of abstract beauty, and fondness for material objects, is reminiscent in feeling of the Louvre's *Mademoiselle Rivière* of 1805 by Ingres, an artist whom Frampton greatly admired. The portrait of Winifred Radford was commissioned by her husband while she was a music student – she went on to have a distinguished singing career, and to teach at the Guildhall School of Music in London. Her love of music is obviously alluded to here by the songbird.

As with the fashions of the early nineteenth century, the simple, unstructured

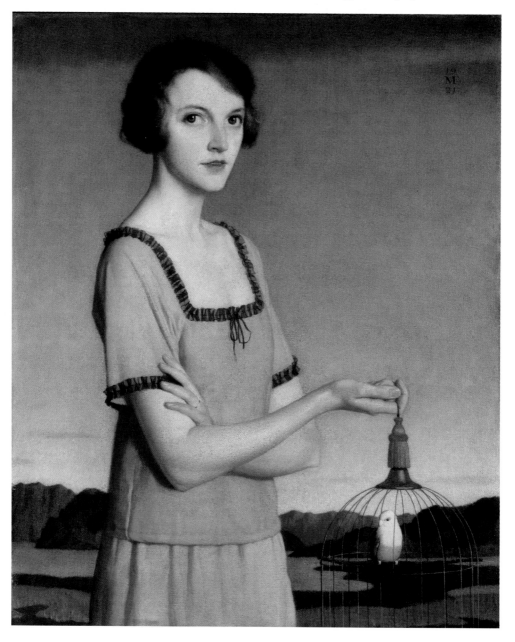

84
WINIFRED
RADFORD,
MRS DOUGLAS
ILLINGWORTH
Meredith
Frampton, 1921.
Oil on canvas,
892 x 746mm
(35⅛ x 29⅜")
National Portrait
Gallery, London
(NPG 6397)

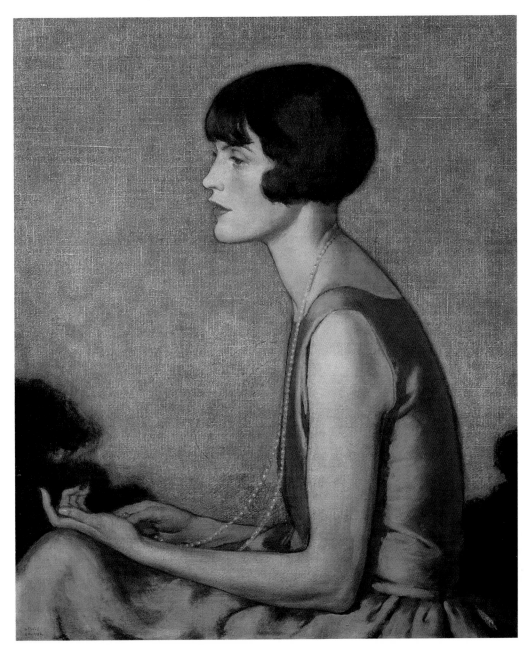

84.1
NOEL
STREATFEILD
(1895–1986)
Lewis Baumer,
exhibited 1926.
Oil on canvas,
762 x 635mm
(30 x 25")
National Portrait
Gallery, London
(NPG 5941)

styles of the 1920s were particularly suited to young women. Radford's costume (it has the look of home dressmaking about it) consists of a T-shaped top, possibly of rayon (the first synthetic fabrics were beginning to make an impact on women's fashions) trimmed with black net, and a plain white skirt with unpressed pleats. The almost childish dress is in complete harmony with the short bobbed hairstyle, which many young women adopted after the First World War, and which we

also see in Lewis Baumer's portrait of Noel Streatfeild (*fig. 84.1*), author of children's books, the most famous being *Ballet Shoes* (1936). Here the artist has caught the uncluttered simplicity of the low-waisted sleeveless yellow dress, and the boyish front (created by a bandeau brassière, which flattened the bosom) gives the portrait a muted androgynous appeal, underlined perhaps by the slightly muscular arms, but mitigated by the delicate neck, and the long string of pearls.

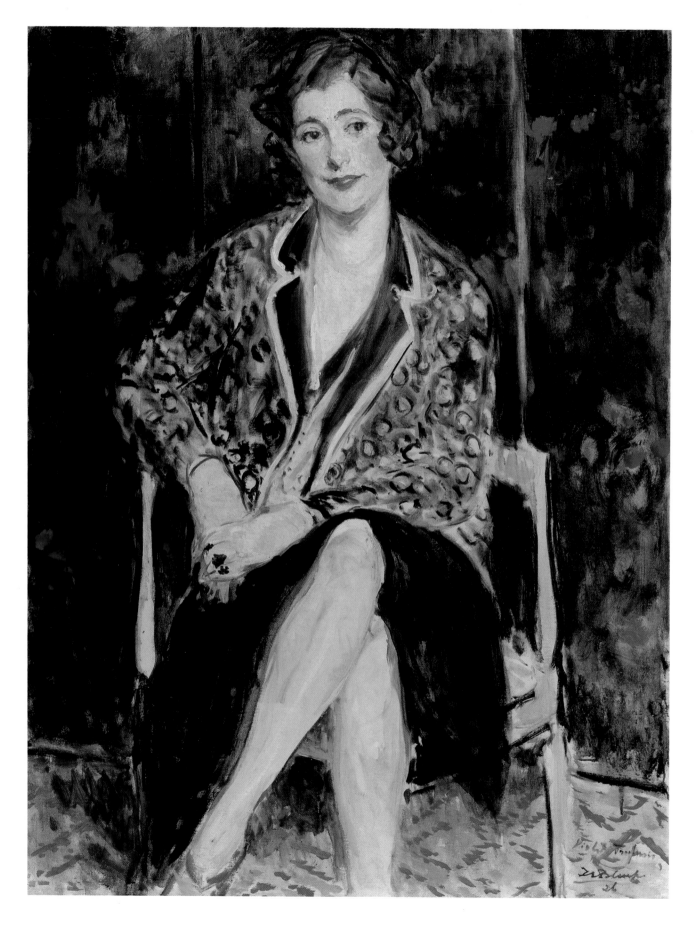

85 VIOLET KEPPEL, MRS DENYS TREFUSIS (1894–1972)

85
VIOLET
KEPPEL,
MRS DENYS
TREFUSIS
Jacques-Emile
Blanche, 1926.
Oil on canvas,
1171 x 895mm
(46⅛ x 35¼")
National Portrait
Gallery, London
(NPG 5229)

The sitter was famous more for her affair with Vita Sackville-West at the end of the First World War, than for her later career as a novelist and well-known hostess (she had homes near Paris and in Tuscany). Blanche, Proust-like in his devotion to the aristocracy, and fascinated by the Sackville-West affair, depicts Violet Keppel seated in front of a painted screen in his Paris studio. The loose brush-strokes of this rather impressionistic portrait were inspired by the later style of Gainsborough, an artist whom he much admired. The sitter looks robust and healthy – the poet Paul Valéry nick-named her 'Madame Très Physique' on account of her love of good food and her rosy complexion – her short hair is lightly permed and she wears an elegant costume, a black-and-white printed jacket and plain black skirt of knitted jersey, a comfortable, understated fabric originally worn for sport and made fashionable by Chanel in the 1920s. By the mid-1920s, women's skirts were short, on the knee, a trend that drew attention to the legs, clad here in 'nude' stockings either of real silk or synthetic rayon, and high-heeled shoes.

The only jewellery she wears, indicated by the artist as touches of green on her fingers, are emerald rings. Emeralds were particularly popular in the twenties, and here perhaps recall the 'striking emerald' worn by Iris Storm in Michael Arlen's novel *The Green Hat*, a *succès fou* of 1924.

86
CONSTANT
LAMBERT
Christopher
Wood, 1926.
Oil on canvas,
914 x 559mm
(36 x 22")
National Portrait
Gallery, London
(NPG 4443)

86.1
CONSTANT
LAMBERT
Christopher
Wood, 1927.
Oil on canvas,
584 x 914mm
(23 x 36")
Towner Art
Gallery,
Eastbourne

86 CONSTANT LAMBERT (1905–51)

Artist and sitter met in Paris in 1925, and became close friends with similar views on art and music. They worked together on a ballet, *Romeo and Juliet*, commissioned by Diaghilev, which was premiered in 1926.

Lambert was a composer, conductor and critic, a champion of modernism who urged the incorporation of continental and jazz influences into English music, which was still in thrall to the symphonic tradition of Elgar and his followers; he was also knowledgeable about painting. Wood's artistic influences included Picasso, Cocteau and Modigliani, and his portraits – as here – are noted both for their study of character and for abstract, decorative form.

Lambert's clothing, with its clashing, dissonant colours, would have been regarded as a sartorial affront to the sober formality of mainstream male fashion. He wears a high-waisted lounge suit of greenish-yellowish fabric, which could either be wool or thick cotton, a blue shirt and a red tie. His slightly receding hair is quite bouffant on top, and his heart-shaped face and red lips present – along with his brightly coloured costume – a sexually ambivalent appearance consistent with the contemporary desire to 'épater les bourgeois' (or shake up the hidebound).

A later portrait by Wood of Lambert, in the same irreverent spirit (*fig. 86.1*) shows him in bathing trunks, with a violin and a music manuscript. Swimwear for men was obligatory from the end of the nineteenth century (before then, many men bathed naked), and consisted of drawers or a one-piece combination suit. Short trunks were in vogue on the Continent in the 1920s, but were regarded as rather daring in England until about 1930.

87
HARRIET
COHEN
Ronald Ossory
Dunlop, *c*.1930.
Oil on canvas,
760 x 507mm
(29⅞ x 20")
National Portrait
Gallery, London
(NPG 6165)

87 HARRIET COHEN (1896–1967)

Harriet Cohen was a well-known pianist, educated at the Royal Academy of Music where she won many prizes. Her repertoire ranged from J. S. Bach, to music composed for her by Constant Lambert and Arnold Bax. A beautiful, elegant woman with many friends in the literary and artistic world, she had a great sense of style in dress, and she is portrayed here in a gold lamé evening gown of the kind she wore when giving public recitals. Such a low-necked, sleeveless dress not only shows off the figure, but is also practical, for there are no frills, flounces or other superfluous ornamentation to hinder the movements of the arms when playing in public. In reaction to the short bob of

87.1
HARRIET
COHEN
Herbert Lambert
at Elliott & Fry,
1920s.
Cream-toned
bromide print,
200 x 155mm
(7⅞ x 6⅛")
National Portrait
Gallery, London
(NPG x39249)

87.2
'Aphrodite Leaves
her Temple'
Thomas
Lowinsky.
Illustration from
Raymond
Mortimer, *Modern
Nymphs* (1930).
Hand-coloured
line block,
203 x 130mm
(8 x 5⅛")
Victoria and
Albert Museum,
London

the 1920s, many women grew their hair and wore it in a bun or a chignon at the back, as we can see from a photograph of Harriet Cohen at the piano (*fig. 87.1*). The severity of this hairstyle is alleviated by the pendant earrings which flatter her long neck, catch the light as the head moves and give a rather Spanish appearance, enhanced by the use of the dramatic make-up – heavily pencilled eyes and reddened lips – *de rigueur* for a public performance.

By the late 1920s women's clothing, especially for evening, had become more fitted to the shape of the body and skirts were longer. Fabrics were often bias-cut

(cut on the cross), which created a kind of elasticity, moulding the garment to the shape of the body, and producing a sleek, smooth, streamlined look, which emphasised a return to slightly more 'feminine' curves. For those too well upholstered, the newly invented elastic roll-on girdle proved essential. The 1930s saw a renewed interest in classical art, and the clinging draperies of antiquity could be fashionably re-created by bias-cut evening dresses, as can be seen in Thomas Lowinsky's re-working of mythological themes, his illustrations to Raymond Mortimer's *Modern Nymphs* of 1930 – with jewellery by Cartier – (*figs 87.2* and *87.3*).

87.3
'Daphne'
Thomas
Lowinsky.
Illustration from
Raymond
Mortimer,
Modern Nymphs
(1930).
Hand-coloured
line block,
203 x 130mm
(8 x 5⅛")
Victoria and
Albert Museum,
London

88

HUMFRY GILBERT GARTH PAYNE
Ithell Colquhoun, 1934.
Indian ink and watercolour on paper,
641 x 305mm (25¼ x 12")
National Portrait Gallery, London
(NPG 5269)

88 HUMFRY GILBERT GARTH PAYNE (1902-36)

This preparatory study – sometimes known as *The Man in the Doorway* – for the oil painting also in the National Portrait Gallery (NPG 6230), shows the archaeologist Humfry Payne, Director of the British School in Athens, dressed simply and informally in a blue open-necked cotton shirt and a leather belt round the waist of his turn-up slacks. Turn-ups, first appearing in sporting trousers in the 1860s, were in general use by the turn of the century, and were especially favoured in the 1920s by the Prince of Wales, the future Edward VIII, for both formal and informal wear. Blue became popular for men's shirts in the 1920s and 1930s; such garments were worn by men of liberal and progessive views, for the colour had been, since at least the eighteenth century, associated with working-class clothing. It is therefore not surprising to see the left-wing poet Stephen Spender (*fig. 88.1*) in

88.1
STEPHEN
SPENDER
(1909–95)
Wyndham
Lewis, 1938.
Oil on canvas,
1005 x 595mm
(39½ x 23½")
Potteries
Museum and
Art Gallery,
Stoke-on-Trent

1938 wearing a blue shirt (with his cuffs undone), for he was among the intelligentsia who identified themselves with the movement for democracy in Spain in the 1930s, and fought in the Spanish Civil War on the Republican side.

From this time onwards, many men were increasingly portrayed in relatively simple and unstructured clothing, for the wearing of a formal three-piece suit, with a tailored jacket, stiff collar and tie, was regarded as too boring and conventional. Informal costume helped to create a relaxed body language, equally as revelatory of character as the depiction of the face in a portrait. Michael Ayrton's portrait of Sir William Walton, painted in Capri in 1948 (*fig. 88.2*) shows the composer in a blue shirt and a loose jacket of linen or cotton. Such comfortable and easy-to-care for fabrics, which had revolutionised women's clothing in the post 1914–18 period, have played an increasing role in menswear from the 1920s until the present day.

88.2
SIR WILLIAM
WALTON
(1902–83)
Michael Ayrton,
1948.
Oil on canvas,
613 x 915mm
(24⅛ x 36")
National Portrait
Gallery, London
(NPG 5138)

89 DAME ANNA NEAGLE
(1904–86)

The actress Anna Neagle was famous for her roles as great historical heroines, such as Nell Gwyn, Florence Nightingale and Queen Victoria, and as a star of musical comedies; she is portrayed here in the musical *No, No, Nanette*.

It is a rather crude portrait, deliberately evoking a popular magazine illustration of a fashionable pin-up of the Second World War, almost a parody of a band-box image of wholesome, well-groomed sexiness, conveyed by her flirtatious glance, the

89
DAME ANNA
NEAGLE
McClelland
Barclay, 1940.
Oil on canvas,
1649 x 1268mm
(64⅞ x 49⅞")
National Portrait
Gallery, London
(NPG 6054)

89.1
DAME ANNA
NEAGLE
(1904–86)
Bassano, 1938.
Half-plate glass
negative
National Portrait
Gallery, London
(NPG x34226)

reddish-blonde curls tumbling over her shoulders, the scarlet fingernails drawing attention to the tiny waist of her dress and the glimpse of a green peep-toe shoe. Her dress is of yellow satin, with short sleeves and a 'sweetheart' neckline with horizontal ruching that emphasises the bust. The late 1930s saw the introduction of an ultra-feminine look for evening wear, with tight-waisted dresses and billowing skirts inspired by the fashions of the mid-nineteenth century as depicted by Franz Xaver Winterhalter. This romantic style remained fossilised as an icon of feminine desirability during the diffi-

cult years of wartime privation and clothes rationing.

Victorian themes featured generally in women's fashions of the later 1930s; in a photograph of Anna Neagle in 1938 by Bassano (*fig. 89.1*) we see her wearing a high-crowned hat with a veil, and a fur shoulder cape reminiscent of the styles of the late nineteenth century. Otherwise, her shoulder-length curled hair and the short, square-shouldered boxy dress or suit typify the style that remained more or less constant during the period 1939 to 1945.

90
ANNA
KATRINA
ZINKEISEN
Self-portrait,
*c.*1944.
Oil on canvas,
752 x 625mm
(29⅝ x 24⅝")
National Portrait
Gallery, London
(NPG 5884)

90 ANNA KATRINA ZINKEISEN (1901–76)

The artist was a well-known muralist, whose work decorated the great ocean liners of the inter-war period, the *Queen Mary* and the *Queen Elizabeth*. During the Second World War she worked as a medical artist at St Mary's Hospital, Paddington, her experience as an auxiliary nurse in the casualty department there standing her in good stead as she recorded operations, body parts, and so on –

the civilian victims of the bombing added to the normal workload of a busy hospital.

She is shown here in her working clothes as an artist, a blue smock (over a red dress), with her right sleeve rolled up. She holds her paint brushes and cloth, and on her wrist is a bracelet with an enamelled Maltese cross, the Order of St John of Jerusalem.

The most striking part of her appearance

90.1
DORIS CLARE
ZINKEISEN
(1898–1991)
Self-portrait,
exhibited 1929.
Oil on canvas,
1072 x 866mm
(42¼ x 34⅛")
National Portrait
Gallery, London
(NPG 6487)

is her hair and face. During the war years, especially after the introduction of the Utility regulations in 1941, which drastically rationed clothes, one of the few ways in which women could vary the monotony of a limited wardrobe, and retain and enhance their femininity and self-esteem, was to arrange their hair in elaborate styles and wear cosmetics. Make-up, vastly improved as a result of the film industry, was widely available as a boost to morale. Zinkeisen's long hair is carefully permed and set in waves to the shoulder and pinned in rolls above the brow, a style characteristic of the period. Her face is prominently made up – eyes enhanced with pencil and mascara, rouge applied to the cheeks, and lipstick to the lips.

Anna's sister Doris was also an artist, specialising in decorative scenes and designing for the theatre. Her talents as a costume designer for the stage are perhaps indicated in this theatrical self-portrait exhibited in 1929 (*fig. 90.1*), where the prominent make-up of the period is stressed and the eye is drawn, via the sitter's naked neck and bosom, to the dramatic sweep of an embroidered Chinese shawl.

91 CONVERSATION PIECE AT THE ROYAL LODGE, WINDSOR

In the re-designed Gothick setting of the Royal Lodge at Windsor (a portrait of George IV hangs above the fireplace), this informal image of the royal family taking tea is a deliberate echo of the conversation piece of the eighteenth century (see *fig. 41*, for example). The King is the focus of attention of his wife and daughters, a corgi stretched out behind his chair. George VI (1895–1952) wears what had become the informal 'uniform' of most upper-class men of the time, a tweed lounge suit. With this he wears a pale blue shirt, a beige knitted pullover and highly polished brown lace-up shoes – such a costume would not look out of place today among élite men of a certain age.

The Queen (now Queen Elizabeth the Queen Mother; b.1900) wears a pale blue embroidered dress, and high-heeled sling-back

91

Conversation Piece at the Royal Lodge, Windsor
Sir James Gunn,
1950.
Oil on canvas,
1511 x 1003mm
(59½ x 39½")
National Portrait
Gallery, London
(NPG 3778)

91.1
Royal Conversation Group
Dorothy Wilding, 1946.
Toned bromide print,
385 x 5654mm
(15⅛ x 22¼")
National Portrait Gallery, London
(NPG x35456)

shoes, like her two daughters. Princess Elizabeth (later Queen Elizabeth II; b.1926), wears a tailored suit – very much the style of the 1940s – but her more fashion-conscious sister, Princess Margaret (b.1930), has chosen a modest version of the New Look, introduced by Christian Dior in 1947. Her dress is a printed silk, with three-quarter-length sleeves and a long, full skirt, which emphasises her small waist. Another minor signal, perhaps, of Princess Margaret's new sartorial independence is the absence of pearls, *the* conventional jewellery of the upper classes, even today. Both the Queen and her eldest daughter wear pearl necklaces, and, in addition, Princess Elizabeth – heir to the throne, and mother of the future heir – wears a sapphire-and-diamond brooch, which was a gift to Queen Victoria from Prince Albert on their marriage in 1840.

The change in women's dress from the wartime square silhouette to the longer, more feminine fashions of the late 1940s can be seen by looking at a photograph of the royal family taken in 1946 by Dorothy Wilding (*fig. 91.1*). Although the war had just ended, the war-time mood prevails, with the King in naval uniform, and the young princesses in short-sleeved, short-skirted dresses based on Utility designs. Only the Queen remains relatively unchanging in the matching dress and jacket style (known as a 'costume'), which became part of her persona (later it developed into a coat and matching dress ensemble), just as her mother-in-law, Queen Mary, was fixed in the public mind until her death in 1953, as a stern, unbending figure in her Edwardian long dress and toque hat.

92 EDWARD, DUKE OF WINDSOR (1894–1972), AND WALLIS, DUCHESS OF WINDSOR (1896–1986)

There can have been few couples so united in their love of fashion and so stylish in appearance as the Duke of Windsor (briefly King Edward VIII in 1936) and the American divorcée Wallis Simpson, whom he married in 1937.

As Prince of Wales and Duke of Windsor, he set a number of fashions –

92
EDWARD,
DUKE OF
WINDSOR,
and WALLIS,
DUCHESS OF
WINDSOR
Dorothy
Wilding, 1955.
Cream-toned
bromide proof
print, taken in
Wilding's New
York studio
233 x 185mm
(9³/₁₆ x 7⁵/₁₆")
National Portrait
Gallery, London
(NPG x32656)

92.1
Cardigan worn by Wallis, Duchess of Windsor. Navy cashmere trimmed with ivory grosgrain braid, c.1950.

these included the Fair Isle jersey for playing golf, suede shoes, chalk-striped double-breasted suits, the backless waistcoat for formal morning wear and the dark blue evening dress tailcoat. On his visits to the United States, where he was very popular, he had been impressed by the informality, both in clothes and in manners, that he found there and he attributed his guiding principles in dress – 'Comfort and Freedom' – to American influence. Such principles, he claimed, 'underlay the changes in male fashions throughout the freer and easier democratic age between the Wars'. The Duke of Windsor was interested in his appearance – he retained his slim and elegant figure throughout his life – and he had decided views on his clothes. During the Second World War, when he was Governor of the Bahamas, he started to have his trousers made in New York (the high-waisted, fuller styles, with a pleat front and turn-ups, were impossible to obtain in wartime London), but his jackets were tailored in Savile Row

by Frederick Scholte. He kept swatches of fabric from his clothes, including a dark blue Highland wool with a white overcheck, which was made up into the jacket (part of a suit) that he wears in this photograph. The shirt has a soft, turned down collar, and his tie is a printed silk with a small Paisley pattern.

The brittle elegance and cosmopolitan chic of the Duchess of Windsor is revealed in her well-groomed appearance and her dress. Her hair is centrally parted and carefully waved, and immaculate make-up enhances her beautiful complexion (Cecil Beaton said that her skin was as smooth as the inside of a shell). She wears a navy, knitted cardigan with ivory, zigzag grosgrain braid at the neck and wrists, possibly by Mainbocher, one of her favourite American designers (*fig. 92.1*). The Duchess was famous for her jewellery, preferring the contemporary to the antique. On her engagement ring finger is a large square table-cut yellow diamond, and at her wrist a Cartier diamond bracelet with jewelled crosses; even the pearls she wears – a choker necklace and clip-on earrings – look more up-to-date than the traditional styles (*fig. 91.1*) favoured by the women of the royal family.

The Duchess's innate sense of style, her good bone structure and her ability to present herself well, made her an excellent subject for the photographer, whether an undemanding and conventional society photographer such as Dorothy Wilding or a creative artist like Irving Penn, whose portrait (*fig. 92.2*) is a more dramatic image. Wearing a jersey dress with the calf-length skirt of the New Look, and fitted at the waist with a belt and a wide band of contrasting colour, she stands hemmed in by threatening walls, as though in a cavern. Is she meant to be Ariadne, who gave Theseus the thread by which he could return safely from the labyrinth after having killed the Minotaur, and who was then abandoned on the island of Naxos?

92.2
WALLIS, DUCHESS OF WINDSOR
Irving Penn, New York 1948.
Gelatin silver print,
241 x 181mm
(9½ x 7⅛")
National Portrait Gallery, London
(NPG P604)
Copyright ©
1960 by Irving Penn. Courtesy *Vogue*

93
EILEEN JOYCE
John Bratby, 1959.
Charcoal on paper,
976 x 710mm
(38½ x 28")
National Portrait
Gallery, London
(NPG 5975)

93 EILEEN JOYCE (1912–91)

This portrait demonstrates the least innova-
tive aspects – in terms of fashion – of the
1950s, especially in formal dress, which
was indebted to a continuing New Look,
with a tight torso and full skirt. Drawn in
the artist's studio in Blackheath, south-east
London, the sitter was a good-looking
Australian-born concert pianist with a talent
for self-publicity. She was not the first musi-
cian to court the public by playing popular
works, and she was famous for changing
her dress between each item on the
programme.

Bratby, who got on well with his sitter –
'I liked her' he recalled in a letter written in
1990 – none the less seems to have been
overwhelmed by her costume, a patterned
concert dress with a semi-fitted bodice and
wide, shallow neckline, and a vast tent-like
skirt. The portrait is a rather dizzying study
of odd perspectives (the sitter seems to hover
above the chair), and patterned surfaces –
the half-completed large flower design of
the printed dress is balanced by the chevron
pattern of the parquet floor and the ging-
ham fabric at her feet.

94 HAROLD PINTER (b.1930)

The 1960s is the first decade in which a variety of influences on men's clothing – working-class styles, popular music and film, as well as 'alternative' fashions – can be seen alongside mainstream fashion, which centred on the suit, a continuing staple of the male wardrobe. The suit, like other great classics such as the cardigan and the kilt, for example, has the ability constantly to re-invent itself.

Cecil Beaton's photograph of the playwright Harold Pinter, a clever overlapping of four images, shows a handsome young man in the kind of conventional dark suit that would be bought to signal a specific rite of passage – such as leaving school, going to university, gaining a job, marriage – or as a symbol of material success. Pinter claims: 'I never had a suit until 1960', the year of his first really successful play, *The Caretaker*, and this is the suit

94
HAROLD
PINTER
Cecil Beaton,
1962.
Bromide print
multiple exposure,
294 x 244mm
(11⁹⁄₁₆ x 9⁵⁄₈")
National Portrait
Gallery, London
(NPG x26070)

in the photograph, purchased from Austin Reed. It comprises a moderately fitted jacket with three buttons (only the middle one was to be fastened), and narrow-cut trousers with turn-ups. His hair, slightly receding at the temples, is cut short and he holds a pair of spectacles as well as the cigarette – smoking featured widely in photography of this period.

A suit also appears in a photograph taken by Norman Parkinson for *Queen* magazine in 1962. This shows the pop singer (later actor) Adam Faith, with a number of well-known model girls, performing a popular dance called the Madison (*fig. 94.1*). This suit is a kind of photographic negative of Pinter's suit – white with a dark shirt – and Faith wears no tie. The models wear knee-length dresses with shoe-string shoulder straps ('petticoat' dresses), and shoes with stiletto heels and pointed toes; their style of dress and simple

94.1
ADAM FAITH
(b.1940)
Norman
Parkinson, 1962.
Bromide print
on card mount,
304 x 460mm
(12 x 18⅛")
National
Portrait Gallery
(NPG x30035)

94.2
THE BEATLES
Linda McCartney,
1967.
Platinum print,
355 x 515mm
(14 x 20¼")
National Portrait
Gallery, London
(NPG P577)

hairstyles have contemporary appeal today.

The simplicity of line seen in the clothing in this image looks more modern than that seen in a photograph taken by Linda McCartney just a few years later of The Beatles, the first British pop group with a truly international status and following (*fig. 94.2*).

In the late 1960s a truly eclectic mixture of sartorial styles was acceptable. The more conventional clothing is worn by the more conformist Beatles, Paul McCartney in a pin-striped jacket and Ringo Starr in a double-breasted blazer and tie, whereas the more experimental – subversive even – members of the group, George Harrison and John Lennon, have adopted elements of the hippy/flower-power styles just beginning to appear, such as the frilled floral shirt, the embroidered Afghan coat, gold-rimmed 'granny' glasses and long hair.

THE GALLERY OF FASHION

95 SIR ROY STRONG (b.1935)

It is fitting that in this portrait by Bryan Organ (an artist taught by Graham Sutherland and painting in the realist tradition), Roy Strong, one of the most successful and dynamic directors (1967–73) of the National Portrait Gallery, should be posed in front of the Gallery's painting of the *Somerset House Conference* (1604; NPG 665). It was Strong's research and enthusiasm that established Elizabethan and Jacobean portraiture as a serious subject of study. With a slightly demure pose, he wears a dark blue suit with the waisted jacket and narrow shoulders typical of the tailoring of the early 1970s, as is the wide, patterned tie with a Windsor knot. Strong has the longish hair

and moustache that many young men had begun to adopt in the late 1960s, and his intense stare is heightened by the round 'John Lennon' spectacles in vogue at that time.

Strong's talent for self-advertisement (which contributed to the high profile of the National Portrait Gallery during his 'reign'), was linked to his flair for fashion. His diaries record, with a keen eye for detail and an acerbic wit, the clothes and appearance of the people he met, and in his own outfits there were often appropriate historical touches – Regency-style frock coats, 1930s-style fedora hats – the kind of 'male sartorial display' that, he noted, was allowable in the late 1960s.

With the historian's love of the past (and an antiquarian zeal for which dress

95
SIR ROY
STRONG
Bryan Organ,
1971.
Oil on canvas,
1775 x 1775mm
(69⅞ x 69⅞")
National Portrait
Gallery, London
(NPG 5289)

95.1
Suit worn by
Sir Roy Strong
Blades, *c.*1968.
Museum of
Costume, Bath

historians are grateful) Sir Roy has either kept many of his clothes, or donated them to museums with important costume collections, such as the Victoria and Albert Museum in London, or the Museum of Costume in Bath. In the latter museum there is a suit (*fig. 95.1*) that he bought in about 1968 from the fashionable tailor Blades (which opened in 1962 and specialised in Savile Row suits cut with a new flair and style). 'The best suit I ever had made', he commented, describing it in his diaries in the following words: 'It was blue, double-breasted with six buttons, tightly waisted and with side vents seemingly to

the armpits, very narrow sleeves and straight-cut trousers ... With them went a black fedora hat from Herbert Johnson, a pair of glasses, a shirt and tie from Turnbull & Asser in raspberry ripple stripes and a pair of black shoes.'

Alex Syme's photograph in the *Sunday Times* colour supplement of 23 May 1971 (*fig. 95.2*) shows Bryan Organ and Roy Strong in front of the *Somerset House* painting. The artist wears a fashionably casual polo-neck sweater and a leather jacket, while Strong wears the Blades suit with a floral patterned shirt and a light-coloured tie.

95.2
SIR ROY
STRONG and
BRYAN ORGAN
at the National
Portrait Gallery.
Alex Syme, 1971.

THE GALLERY OF FASHION

THE GALLERY OF FASHION

96
JEAN MUIR
David Remfry,
1981.
Watercolour
on paper,
1026 x 689mm
(40⅜ x 27⅛")
National Portrait
Gallery, London
(NPG CP33)

96 JEAN MUIR (1928–95)

The setting for this portrait was the designer's all-white flat near the Albert Hall, Kensington, a suitably austere background to her costume, a shirt and culottes of navy jersey with matching tights and shoes. In the catalogue to an exhibition of Jean Muir's clothes in 1981 the historian Antonia Fraser wrote that she looked 'like a modish Puck dressed in navy blue'.

Miss Muir (it was regarded as a kind of *lèse-majesté* to be more familiar) believed in unity and harmony in clothing, referring to her work as 'architectural designing'. She created classic, tailored yet fluid shapes, which were partly inspired by Chanel in the 1920s. In this portrait her hair is cut short and straight like a twenties bob and her make-up, which dramatises eyes and lips, owes much to that decade.

Jean Muir's clothes were very much in vogue during the 1970s and 1980s; they were noted for their simple, uncluttered lines

96.1
Jean Muir
Checking Buttons
Anthony Green,
1979.
Oil on board,
2134 x 1828mm
(84 x 72")
Private collection

and subtle, muted colours. Fabrics were carefully chosen – fine woollen crêpe, soft leather and suede, and – most typical of all – sleek silk or rayon jersey, because of the way it moved on the body. She paid meticulous attention to such details as top-stitching on collars, cuffs and hems, and the right buckles and buttons – these last were particularly important, and often hand-crafted (*fig. 96.1*).

Jean Muir's clothes, especially her dresses, flattered women of all shapes and sizes, and because of their almost 'timeless' styles, which combined elegance and comfort, they were usually kept for many years, as this writer can testify. In Paula Rego's impressively honest portrait of the academic and feminist writer Germaine Greer (*fig.*

96.2) a venerable Jean Muir dress (probably of early 1970s vintage) is shown – of red jersey with characteristic top-stitching, and a large button at the neck and the cuffs. Greer says that it was the first decent dress she had ever bought, and a favourite; she chose it for her portrait 'because of the colour and the texture and its classic shape, and because it was comfortable'. With it she wears rather battered gold lace-up shoes – 'the sole is coming off one of them', commented the artist – a choice dictated more by comfort than elegance, for the movement and swing of a Jean Muir dress was best achieved by the wearing of medium-high-heeled shoes, as the designer herself wears in the Remfry portrait.

96.2
GERMAINE
GREER
(b.1939)
Paula Rego,
1995.
Pastel on paper
laid on
aluminium,
1200 x 1111mm
(47¼ x 43¾")
National Portrait
Gallery, London
(NPG 6351)

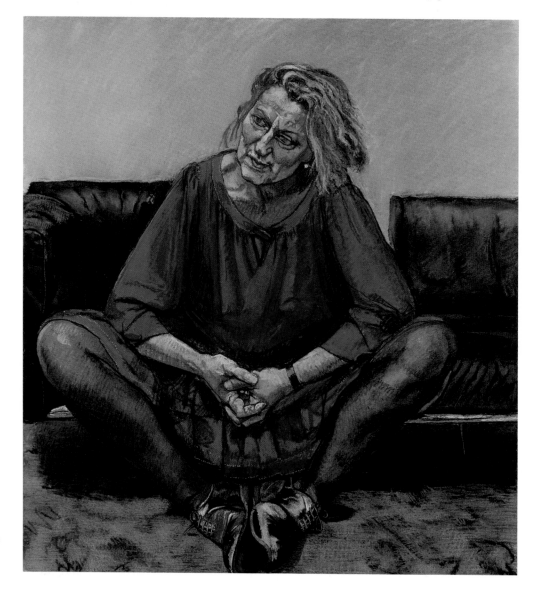

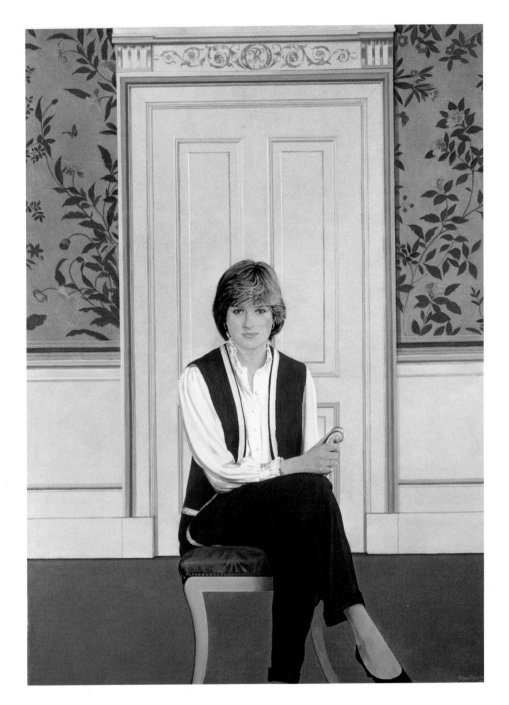

97
DIANA,
PRINCESS
OF WALES
Bryan Organ,
1981.
Acrylic on
canvas,
1778 x 1270mm
(70 x 50")
National Portrait
Gallery, London
(NPG 5408)

97 DIANA, PRINCESS OF WALES (1961–97)

This portrait, painted at the time of her engagement to the Prince of Wales, shows Lady Diana Spencer in the Yellow Drawing Room at Buckingham Palace. Already her personal style is evident, the ability to catch and interpret the fashion mood of the time. Informality is the key word in this image, both her dress and her pose – seated sideways on a green Regency damask chair – almost subverting the grandeur of her surroundings. Her lightly streaked blonde hair is styled in a simple short bob with a full fringe, and her costume consists of a matching knit jersey waistcoat and trousers. She

wears a white blouse with a 'pie-crust' frilled collar, one of the earliest fashions she popularised – even Mrs Thatcher (*figs 98* and *98.1*) followed suit. The trousers draw attention to the Princess's long legs and elegant ankles, black high-heeled shoes complementing her outfit. After her marriage the Princess amassed a considerable collection of fine jewellery, but all she wears here are simple gold hoop earrings, a bracelet of coiled gold and inexpensive rings – opals set in silver and a gold signet ring on her little finger.

The Princess of Wales's love affair with the camera – she was a natural model – is well attested. In all but the most perceptive photographs, the camera did not delve into her character too much, but projected a flattering image of her beauty and radiance, which rises above the clothes she wears, whether evening dress or T-shirt and jeans,

as a set of images by Terence Donovan, taken from sittings she gave him in 1986, 1987 and 1990 indicate. Rather endearingly, some of the dresses are not especially flattering; some are too matronly and some ill-fitting and creased, unpacked in a hurry. Some do not suit her, such as the Bruce Oldfield dress (*fig. 97.1*) of crushed purplish-blue velvet, on top of which her head and shoulders emerge in a slightly surreal way (the dress was intended to have a fur collar, but the Princess removed it, being anti-fur). Much more engaging is the Donovan photograph taken in 1987 (*fig. 97.2*) where the Princess wears a cotton T-shirt and dungarees (known as overalls in the United States); the simplicity of the costume and the directness of the gaze hark back to the candour of the Organ portrait, although the innocence has, inevitably, disappeared.

98 MARGARET THATCHER, BARONESS THATCHER OF KESTEVEN (b.1925)

How does a portrait painter encompass on the canvas the distinguished life and achievements of the first woman to reach the highest elected office in the land (she was Prime Minister from 1979 to 1990)? Here, he resorts to an image of regal dignity (the artist claimed van Dyck as one of his sources of inspiration), and paints his sitter in the official residence of the Prime Minister, 10 Downing Street, the centre of political power. He depicts, as best he can through her features and pose, her authority, her inner strength and determination, but this is softened by the almost Edwardian femininity of her high-necked, full-sleeved pale grey blouse with its frilled collar and loose ribbon

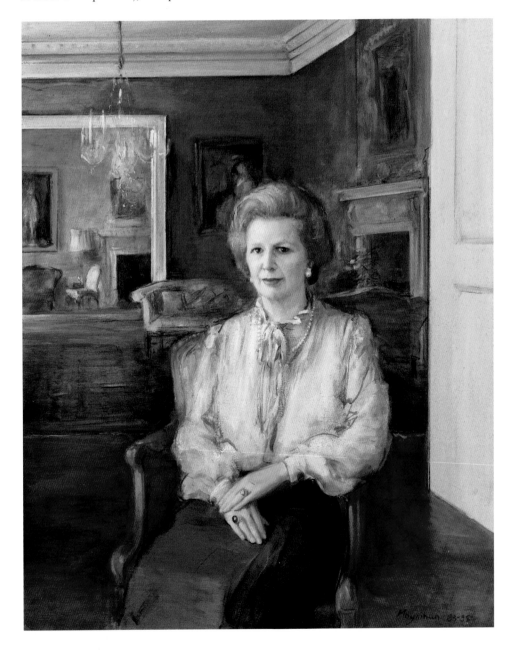

98
MARGARET
THATCHER,
Baroness Thatcher
of Kesteven
Rodrigo Moynihan,
1983–5.
Oil on canvas,
1265 x 1015mm
(49¾ x 40")
National Portrait
Gallery, London
(NPG 5728)

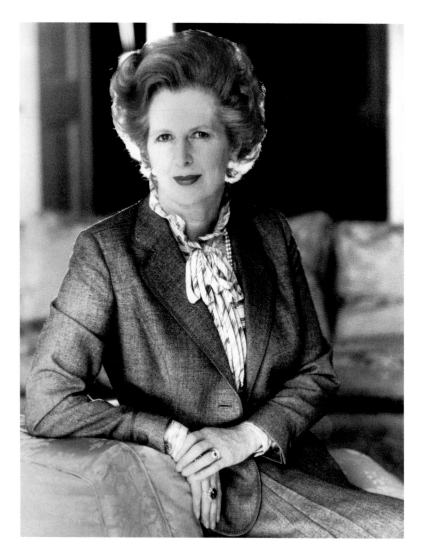

98.1
MARGARET
THATCHER,
Baroness Thatcher
of Kesteven
Norman
Parkinson, 1981.
Colour print,
492 x 394mm
(19⅜" x 15½")
National Portrait
Gallery, London
(NPG P177)

ties, her pearl jewellery and her carefully set dark blonde hair.

The portrait had a difficult gestation. The first version, completed in 1984, displeased Mrs Thatcher, as she felt that the artist had given her a squint (she had had an operation on her right eye just before the portrait was begun), so Moynihan aligned the eyes, and slightly repainted the blouse, 'in order', he said, 'to reveal the structure of the body beneath'. It was finally approved by the sitter, who claimed 'his genius has shone through'.

Only a few years earlier Mrs Thatcher had been photographed by Norman Parkinson (*fig. 98.1*). This is a more flattering – even glamorous – image of the Prime Minister relishing the burden of office (this was before the Falklands War of 1982), even with a slight smile (unlike in Moynihan's portrait, where the artist complained that her face was too 'set' and that there was little movement except round the mouth). In the Parkinson photograph Mrs Thatcher looks like a successful professional woman (Businesswoman of the Year, perhaps), wearing the tailored suit, redolent of order and efficiency, that we associate with her public image. In the 1980s 'power' suits became a popular choice for women in a man's world. The grey suit (by Aquascutum) was the photographer's choice; he wanted her to look formal, but he liked the pearls as a contrast and to provide a touch of femininity.

99 VIVIENNE WESTWOOD (b.1941)

At first glance, this avant-garde designer is a world removed – in appearance, reputation and the fashions she creates – from the restraint and classic understatement of Jean Muir (*fig. 96*). To some extent Westwood has based her career on shock tactics and a highly developed sense of the dramatic, most memorably with her punk and fetish designs of the 1970s, inspired by the vitality and anarchy of London street style and created in partnership (1970–83) with Malcolm McClaren, manager of the pop group the Sex Pistols. From the late 1970s her designs began to show a softer edge, a New Romantic look (her Pirates collection of 1981–2, *fig. 99.1*, is an example), increasingly influenced by an eclectic historical revivalism. Westwood's solo career began in 1984, and she opened her shop in Mayfair in 1990, the year she was made British Designer of the Year – an accolade she also received in 1991.

Young British designers are trained to look to the past in a creative way, and in this regard, Vivienne Westwood is a pioneering force; her veneration for historic costume has inspired designs for both fashion and textiles. The dress stand on which she leans is printed with one of her textiles,

incorporating scenes of an historic interior (the château of Compiègne, in northern France), with furniture, tapestry and porcelain in the grand style. She herself presents an image of jaunty masculinity, with her blonde hair cut short, checked shirt and tie, and a tweed three-piece suit with exaggerated lapels; imitation Victorian watch chains are draped over her waistcoat. The suit, jokey although it may appear, is a kind of homage to the long-established traditions of the English tailor, and a reference to her own tailoring skills. In common with Jean Muir, Westwood knows that craft – technical knowledge and respect for the fabrics – is all-important, an attribute not always to be found in designers, past and present, who assemble garments rather than cut them with creative flair.

99.1
VIVIENNE WESTWOOD with Annabella of the pop group Bow Wow Wow, Denis O'Regan, *c.* 1980.
35mm monochrome

99
VIVIENNE WESTWOOD
David Secombe, 1992.
Cibachrome print, 263 x 268mm (10⅜ x 10½")
National Portrait Gallery, London (NPG x68821)

100
TONY BENN
Humphrey
Ocean, 1996.
Oil on canvas,
1041 x 816mm
(41 x 32⅛")
National Portrait
Gallery, London
(NPG 6371)

100 TONY BENN (b.1925)

The rapport between artist and subject is evident here, Ocean capturing the alert intelligence of his sitter – he claimed that Benn was 'the sanest man in or near my studio', and that he 'spoke very well about painting'. Tony (Anthony Wedgwood) Benn, radical Labour Member of Parliament – one of the great orators both inside and outside Parliament – inherited the title of Viscount Stansgate in 1960, thus being debarred from the House of Commons. In 1963 he won his campaign for the right to reject hereditary peerages, after which, re-elected as an MP, he held office in the Wilson and Callaghan governments of the 1960s and 1970s.

The artist said of his sitter, comparing him favourably to other politicians he had painted: 'patrician he may be, but foppish he isn't', and recalled that although his suits

were tidy, they were 'always disfigured by the wealth of gadgets, bleepers and pagers in all pockets' (Benn's political career had included responsibility for telecommunications). The artist explained that sittings for the portrait, nine in all, took place in January, 'so it is a winter portrait, suit and cardigan'. As painted, the suit is too impressionistically presented to determine much about cut or fabric, perhaps deliberately so, for the sitter claimed a lordly indifference to what he wears here, saying 'the clothes I wear are the same sort of clothes I always wear'. This is the archetypal suit of an upper-class Englishman of a certain age, slightly baggy and rumpled in style, moulded by long use to the characteristic movements and body shape of the wearer. With his suit, Tony Benn wears a ribbed, woollen cardigan (old-fashioned but comfortable), a blue shirt (now a completely classless colour) and a dark red tie, a coded reference, perhaps, to his socialist beliefs – out of fashion in the New Labour Party of the late 1990s.

Benn's clothes relate to his caste and his generation, and it would be pretentious to disclaim them in favour of more 'proletarian' clothes (a tactic sometimes adopted by a few left-wing MPs of impeccable middle-class

background during the eighteen years that Labour was out of office).

Some of the new, younger generation of male Labour MPs, who come from varied backgrounds and cultures, seem to make more of a distinction between their 'official' clothing in the House of Commons (where the formality of a suit or at least a jacket and tie, is demanded), and what they wear outside Parliament, clothes that reflect their personal style, and in some cases their multicultural interests. The Home Office minister Paul Boateng, for example, is a man with an avowed interest in modern design, believing that clothing should be 'about comfort and utility', and that a 'politician's clothes ought to complement, not detract from his message'. Two photographs taken by Stephanie Rushton for the London *Evening Standard*, for the official Notting Hill Carnival Guide of 1998, indicate the range of his wardrobe. One image (*fig. 100.1*) reflects Boateng's Ghanaian heritage by showing him in an Asante *kente* jacket, and in the other photograph (*fig. 100.2*) he wears a black Nehru suit (bought from Les Deux Zebres, a shop in Covent Garden opened in 1978), which, he explains, was worn 'over a white tee shirt (army surplus) not a turtle neck (a style offence)'.

100.1
PAUL
BOATENG MP
(b.1951)
Stephanie
Rushton, 1998.

100.2
PAUL
BOATENG MP
Stephanie
Rushton, 1998.

BIBLIOGRAPHY

Ashelford, J. *A Visual History of Costume: The Sixteenth Century* (B. T. Batsford, London, 1983)

—, *The Art of Dress: Clothes and Society, 1500–1914* (The National Trust, London, 1996)

Brilliant, R. *Portraiture* (Reaktion Books, London, 1991)

Byrde, P. *A Visual History of Costume: The Twentieth Century* (B. T. Batsford, London, 1986)

—, *Nineteenth-Century Fashion* (B. T. Batsford, London, 1992)

Cumming, V. *A Visual History of Costume: The Seventeenth Century* (B. T. Batsford, London, 1984)

Foster, V. *A Visual History of Costume: The Nineteenth Century* (B. T. Batsford, London, 1984)

Garstang D. (ed.), *The British Face: A View of Portraiture, 1625–1850* (exh. cat., P. and D. Colnaghi, London, 1986)

Gibson, R. *Twentieth-Century Portraits* (National Portrait Gallery, London, 1978)

—, *The Portrait Now* (National Portrait Gallery, London, 1993)

Hayes, J. *The Portrait in British Art* (National Portrait Gallery, London, 1991)

Kerslake, J. *National Portrait Gallery: Early Georgian Portraits* (National Portrait Gallery, London, 1977)

Lambert, M., *Fashion in Photographs, 1860–1880* (B. T. Batsford, London, in association with the National Portrait Gallery, 1991)

Lewitt, S., *Fashion in Photographs, 1880–1900* (B. T. Batsford, London, in association with the National Portrait Gallery, 1991)

Linkman, A. *The Victorians: Photographic Portraits* (Tauris Parke Books, London, 1993)

Ormond, R. *National Portrait Gallery: Early Victorian Portraits* (National Portrait Gallery, London, 1973)

Owen, E. *Fashion in Photographs, 1920–1940* (B. T. Batsford, London, in association with the National Portrait Gallery, 1993)

Pepper, T., *High Society: Photographs 1897–1914* (exh. cat., National Portrait Gallery, London, 1998)

Piper, D. *Catalogue of Seventeenth-Century Portraits in the National Portrait Gallery, 1625–1714* (Cambridge University Press, Cambridge, 1963)

—, (ed. M. Rogers), *The English Face* (first published Thames & Hudson, 1957; republished National Portrait Gallery, London, 1978, revised 1992)

Ribeiro, A. *A Visual History of Costume: The Eighteenth Century* (B. T. Batsford, London, 1983)

—, *Dress and Morality* (B. T. Batsford, London, 1986)

—, *The Female Face in the Tate's British Collection, 1569–1876* (Tate Gallery, London, 1987)

Rogers, M. *Camera Portraits: Photographs from the National Portrait Gallery, 1839–1939* (National Portrait Gallery, London, 1989)

Rolley, K., with Caroline Aish, *Fashion in Photographs, 1900–1920* (B. T. Batsford, London, in association with the National Portrait Gallery, 1992)

Strong, R. *National Portrait Gallery: Tudor and Jacobean Portraits* (National Portrait Gallery, London, 1969)

—, *The English Icon: Elizabethan and Jacobean Portraiture* (The Paul Mellon Foundation for British Art/Routledge and Kegan Paul, London, 1969)

—, (introduction), *The British Portrait, 1660–1960* (The Antique Collectors Club, Woodbridge, 1991), and other essays in the same volume.

Wendorf, R. *The Elements of Life: Biography and Portrait-Painting in Stuart and Georgian England* (Clarendon Press, Oxford, 1991)

Wilton, A. *The Swagger Portrait: Grand Manner Portraiture in Britain from Van Dyck to Augustus John, 1630–1930* (exh. cat., Tate Gallery, London, 1992)

Woodall J. (ed.), *Portraiture: Facing the Subject* (Manchester University Press, Manchester, 1997)

Yung, K. K. *National Portrait Gallery Complete Illustrated Catalogue, 1856–1979* (National Portrait Gallery, London, 1981)

COSTUME COLLECTIONS
IN THE UK AND US

Many museums in the United Kingdom contain collections of costume, some general, some specialist; for information, the following works are useful:

J. Arnold, *A Handbook of Costume* (Macmillan, London, 1974)
K. Baclawski, *The Guide to Historic Costume* (B. T. Batsford, London, 1995)

Museums in the United Kingdom and the United States with important collections of costume:

UK
Bath, Museum of Costume
Edinburgh, Museum of Scotland
London, Museum of London
London, Victoria and Albert Museum
Manchester, Gallery of English
 Costume

US
Boston, Museum of Fine Arts
Los Angeles, County Museum of Art
New York, The Costume Institute,
 Metropolitan Museum of Art
Philadelphia, Museum of Art
Washington, DC, Smithsonian Institution

PICTURE CREDITS